INSTITU-
TIONAL
TIME

Judy Chicago

INSTITU-TIONAL TIME

A CRITIQUE OF STUDIO ART EDUCATION

THE MONACELLI PRESS

Photographs © 2014 by Donald
Woodman unless otherwise
noted.

Pages 48 and 59: Courtesy of the
Pennsylvania Academy of the
Fine Arts, Philadelphia. Gift of the
artist. Page 52, left: Courtesy of
the National Museum of Women
in the Arts, Washington, DC.
Gift of Wallace and Wilhelmina
Holladay. Page 52, right:
Nimatallah/Art Resource, NY.
Page 57: Courtesy of the National
Museum of Women in the Arts,
Washington, DC. Gift of Wallace
and Wilhelmina Holladay.
Page 60: © Reproduced with
permission of The Estate of
Dame Laura Knight DBE RA 2013.
All Rights Reserved.

ISBN 978-1-58093-366-7

Library of Congress Control
Number: 2013952209

Design: Gina Rossi

Printed in China

www.monacellipress.com

CONTENTS

"Although I hold a Master of Fine Arts degree in sculpture, I do not have the traditional skills of the sculptor; I cannot carve or cast or weld or model in clay . . . why not?"

—Howard Singerman
Art Subjects: Making Artists in the American University

INTRODUCTION

Art has been the focus of my life. I began drawing before I talked, and I started attending art classes at the Art Institute of Chicago when I was five years old. My parents were political radicals, at least my father was; I always suspected that my mother went along with his program. When she was young, she wanted to be a Martha Graham–type modern dancer. However, observing my grandmother walking home from work in the snow in order to save the penny required for a bus ride changed my mother's plans. She dropped out of high school in order to get a job and help support her family. But she always maintained an interest in the arts, making sure that I could go to art school despite my parents' modest income.

My family's aspirations for my younger brother, Ben, and me involved encouraging us to "make a difference," a notion that seems almost inconceivable in today's money-driven climate. But my mother and father, children of the Depression, were caught up in the revolutionary politics that persuaded many intellectuals to think, wrongly, that the adoption of Soviet-style Communism would transform a world full of injustices into some type of utopia with equality for all.

Ben and I were geared toward highly idealistic goals—so idealistic, in fact, that neither of us had a proverbial pot to piss in for most of our lives, although my brother was able to provide a home for his own family shortly before his premature death of amyotrophic lateral sclerosis—Lou Gehrig's disease—at age forty-seven. My childhood had been full of death, which made me acutely aware of my mortality. One cousin died during World War II, not from battle wounds but by falling into an open manhole as he was disembarking from his ship. When I was nine, a paternal uncle died from the same horrible disease that would later claim my brother. A few years afterward, an aunt dropped dead of a heart attack on an icy Chicago street just a few blocks from our house.

Then my beloved father died when I was thirteen, leaving me with a gaping wound of grief that did not heal for many years. Eight months later another uncle, the husband of my father's closest sister, was shot in his bar during a holdup. And just before I graduated from high school, our neighbors were killed in a terrible collision between a train and their car. Their eldest daughter had been my best friend during most of my childhood.

Such unrelenting tragedy caused me to stumble through high school though, somehow, I managed to get good grades. As soon as I graduated, I fled to California for college with the hope of escaping the fingers of death that seemed to have such a firm hold on my life. I achieved some modicum of peace there, but only until my first husband was killed in an automobile accident, leaving me a widow at twenty-three, struggling to emerge from the stranglehold of so much loss and grief. These deaths contributed to the urgency I felt to work in my studio: this was my way of fulfilling my father's mandate to make a difference while also satisfying my burning desire to make art.

I graduated from UCLA in 1964—a year after my husband died—with a master's degree in painting and sculpture. A part-time teaching job, along with the occasional sale, allowed me to spend a minimum of sixty hours a week in my studio. During this period, I discovered with some shock that not everyone shared my parents' belief in equal rights for women. As a result, I spent a considerable amount of time battling the art world's insistence that one couldn't be a woman and an artist too.

Of course, I'd had my share of problems when I was in college. Most of my art professors were male, and by the time I was in graduate school, I was on a collision course with them. They did not like my imagery because the forms reminded them of wombs and breasts, which they clearly disdained. As a result, I tried to excise any hint of womanliness from my work. Although I was able to make a place for myself in the macho 1960s Los Angeles art scene, after a decade of professional practice, I became fed up with the isolation I felt as a woman artist and decided to change course. I was determined to figure out a way to reconcile my gender and my artistic ambitions in an altogether new artmaking practice, one that would become known as feminist art.

One challenge was that, in order to be taken seriously as an artist in L.A., I had severed my artmaking style from my personal impulses as a woman. As a first step towards reconnecting these, I took a full-time job at Fresno State College (later, California State University–Fresno), where I created a studio art program for women. My hope was that by helping young female

students construct an artistic identity that fuses their gender with their art, I would be able to accomplish this same goal in my own work.

In the process, I developed a radical new pedagogy, one that I came to intuitively. At that time, there was no precedent for an art course tailored to the needs of women. In order to convince the department chair to allow such a class, I argued that many female students majored in art but few emerged as practicing professionals, adding that I had witnessed this attrition myself, having gone to college with many women who no longer were working—or if they were, they were not visible in the L.A. art scene. Because I had achieved some modicum of success, I believed that I might have something to offer about how to forge a viable artistic career, information that was not usually available to women.

Lastly, as soon as I started teaching, I encountered the problem that some students were not participating, which was unacceptable to me, probably because I had inherited my father's passion for equality. During the frequent political discussions that had taken place in my childhood home, my father always made sure that everyone spoke up by employing what I would later describe as a circle methodology that involved asking each person in the room his or her opinion. By applying his example, I discovered that, in addition to encouraging a more equitable environment, this approach made everyone feel as though their views were worthwhile and also created a communal atmosphere of support and strong group bonds that seemed to accelerate the learning process. This was in sharp contrast to the competitive atmosphere in most art classes.

The Fresno course was structured so that the students were able to devote most of their class time for a year to learning how to be artists while engaging in an intensive inquiry into women's history, art, and literature. Earlier, I had begun a similar self-guided study tour, one that had changed my life by providing me with both a sense of my own history and considerable pride in women's achievements. I shared my discoveries with my students and watched them gain a comparable sense of empowerment as they made this heritage their own.

That first feminist art program was extremely successful. Nine out of the fifteen students became professional artists, an astounding statistic given that most art schools anticipate that only a small percentage of art students will make it into professional practice. The Fresno program also resulted in a two-year stint at the California Institute of the Arts (CalArts), a new school on the north end of L.A., where, with artist Miriam Schapiro,

I established the Feminist Art Program, which produced *Womanhouse,* the first openly female-centered art installation. This ground-breaking work attracted a wide viewership and extensive media coverage. It also announced the beginnings of feminist art.

In 1974, I quit teaching to return to the studio full time. Working with students had indeed helped me to find my own voice again. I was ready to undertake a major project. I was thrilled about the discovery of a treasure trove of information about women's history I had discovered, but I was in a state of fury about having been deprived of any knowledge of this rich heritage. Women's achievements—along with a considerable amount of women's production in the visual arts—had been repeatedly omitted from the historic record.

I set out to tell this story and, hopefully, to overcome this ongoing erasure through *The Dinner Party,* 1974–79, a symbolic history of women in Western civilization. *The Dinner Party* required five years to complete, along with more than twenty-five years of effort to achieve permanent housing, which was my goal from the start so that the piece would not be obscured as had happened to so much of art created by women. Thanks to the vision of Elizabeth Sackler, it is now permanently housed at the Elizabeth A. Sackler Center for Feminist Art at the Brooklyn Museum.

Throughout these years, I managed to keep working in my studio, completing three more major collaborative projects (the *Birth Project,* 1980–85; the *Holocaust Project: From Darkness into Light,* 1985–1993; and *Resolutions: A Stitch in Time,* 1994–2000) along with a prodigious amount of individually produced art and more than a dozen published books. Not surprisingly, because my energies were so focused on artmaking and writing I spent very little time in academia, except as a visitor who would parachute into one or another university or art institution to present a lecture, seminar, or critique, staying only long enough to attend the requisite dinner or other social function.

I suppose that these lectures and workshops might be characterized as guerilla actions. I would arrive on campus and cause some flurry of inspiration, particularly for the women. But my visits were brief and therefore my presentations could be easily forgotten by both students and faculty—though, from time to time, students would tell me that hearing me speak had changed their lives.

Everywhere I went, I was asked if things were different in the art world from when I was a young artist. To tell the truth, I wasn't sure. On the one

hand, I often heard complaints from female students about how they were being treated. I also had the occasional run-in with entrenched male art faculty, some of whom seemed threatened by my presence. At the same time, the administration and the faculty would assure me that there had been many changes since I was in school.

It would be foolish to deny that more women and people of color were exhibiting and women artists were much freer to express themselves than had been possible when I was their age. These were all changes worth celebrating. Still, there were many disquieting signs that suggested we had not yet arrived at a post-feminist world, a subject to which I will return later on.

In the early 1970s, while I was establishing my feminist art programs, art historian Linda Nochlin published an essay titled "Why Have There Been No Great Women Artists?"[1] This alleged absence was continually cited to dissuade women from pursuing artistic careers. Nochlin disproved this widely held assumption, demonstrating that women's historic exclusion from academic art training and professional practice had placed overwhelming obstacles in their paths. If male artists had faced a similar situation, I doubt if any of them would have attained greatness either.

Spurred on by Nochlin's research and supported by second-wave feminism, dozens of feminist art historians began to prove that, even with these prohibitions, some women had been able to acquire an art education, usually in the studios of their artist fathers. As a result, in the past four or five centuries, a number of women artists became famous and successful in their own time, only to have their work subsequently ignored or deleted from the historic record. This predicament raises an unavoidable question: will contemporary women artists' success turn out to be as fleeting as that of their predecessors'?

Despite the ever-growing and substantial body of research attesting to the existence of many important women artists (past and present), most university art and art history curricula continue to be male-dominated. If there are any courses on women in art, they tend to be add-ons. As I often say, there are BIG art history survey courses and LITTLE classes about women in art (a corresponding phenomenon exists across all academic disciplines). Meanwhile, female art students have become more numerous than male students at both the undergraduate and graduate levels and there are an increasing number of women in positions of power in the art world—both in and out of academia. Unfortunately, the presence of more women in institutions has not always translated into real change.

In the early 1990s, I began receiving letters from female students at numerous universities and art institutions all over the world—by then, I was lecturing internationally. They reported that they were learning almost nothing about women's history or women's art. In fact, many of their art professors, both male and female, were hostile to female-centered work or unable to adequately critique it. As a result, they felt unsupported or entirely stranded in terms of their artistic growth. Moreover, most of them were unaware of the feminist art movement of the 1970s, which is now noted for having dramatically affected art practice. For those not familiar with this movement, its aim was to alter both the art world and the universities so that women were better represented and artists of all denominations were able to openly express their identities. (And yes, men can make feminist art).

I was distressed at this seeming demonstration of what Gerda Lerner, the pioneering women's historian, has described as a tragic repetition in which women do not learn what women before them thought, taught, or created. The result is an inability to build upon their foremothers' experiences and wisdom. But I was not involved in academia at that time, so I could neither confirm their accounts nor do anything about the situation.

Then my personal circumstances changed. In 1996 my husband, photographer Donald Woodman, and I moved into a dilapidated former railroad hotel in Belen, New Mexico, a small town south of Albuquerque. Because Donald has a background in both architecture and construction, he did the renovations, which took three years. With the modicum of comfort the hotel brought us came something I had always avoided: a mortgage. But Donald was adamant that we should have a home of our own. Although this sounded like a good idea, it required that I increase my earnings.

Happily, I soon discovered that even though my career had not rendered me financially independent, it had brought me the opportunity to earn a respectable sum of money through teaching. However, as I am incapable of being motivated entirely by money, I hoped that I might be able to offer something valuable to students—my decades-long experience as a practicing artist and the pedagogical methods that I had begun developing in the 1970s. I thought that my pedagogy might still prove empowering, and perhaps not only for women.

After a twenty-five year absence, I returned to academia. Between 1999 and 2005, I did semester-long stints at six institutions around the country. I worked alone at Indiana University–Bloomington, Duke University, and the

University of North Carolina, Chapel Hill, and then with Donald at Western Kentucky University, Cal Poly Pomona, and Vanderbilt. This provided an opportunity to see how university studio art education had developed since I stopped teaching in the mid-1970s.

During our years of teaching, Donald and I had many conflicts with rigid bureaucracies and uptight faculty members. In my opinion, these reflected the uneasy truce between art and academia that was struck after World War II, when art first became an academic discipline, another subject that I will explore later. I also came to realize how different my content-based pedagogy was from the prevalent approach to studio art, which focuses on form, materials, techniques, and often professional socialization—that is, how to make it in the art world.

Before I take up the narrative about my return to academia and my thoughts about the present state of university studio art education, I wish to discuss my personal conflicts about teaching. I broach this subject for two main reasons. First, I believe that many artists who teach also feel conflicted, and that their feelings sometimes impact their classes in extremely negative ways. I was told about one teacher who spent most of his time drawing in his office behind a locked door rather than interacting with his students. Then there was the sculptor who turned the school's sculpture studio into his personal atelier, where his work dominated the space. Although I am extremely critical of this type of behavior—it can never be justified—I believe that I understand its cause. In all likelihood, the professors had a desperate need to make their own art rather than to facilitate their students' work, which was the job they were ostensibly being paid to do.

Second, I have seen the careers of many women artists derailed by trying to "have it all," that is, a career, marriage, and a family. In my own case, it was clear to me from the time I was a young woman that, as unfair as it might be, this was not possible, at least not for women of my generation. Also, my study of history had shown me that most of the successful women artists had not had children. And if they did have a family, they ended up juggling their domestic responsibilities with finding enough time to work in their studios, usually to the detriment of both their children and their work.

Most women do not know their own history and thus cannot draw on the experiences of earlier women to guide them. This was certainly the case for me when I was young. One reason that I am writing this book is so that young women will not be seduced by the illusion that there are no more

obstacles for them, that they can move forward on equal footing to men. Although I wish this were true, it is not, a contention that I hope to prove. I realize that some readers might be put off by my candor. But I feel strongly that it is important to speak plainly about what I have learned during my decades of struggling with these issues.

Early on, I became determined to use my time on earth to create art—as much of it as possible—and to make a place for myself in art history. Once I was an adult, I felt even more certain that I had a lot to say about life, about women's circumstances, and about the world and its many injustices. Because I was so driven, from the moment I emerged from graduate school I felt compelled to devote most of my waking hours to art. All else took second place, including personal relationships, financial security, and teaching—which I was only willing to do on a limited basis.

During those years, as I witnessed one woman artist after another curtailing or giving up her career for motherhood, I was often glad that I had never felt an overwhelming desire to have a baby. In fact, apart from the short-lived nature of even the best of conjugal relations, I abhorred the idea of having some other being inside my body and never understood how women could accept this without at least complaining. The idea of any creature feeding off my body while it lived in my womb then sucking milk from my breast repelled me.

And the notion of spending my time meeting a child's myriad of needs? No, never, not for me. I wanted to nurture myself, not some other being. Giving away my time, not to mention my energy, to anything but expressing myself through art seemed tantamount to defiling myself. Not only did I have zero interest in becoming a mother, soon after I began to teach part time, I discovered that I didn't get off on being a teacher, either, as some of my colleagues claimed to do. Not that teaching is a bad thing to do; on the contrary, like motherhood, it can be an entirely commendable occupation. However, also like motherhood, it requires a level of selflessness that I seem not to possess.

I realize that admitting these feelings will not make me popular in some quarters, but then I've never seen my life as a popularity contest, perhaps because I have always been so focused on my goals. I am pretty sure that there are other women who share these sentiments, but it is still unacceptable to admit them. We're all supposed to look forward to motherhood. I know from my study of history that I am not the only woman artist who realized that a certain amount of selfishness was essential for a successful

career. For instance, if Georgia O'Keeffe was interrupted while painting (nude), she would chase away the offending intruder in a manner so fierce as to not endear her to either the visitor or to history. Certainly such behavior by a male artist would only have contributed to his mystique whereas, for a woman, putting oneself first has usually been taboo.

Along with a high degree of selfishness, though, I also possess a soft heart. The only way I have been able to prevent myself from being overly generous to others (as women generally are) is to isolate myself, sometimes for long periods of time. What I am describing is a near-constant state of ambivalence. I want the freedom and solitude to follow my inner voices but I also crave human contact and acceptance. Achieving the latter, though, renders me vulnerable to other people's needs. Consequently, I have veered back and forth from one extreme to the other, from isolation to near-total engagement. I'm sure this erratic behavior must have confounded many who knew me and certainly befuddled those who only glimpsed my path.

During the course of my career, which now spans five decades, I have been determined to make my work accessible and comprehensible to a broad and diverse audience. This has put me on a decidedly different track than many of my peers whose work is generally more opaque. Consequently, my art has often elicited hostile, even vitriolic criticism for reasons that hopefully will become clear. At the same time, I am widely viewed as a successful artist. Whatever success I have achieved, though, was earned by bucking the system, not by succumbing to it.

Perhaps there are some artists out there who will have the courage to do what I did. That is, to forge their own path. If so, I hope that this publication will assist them in the same way that my first book, *Through the Flower: My Struggle as a Woman Artist,* helped young women around the world realize that their difficulties were not proof that there was something wrong with them or their art but, rather, the result of an art world that was exceedingly hostile to women.

As I've acknowledged, there have been many positive changes since 1975, when *Through the Flower* was published. At the same time, during the recent years I've spent in academia, I have been asked repeatedly why young people are so afraid of the word "feminism." The answer is so obvious, at least to me. As long as women's history, feminism, and feminist art are thought of as special-interest topics instead of required curricula in all fields, students will not take pride in women's heritage. Instead, they will continue to labor

under the notion that to be identified as a feminist is something heinous. Feminism, the belief that everyone is entitled to a life of dignity, has evolved over several centuries and brought women in the Western world unprecedented opportunities. This historic struggle for freedom deserves to be both honored and taught—to everyone. Moreover, the idea that gender matters must be translated into tangible institutional change.

When I decided to go to Fresno to set up a women's art class, I was not at all sure how I would proceed. I only knew that I didn't want my students to have to face what I had experienced in college or in the decade I spent battling to make a place for myself in the L.A. art world. Even though I didn't yet see my path clearly, I knew that I wanted to forge an alternative for female students and also for women artists, one that allowed us to be ourselves as women while striving for excellence as artists. That year in Fresno gave me the space that I needed to think, to dream, and to experiment.

Since that time, I've had the opportunity to hone the teaching methods that I developed there. In this book, I plan to describe my pedagogical methods and outline some of the challenges and obstacles that (along with Donald) I faced as we tried to bring this approach to various institutions. After spending a number of years teaching in universities and colleges around the country, I am more convinced than ever that present-day university studio art education needs to be challenged or perhaps even completely upended and replaced with something new, something that allows art to be reconnected with its true source, the human spirit, which manifests itself in a wide diversity of forms.

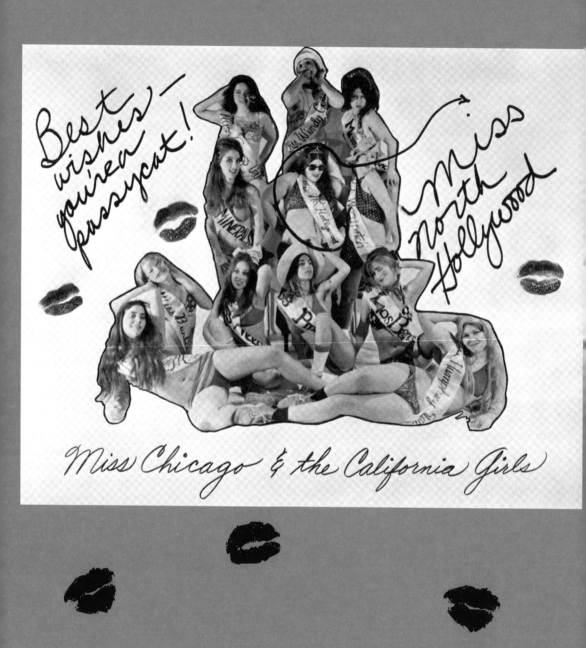

ONE:
CALIFORNIA
DREAMING

In the early 1960s, when I was starting my professional career in Los Angeles, it was possible for artists to get along on a minimum of money. Studio space was cheap, opportunities were plentiful, and "something always happened" to pay the bills. (The "something's going to happen" school of thought guided my decisions throughout most of my career). Even though it was often frightening to live such a financially insecure life, after awhile I became accustomed to it and adept at managing the anxiety.

After graduate school, I got a part-time job at the UCLA Extension teaching a high school art class on Saturdays. It was there that I first introduced my circle methodology, where I would call on each student so that everyone would have a chance to speak, if only to say "I pass." Some scholars have attributed this technique to the consciousness-raising groups of the 1970s women's movement but it actually had a different source—when I was a child, my father used to lead political discussions in our living room and he always made sure to involve everyone, including the women.

When I began to use this method, I soon discovered that the loudest voices in the room were not always the most knowledgeable, but they were almost always male. The same situation had existed in most of my own college classes, which I could not abide. Even then, I had enough feminist consciousness to be able to recognize that the obstacles I encountered at UCLA and then in my early professional life were related to issues of gender. Fueled by the civil rights and antiwar movements, by the end of the 1960s, women began to speak out about their oppression, which was made apparent by the attitudes of some of the men in the left (notably, the often-quoted comment by Stokely Carmichael, when he was a leader of the Student Non-Violent Coordinating Committee that women's appropriate position in SNCC was "prone").

Miss Chicago and the California Girls, c. 1970–71. Poster. Fresno Feminist Art Program, Fresno State College, California. Photograph by Dori Atlantis

I read early feminist literature with something akin to what a drowning woman might feel when spotting a life preserver. At that time, the prevailing assumption was that women *had* no history. Women's studies courses were nonexistent then; there was no such thing as a course on women and art. Men had taught most of my studio courses, and few of my female classmates had emerged from graduate school into professional art practice. Even if they had somehow managed to avoid being seduced by their professors, most of them were steered away from fine art into graphic design, textiles, art education, or, as the prominent art critic Lucy Lippard so aptly described it, into the "housekeeping" of art, wherein women write about, promote, exhibit, and preserve the work of male artists.

Because I was so ambitious, this did not happen to me. By the end of the 1960s, I had managed to establish somewhat of a reputation as an artist but it was always conditional; I was sort of a mascot to the all-male players that comprised the teams of the prominent galleries. Because I desperately wanted to be taken seriously as an artist, I had adopted what I now describe as "male drag," trying to act, and make art, as if I were a man. During these years, my work became increasingly minimal, which wasn't an altogether bad thing as I developed considerable formal control and visual mastery, which would prove valuable to my development as an artist.

Inspired by the early women's liberation literature and my own research into women's history, I set out to forge a different type of artmaking practice, one in which my gender didn't have to be either excised or concealed. If my needs and interests differed from those of male artists—which is how it appeared to me at the time—perhaps I would have to figure out how to establish both an art practice and an art context that was more suitable.

I became convinced that we women would have to create our own art community. This would involve not only making art that reflected our experiences and concerns but also developing the means to show, distribute, and sell it; teaching other women artmaking skills; and establishing and writing our own art history, one that allowed us to discover and focus upon the contributions of women artists past and present. I couldn't clearly articulate my goals at the time because it scared me to openly admit the scale of my ambition. which involved creating an alternative approach to studio art practice.

At this moment in history, such ambition might seem fraught with hubris. But the climate of the 1970s was full of hope and radical change was in the air. Also, in southern California the aesthetic imprint of Europe was far less

daunting than in New York. In fact, the Los Angeles art scene was still in its infancy and many artists reveled in their outsider status. The pressures of the art market were almost nonexistent and self-invention was the norm. Add to this my own radical upbringing, and it is not difficult to imagine how I could dream of constructing a new form of art practice.

Trouble was, I didn't think that I could undertake this task in Los Angeles. I felt the need for complete solitude in order to paint, study, think, teach, and try out my ideas. In the fall of 1969, I began to look for openings in art departments around the state and discovered one at the state university in Fresno. This central California town was still semirural and definitely out of the art loop. Moreover, it was only two hundred miles from Pasadena, where I was then living. It seemed like the perfect place—far enough away to provide psychic privacy but close enough to commute. During the spring semester of 1970, I taught three days one week and only one day the next, a schedule agreed to by the department chair so that I could complete the series of paintings in which I was then immersed. The first semester, I taught a mixed-gender class on outdoor sculpture, which culminated in an exhibition on a piece of land loaned by a local art collector.

Among my students was a fellow named Jack Rhyne, who would become my studio assistant. I rented an old supermarket in Kingsburg, just south of Fresno, a small town of fewer than 3,000 residents, and with Jack's help I turned the market into studio space, an office (in the meat locker), and a modest living area. Over the summer, I moved in. My intention was to begin work on a new series of large paintings on sheet acrylic and the studio was set up specifically to accommodate this goal.

That same spring, I put up notices in the art department announcing a women's class, slated to begin in the fall and to run for two semesters. I had convinced the department chair that this was a good idea by saying that I needed to work intensively with the students. I pointed out the discrepancy between the large number of women in undergraduate art classes and the paucity of their representation in professional art practice. In retrospect, it seems somewhat incredible that he agreed to my plan. Perhaps he was just eager to hire me, or maybe he had a sincere desire to help his female students. I really don't know.

Because there were no precedents for what I wanted to do—at least none that I knew of—I had mainly my own experiences as an art student and a young artist to guide me in the classroom. In my recent research for this book, I discovered that, even now, there is very little published material about the

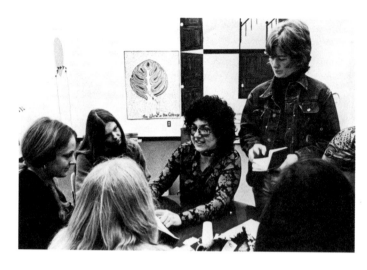

Judy Chicago with
students, Fresno
Feminist Art Program,
c. 1970–71

subject of university studio art education. As noted by Robert Bersson in 2005,[2] "The amount of writing on art pedagogy is astonishingly small." (This is true for the university level; there is a huge amount of literature on K–12 art education). One of the few helpful publications was Howard Singerman's book *Art Subjects: Making Artists in the American University.*[3]

In structuring the Fresno women's class, I drew upon my own education as a negative example of the ways in which women's needs were not directly addressed. Also, when I was in graduate school, no one was taught anything about what was involved in establishing and running—not to mention financing—a studio. I can still remember visiting the atelier of Billy Al Bengston, a dashing local artist who was teaching a graduate class at UCLA, and my shock when he told me how much money it cost to maintain it.

Throughout the spring of 1970, I interviewed prospective students. My plan was to select fifteen women based upon portfolio review and personal interviews. However, many of the students didn't have any photo documentation of their work so I looked at drawings, paintings, and, in one case, weavings, until I identified women who seemed like good candidates for the program. This process also demonstrated that I would have to provide training in how to present work, as few of the students had anything resembling a suitable portfolio.

I was looking for talent, motivation, and ambition but I would soon discover that just because a student announced that she *wanted* to be an artist didn't mean that she had any idea—much less the stamina—how to actually make this happen. Over the years it has become clear to me that

any selection process is ultimately a crapshoot, and Fresno was no exception. In most cases I either under- or overestimated a student's potential. I even nearly rejected a young woman, Suzanne Lacy, who later became an important performance artist. For some reason, I just assumed that all my students would have painting and drawing experience, but Suzanne had none. A twenty-five-year-old psychology student and an ardent feminist, she told me that she wanted to join the class in order to "be creative," words that are anathema to most professional artists, who view art as an extremely demanding job.

Most of the students were ages nineteen to twenty-one, but Faith Wilding, a weaver and graduate student then married to Everett Frost, an English professor at the university, was also twenty-five. At that time weaving, like all of the needle and textile arts, was considered a lowly craft and definitely not art. Like Suzanne, Faith was a committed feminist who wanted to be considered an artist. Taking my class seemed a path to the realization of her goals. Together with Everett, Faith befriended me. She also became my teaching assistant.

When the Fresno program began in the fall of 1970, the first thing I did was to take the students off campus. I wanted them to have a space of their own, somewhere they could feel completely comfortable. I knew that many women became intimidated in the presence of men. At that time, even I found it difficult to be completely honest when they were around. How much harder would this be for young women?

At first we met at the home of one of the girls. I began the class by asking everyone to introduce themselves. Then I asked the group what they'd like to talk about. I had certainly been with art students before, both during my own college days and afterward. Generally, there was *some* discussion about art—but these girls' conversations never swerved from the subjects of boyfriends, clothes, casual experiences, or food. I suddenly became panicked. What had I gotten myself into?

Right then, I made an important step in my commitment to teaching women. I decided to always and honestly reveal my feelings. I said, "You know, you are boring the hell out of me. You're supposed to be art students. Art students talk about art and books and movies and ideas. You're not talking about anything." There was dead silence. I thought that by opening my big mouth I had already blown it. Then I heard a soft voice say, "Well, maybe the reason we don't talk about anything important is that nobody ever asked us what we thought."

Telling this story even now, four decades later, I still feel sad. I remembered the intense discussions that filled my childhood home. Always included, I was made to feel that my ideas were significant. Obviously, these young women had not had the same type of upbringing. They began to tell me about their experiences. At parties, the men did all the serious talking. The females were there as ornaments, always introduced by their first names only. They were just the "girls" who were expected to go along with the men's wishes.

One of our first exercises involved changing the way in which they presented themselves. I insisted that they use their full names and shake hands while looking into the eyes of the person to whom they were being introduced. I had already instituted the practice of going around the circle and encouraging everyone to participate. (Earlier, I mentioned that it was possible to say "I pass" if someone was not prepared to talk. Generally, I have found that if a student is allowed extra time, she will ask for a turn after everyone else has spoken.)

By then, I had also discovered the importance of strategic silence. If students don't speak up, I wait—no matter how long it takes. Eventually someone breaks the quiet and, slowly, others come forward until any initial passivity begins to give way to active involvement. This is what happened in Fresno, too. Soon the young women were enthusiastically exchanging ideas, feelings, and thoughts.

From the time I first started teaching, I viewed the teacher's role as that of a facilitator rather than an authority figure, probably in reaction to the authoritarianism exhibited by my male professors at UCLA. Of course if there is specific information to impart, such as how to apply gesso to a canvas, the teacher does become an authority by sharing her knowledge with the students. But that momentary power should not harden into a rigid role.

Most students are used to teachers who act as authority figures and they are usually adept at allowing them to assume this role; after all, it means that the students don't have to do much other than sit there. By allowing silence, the teacher communicates that she will not step into this autocratic role. Instead, it is her job to make sure that all members of the group become actively involved.

By acting as one of the members of the circle myself, the students were able to see me as a person. When necessary, I reasserted my leadership, using it to move the discussion along or to help students develop more awareness about what they were saying or hearing. During this process, I

would move back and forth between the roles of facilitator and participant while being careful not to become too dominant, which would undercut my effectiveness as a facilitator.

The class met several afternoons a week. I had arranged for the students to get six credit hours, the equivalent of two classes. In addition to the meetings, time was spent looking for a studio space because, as I explained, being an artist entails having a studio. Once we found a building, everyone— including me—paid $25 a month, which also provided a small budget for materials (the rent was ridiculously low). This studio was to provide workspace, a discussion room, a performance area, a kitchen so the students wouldn't have to leave for meals, and eventually, exhibition space.

The women then set to work preparing the building, which was somewhat dilapidated. I had to teach most of them how to use power tools and how to construct and paint walls. A few of the girls asked their boyfriends for help, which was as close to the studio as men ever got until the end of the year, when we set up our final show. Some of the guys were very supportive while others challenged their girlfriends every step of the way.

My intention was not only to help the young women acquire building skills but also to help them gain confidence in themselves physically. However, their manner of dress was hardly suited to the tasks at hand. Suzanne Lacy still talks about my insistence that everyone wear work boots in lieu of the flip-flops most of them sported. She ended up falling in love with hers, rarely taking them off even when she got dressed up. She eventually bronzed them and gave them to me as a gift.

Once the studio was finished, we moved in. The discussion room was filled with pillows that the students had made, which contributed to a warm, homey atmosphere. It was here that we spent many hours "going around the circle" for reading discussions and for something that I dubbed "content search"—mining personal experiences for potential subject matter for art.

As I mentioned, the Fresno program took place during a period when consciousness-raising groups were active, although I was never in such a group. Some writers have described my circle-based teaching method as consciousness-raising, but that is not accurate. Neither is it a form of therapy, though it may have therapeutic effects. Consciousness-raising is exactly what the term implies—the raising of political consciousness in order to become aware of the forces that contribute to women's oppression. It is based upon talking with other women about personal experiences in order to see the many ways in which the personal is political, that is,

understanding one's life in a larger social and political context. Therapy involves employing a range of techniques intended to help patients see their problems more realistically so that they can cope with them more effectively. In contrast, my circle-based pedagogy helps students discover that their life experiences can provide meaningful content for their art. The process is not an end in itself; rather, it is only the first step.

This method also helps to build group cohesion. As people listen to each other's stories, they become increasingly close. At the same time, the group analysis that takes place helps each student become more independent as

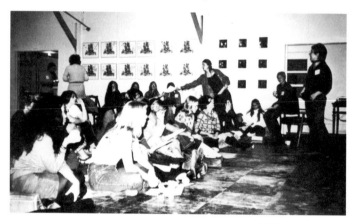

Rap Weekend. Fresno Feminist Art Program, April 1971

they begin to see their experiences in a larger context. Another difference between "content search" and classical consciousness-raising is that, in the latter, no one interrupts. I used my position as a teacher to intercede in the circle whenever I deemed it necessary to make a point or to engage in dialogue intended to help the student find subject matter that was important to her.

For example, one day we discussed being verbally harassed on the street by men, an experience most women have had many times. As each woman spoke, the others nodded in sympathy at the common and unpleasant sensation of being objectified. Early on, I realized that ideas and feelings discussed in our "rap room," what we called the pillow-filled space, could become the subject matter and catalysts for performance pieces that were honed by the group. Through this process, the topic of female passivity was transformed into the famous "Waiting" monologue that Faith Wilding has presented over the years.

As a child, I would put on plays on our back porch with children from the neighborhood. Consequently, I found it easy to get into role playing

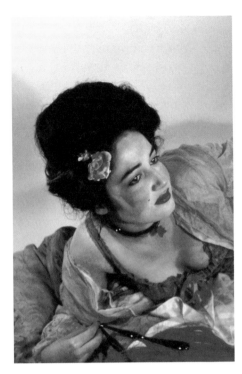
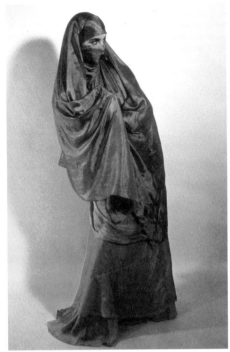

with my students, who were all quite adept at costuming themselves and assuming various female personae—later feminist theory would argue that femininity itself was a social construct that women "perform." In Fresno, theory and practice became one as my students began to photograph each other in various roles, a precursor to a good deal of subsequent feminist art such as Cindy Sherman's.

It was amazing to me how quickly this process unfolded; it was almost as if I had lifted the lid on a pot of boiling water. At one point in the first semester, I wrote the *Cock and Cunt* play, which was useful in helping my students work through some of the issues associated with the construct of femininity or as we used to describe it, the female role. Over the last few decades, there has been a considerable amount of literature on this subject. I had come to understand that the many ways in which girls are socialized hampers the full expression of their talents. Struggling to overcome this socialization was what I had done alone in my studio, where I came face to face with many obstacles—external and internal—related to my gender. I also learned to recognize habits and patterns that interfered with my professional aspirations, for

Karen Lecocq, *Victorian Whore,* 1970. Costume by Nancy Youdelman. Fresno Feminist Art Program. Photograph by Dori Atlantis

Shawnee Wollenman Johnson, *Veiled Woman,* c. 1970–71. Costume by Nancy Youdelman. Fresno Feminist Art Program. Photograph by Dori Atlantis

example, my tendency to put aside my work in the face of emotional demands from partners or friends. In other words, I learned to say no, an ability that I had to help most of the students develop. My students were lucky; they had the support of both the group and me.

Before I describe this play, I must admit to the terror I felt while writing it in the confines of the meat-locker-turned-office in my Kingsburg studio. My words were fueled by rage—from years of being put down for being a woman as well as from feeling sexually used by male partners. Even while the sentiments were pouring out of me I felt extremely anxious, as if I would be punished for expressing my anger. And for months, every time my students performed it, I would be apprehensive.

In my opinion, this deeply internalized fear is brought on by living in a world in which women are still called bitches if they act too aggressively. For example, while I was working on this book, I gave a lecture at a college in Arizona. The African-American woman who introduced me spent most of her time explaining why she was so often called a bitch, saying that it was because she insisted upon standing up for herself. The fact that she felt compelled to justify what should be every human being's right demonstrates precisely the problem I am discussing—that is, the many ways in which women are psychologically discouraged from expressing important aspects of their personalities.

Somewhat later in the year of the Fresno program, I met the writer and diarist Anaïs Nin (1903–1997), who became famous for the journals she kept meticulously over sixty years. She and I spent many hours discussing the idea of a female aesthetic, a subject that I was very focused on at the time. In the course of our conversations, the topic of anger came up frequently. As someone older, Anaïs was even more nervous than I about openly expressing what she considered a negative emotion. In fact, she was adamant that women should not express anger—in life or in art.

I totally disagreed, arguing that suppressed rage leads to depression. Moreover, women have the right to the full range of our emotions. The social and psychological prohibitions against anger are deleterious to the creative process. This is where the *Cock and Cunt* play came in. It was definitely a loud shriek against female oppression, be it in the bedroom or the kitchen. I have included the text as an appendix, as I believe that it might still be a useful pedagogical tool.

In *Cock and Cunt*, two performers dressed in black leotards take on the parts of "He" and "She" and engage in a lilting dialogue about the politics

of housework. This discourse was raging at the time, as women cast off widely held expectations that they should always be the ones to handle the domestic duties. This was a subject fraught with anxiety for both women and men; women because they were challenging male privilege and men because they were being asked to do something that they had always viewed as "women's work."

Many of my students had great difficulty in taking on the male part—I insisted that everyone play both roles—because it required them to be openly aggressive, which seemed to be as frightening for them as it was for me. As I helped the young women enact the two different parts and in so doing express different aspects of their personalities, I gradually became more comfortable with both the play and my own anger.

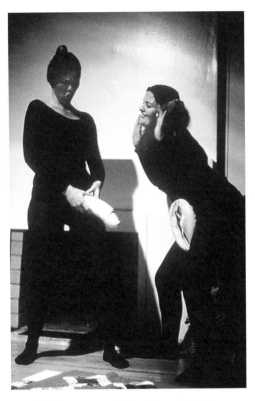

After a few months the studio saw an explosion of energy, a result of the students being encouraged to find natural aesthetic outlets instead of being forced into a male-centered educational mode. A typical studio art assignment at that time might have been something like laminating wood planks together to make a cube, cutting that form into various shapes, and reassembling them as a sculpture. Things might be different now in that girls might be trained in basic construction techniques, but I certainly wasn't and neither were my students. Then, female art students were expected to move out of their own frames of reference and into another without so much as a gulp.

In addition to the rap room and the performance space, the Fresno studio also had a small area for showing slides. I had begun assembling an archive of women's art by photographing images (usually black and white) from old books, many of which were from the late nineteenth century. At that time, I was

Faith Wilding and Janice Lester performing in Judy Chicago's play *Cock and Cunt* from *Womanhouse*, 1972. Feminist Art Program, CalArts

lecturing around the country and everywhere I traveled I looked for work by women, buying any slides that were available to amplify my image library, which the students soon became engaged in expanding.

I also shared with them my study of women's history and literature. I had virtually given up reading books by men, in part because I couldn't relate to many of their female characters but also because, by then, I was already well versed in male writing. I wanted my students to get a healthy dose of female-centered writing, which we discussed weekly. My only regret about this course of study was that the Fresno students were far less sophisticated than I, who had been exposed to some of the world's greatest art, literature, and philosophy (my minor in college). My insistence on studying only women's work meant that they couldn't see this work in a larger context. Of course, the same could be said for programs like Great Books, in which students studied the work of primarily or only men.

By the end of the first semester, the students asked for more studio time. I arranged with the college that, in addition to the six units of credit for the course, they could sign up for an independent study with me. This would allow them additional credit hours, depending upon how much time they put in. We established a schedule in which everyone was free to come and go as she wished. I held individual conferences with each of the students—but only in the afternoons so I could preserve the early part of the day for my own studio work. On Wednesday evenings, we had dinner meetings everyone was required to attend. Soon, the students and I settled into a regular routine in which work dominated both our days and our discourse.

Some months after the program started Ti-Grace Atkinson, a prominent feminist writer and theorist, was invited to speak at Fresno State. The students and I decided to meet her at the airport and then, after her lecture, to take her back to the studio for a festive supper so she could see what the group had been doing. Four of the students decided to make special costumes and to greet her with cheers; so began the development of the "Cuntleaders" with their array of rousing chants in praise of the vulva. The whole class went to the airport with the costumed group in tow—only to encounter dozens of Shriners getting off the plane right ahead of our visitor.

Undeterred, the four young women advanced on Atkinson, shouting their cheers in unison. She responded with a grin. The Shriners were dumbfounded; I tried not to let my embarrassment show. After all, despite my radical intentions, I was brought up a middle-class Jewish girl unaccustomed to such public displays. At the same time, I did not want

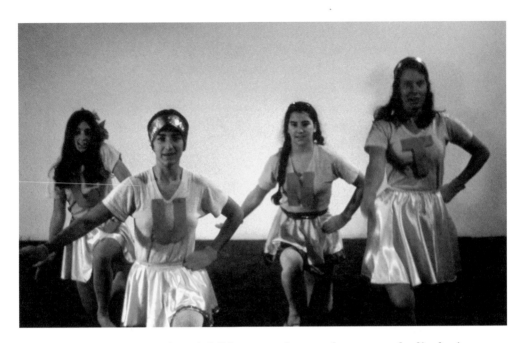

to let my own reactions inhibit my students, who were only displaying the exuberance of youth.

My nervous reaction to my students' performance at the airport reveals something about my state of mind at that time. Though I might have appeared to be a confident teacher, underneath I was far less certain of myself and what I was doing. I was only in my early thirties—still a young artist. And I was often scared to death of what I'd unleashed. Images and ideas were pouring out of the students; they were so powerful that they sometimes frightened me. I soon began to feel an intense need to talk to someone, preferably another female artist.

The only person I could think of was Miriam Schapiro, who was teaching at a new art school called the California Institute of the Arts, where my then-husband, Lloyd Hamrol, was also working. The campus was still being constructed in Valencia, in the San Fernando Valley on the north end of Los Angeles, and until it was finished, CalArts classes were being held at a former convent in Burbank.

When Mimi and I met, I immediately felt a strong affinity with her and even saw similarities in our work, notably between her painting *OX* and my own *Through the Flower*. Both featured an abstract central core, something that I had observed in the work of a number of women artists. Later, when Mimi and I wrote about this phenomenon, there was an outcry

The Cunt Cheerleaders. Fresno Feminist Art Program, c. 1970–71

from other female artists who misinterpreted what we were saying. Somehow, they got the idea that we were insisting that women *should* use the same type of composition. They didn't realize that our remarks simply pointed out what we had done in our own art and had noticed in the work of others.

Even though I didn't know Mimi well, I was aware that she had made her way in the East Coast art world during the heyday of abstract expressionism, which was not exactly welcoming to female artists. I hoped that, as an older and more seasoned artist, she might be able to offer some support. When I called, I hardly gave her a chance to speak before I blurted out all my anxieties. She seemed to understand everything I said and was very reassuring, which meant a lot to me.

Sometime later, I arranged for Mimi to give a lecture at Fresno State and then visit the studio. Apparently, it was the first time she had ever been invited to talk publicly about her work. She was exceedingly nervous about asserting herself—another seeming manifestation of the fears I previously discussed—but her presentation was a big success. Afterward, the students and I gave a party in her honor at the studio. They showed her their work, presented several performances, and shared many of their ideas and emotions with her. Mimi gave them wonderful feedback. She seemed to have a special talent for providing critiques that were gentle and insightful at the same time.

In the spring of 1971, we held an exhibition of the best work done during the year. Many of the images referenced the female body, as my own early work had done. This was not because I had urged the students in that direction, but because it had come out quite naturally. Even today, women in all areas of art practice must contend with an enormous array of negative imagery centering on the female body, some of which has long been considered the defining iconography of Western art (spanning the centuries between Giorgione and de Kooning). Even if my students had not seen a lot of this work, they were the recipients of many of the misogynist attitudes evidenced by such art. So it was not surprising that their art became a vehicle through which they were able to stand up to these attitudes.

As the late artist Hannah Wilke put it in 1982:

> *Stand up for what you want to do. . . .*
> Stand up and be your own cliché. . . .
> Stand up for women to decide
> Stand up, they're bodies you're inside.[4]

Admittedly, some of the students' work was crude because they were young and what we were doing was entirely new; we were trying to build a female-centered iconography against the background of a visual history created by men, a history that features a plethora of images presenting women as objects. For many centuries, the female body has been a battleground in art, "contested territory" in that the nature of female identity has been at stake. One could say that it is a question of who defines that identity.

Some writers, notably the art historian Griselda Pollock, have argued that it was impossible to either subvert or challenge traditional images of the female body, to "decolonize the female body," as she put it.[5] During the 1980s, her views held sway. It would be another decade before feminist art historians began to look back on the work that came out of the early feminist art movement with renewed interest, recognizing its importance as the source of a considerable amount of subsequent contemporary art—by both male and female artists.

The work that emerged from the Fresno program was an early attempt to challenge the historic male views of women. Even though it was the work of young women who lived outside of any major art community, it was innovative and powerful. It was also threatening. At one point, my students and I were invited to do a slide presentation at a school in the Bay Area (I don't remember which one). During the program, one man in the audience became so enraged that he leapt up on the stage and assaulted Faith Wilding, who struck back at him. Afterward, she exclaimed, "How could I have done that? I'm a pacifist." Needless to say, the guy's hostility freaked us out.

Several hundred people attended the year-end exhibition of the Fresno program, including a group from CalArts where Paul Brach, Mimi's husband, was dean of the art department. By then, he had invited me to bring my program, along with a number of my students, to the school. I would team-teach with Mimi. She had already begun helping those students who wanted to go with me to prepare their portfolios. It was a heady time; I was enthused about bringing my program back to Los Angeles, where my roots were deep.

In the early summer of 1971, I closed up my Kingsburg studio and moved south, followed shortly thereafter by quite a caravan down the highway from Fresno to L.A. Along with those students who had been accepted came a variety of husbands, significant others, various pets, and furnishings. They were all really excited; as for me, I was thrilled.

The first year of this program began quite differently than the previous one. In contrast to the funky, self-supported studio the students and I had

set up, here we were to be given our own brand-new studio space along with tools, equipment, course support money for projects and materials, and a full-time art historian with a budget to turn my ragtag slide file into a real art history archive. The establishment of the Feminist Art Program at CalArts marked the first time that a major art school had specifically addressed the needs of female students by incorporating an educational program designed and run *by* women *for* women.

There were twenty-one undergraduate students in the program, which, as in Fresno, was structured as a one-year course. Similarly, everyone had gone through an application process, but most of the CalArts students had

WOMANHOUSE

impressive portfolios. Because the Valencia campus was still not ready, we couldn't move into our official quarters until later in the year. Instead, Mimi and I began meeting with our students in a succession of temporary spaces around Los Angeles.

Then, thanks to a suggestion by our art historian, the late Paula Harper, we came up with a plan for an ambitious project. We would renovate an old house into a series of rooms expressing women's feelings about the home. Women had been confined to domesticity for centuries and had quilted, stitched, baked, cooked, decorated, and invested a good part of their creative energies into enhancing their domiciles. What would happen, we wondered, if women took those very same activities and carried them into fantasy proportions by translating them into art?

On a bright November morning, the students, Mimi, and I arrived at a dilapidated old mansion on Mariposa Street near downtown Los Angeles. Groups of students had scoured the city for appropriate spaces until they found a run-down place that seemed perfect and located the owner's name in the hall of records. She and her family agreed to rent us the house for three months—Mimi and I estimated that it would take two months to work on the space and create the art and we wanted one month to exhibit the results. Armed with mops, brooms, saws, ladders, hammers, and nails, everyone looked around the seventeen empty rooms and began to dream.

The first job was to get the house into shape for the transformation that was to be wrought. The building had been unoccupied for twenty years and had been repeatedly vandalized. The railings in the staircase had been ripped out, windows were broken, the toilets were stuffed up, dirt and grime were everywhere. The walls were peeling, the floors were covered with dusty carpets, and most of the cabinet doors were unhinged. We set to work cleaning, scrubbing, tearing up carpets, repairing broken doors, constructing walls, plastering, putting up wallpaper, and painting.

Most of the new students had to learn how to do construction. By teaming up, they were able to take on many formidable tasks, and in the process they

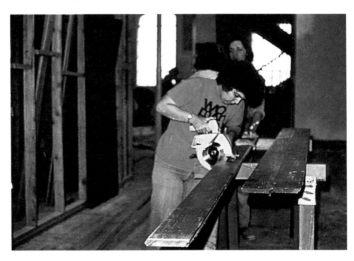

Opposite: Womanhouse catalog cover, showing Miriam Schapiro (left) and Judy Chicago. Feminist Art Program, California Institute of the Arts (CalArts), Valencia, California, 1972

Students working on *Womanhouse.* Feminist Art Program, CalArts, 1971

taught each other how to saw, nail, build, and carry heavy loads. The task of replacing the twenty-five broken windows was helped by one young woman's father, who owned a hardware store; he generously provided glass, putty, and his expertise. Fifty gallons of white paint were consumed in a frenzy of activity and, by the end of the first month, the house was beginning to shape up.

At first, it was difficult to get everyone working at a consistent pace. Some of the students thought that an eight-hour work day was excessive, even though Mimi and I had made it clear during the interview process that this would be one of the demands of the program. The Fresno students were accustomed to the requirements, but many of the new students were used to working when they felt like it rather than on a daily schedule.

Mimi and I were in agreement that regular working hours were important, in part because many of the young women needed to learn that discipline was an essential aspect of being a professional artist. This was

particularly true for those students who had a history of uncompleted work. And we thought that everyone needed to learn about how to push past the frustrations that are inevitably involved in a large undertaking. Few of the students had ever tackled anything as overwhelming in both scale and concept as the house project.

There were tears, confrontations, and arguments; though often part of the creative process, these were sometimes confusing. Apparently, some of the students have never gotten over feeling resentful about having been pushed so hard. For that I am sorry. At the same time, I think it was incredible that such a disparate group of young women was able to create an entire installation in only two months—one that would become a milestone in the development of feminist art.

Mimi and I had invited several women artists from the Los Angeles area to participate, partly to expose the students to a higher level of professional practice and partly to be inclusive of the wider art community. Many years later, I would repeat this process in my teaching projects, expanding the concept so that an equal number of practicing artists and students worked together, which would prove to be a very successful strategy.

After the initial house repairs, we turned our attention to the development of subject matter. By then, everyone had decided in which room they wished to work and with whom. But in most cases, what they wanted to do was still unclear. At no point did either Mimi or I dictate subject matter; this grew out of my circle-based, content search methodology. This process might seem mysterious to some, but it's really not. Remember, one reason art students are in school is to make art. They arrive with ideas—usually too many. The content search process involves helping each student to identify and clarify her interests, then guiding her as she develops her concepts.

For instance, three of the women decided to work together on the kitchen, though they couldn't agree on what to do. The entire group sat on the floor in a circle and began to talk about their memories of their childhood kitchens. It soon became clear that this room was often a battle zone. The giving and taking of food, who made the food, what kind of food was prepared, and when it could (and could not) be eaten often led to power struggles among the parents, children, and siblings. Today, when shared meals are largely a thing of the past, this same phenomenon may not exist, but in the early 1970s, this subject engendered many conflicting emotions.

Because women have been traditionally associated with the kitchen and the preparation of food, the three students decided to create a "nurturant

kitchen" in which the walls, floors, and furnishings were all painted in (an admittedly Caucasian) skin tone. A cascade of plastic eggs would be adhered to the surfaces that would gradually transmute into breasts as they moved from the ceiling onto the walls. This was a metaphor for the notion of the female body—as well as the kitchen—as the source of nourishment.

Through this same process, room after room took shape until the house became a repository of imagery, imagination, and ideas that grew out of specifically female experiences—something that had never before appeared openly in art. Some people might ask whether this wasn't just perpetuating women's entrapment in social roles by creating art that seemed to glorify those behavior patterns. My answer would be no. Growth takes place by starting where students actually are and helping them develop. However, this can only occur when a teacher is willing to discover her students' true concerns and interests, which is what emerges through the pedagogical methods I have been describing.

Womanhouse was one of the first visual expressions of women's feelings about their domestic lives and the many expectations that had shaped their experiences and sometimes constricted their choices. Each room was different. Faith Wilding created a womb-like crocheted environment. Another student made a "Lipstick Bathroom" where the walls, floors, and sink were painted entirely red; row upon row of lipsticks graced one wall. Two women worked together on the "Bridal Staircase" in which a mannequin bride was placed, radiant and beautiful, at the top of the stairs. Her train covered the carpeted stairway and ended up on the back of a second mannequin attached to the bottom wall, symbolically expressing the oppression (for too many women) of married life. Nearby, there was Beth Bachenheimer's "Shoe Closet," where shelves were obsessively crammed with shoes to match every conceivable outfit—sort of Imelda Marcos gone wild. There was also a hidden area called "Personal Space," all pink and soft and "feminine," inside a dirty, messy room.

One of my favorite rooms was "Leah's Room", a re-creation of the boudoir of the aging courtesan in the novel *Chéri* by the proto-feminist writer Colette. Devised by Nancy Youdelman and Karen LeCoq (both former "Fresno girls," a politically incorrect term but, for me, one of endearment), the installation involved each of the young women alternately, continually, and obsessively staring at her reflection. Beautifully executed, their work anticipated a lot of subsequent art that also involved the mirror, including that of Helen Chadwick and Carrie Mae Weems.

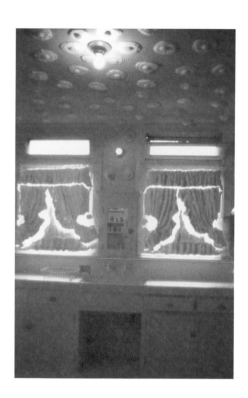

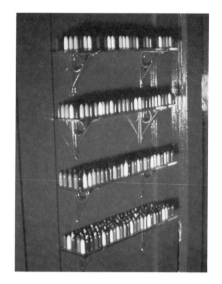

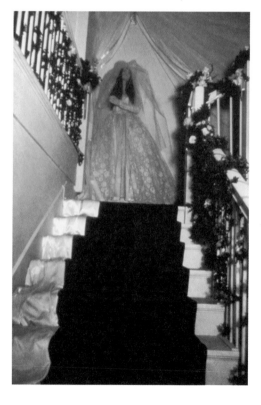

Above: Susan Frazier, Vicki Hodgetts, and Robin Weltsch, "Nurturant Kitchen" from *Womanhouse,* 1972. Feminist Art Program, CalArts

Above right: Camille Grey, "Lipstick Bathroom" from *Womanhouse,* 1972. Feminist Art Program, CalArts

Kathy Huberland, "Bridal Staircase" from *Womanhouse,* 1972. Feminist Art Program, CalArts

ket. I was utterly dazed by the enormous numbers of feminine hygiene products that had appeared on the market since the early 1970s.

Pushing two carts filled to overflowing, the assistant and I went to the checkout stand. A woman waiting in an adjoining line peered over at our purchases and, in a decidedly English accent, said, "My dear, you must have an awfully heavy flow." I feel compelled to repeat that story not only because I find it amusing, but because the "Menstruation Bathroom" turned out to be as shocking in the 1990s as it had been twenty years earlier. If we really live in a post-feminist era, menstruation should be recognized as an unremarkable aspect of life.

Throughout the fall of 1971, while work on *Womanhouse* was under way, I facilitated a performance workshop. Many of the Fresno girls were involved, as were a few of the new CalArts students. We met regularly at my residence in order to have more quiet than was possible at the house, which

Womanhouse invitation. Feminist Art Program, CalArts, 1972

was filled with construction sounds. We turned the living room of *Womanhouse* into a performance space where the students presented a series of pieces, including my play *Cock and Cunt*. Faith performed "Waiting," which has become a classic in both feminist and performance art.

There were several duration performances in which a woman ironed or mopped the floor in real time—again, as far as I know, the first examples of a genre that would become popular among subsequent generations of artists, both male and female. Other performances included the "Birth Trilogy," in which six women took turns symbolically birthing and then nurturing each other, an early exploration of themes that many later feminist artists explored; and "Three Women," which examined female stereotypes and the construct of femininity.

In January 1972, two months after work had started on the project, *Woman-house* opened to the public with a flurry of press, probably because no one had ever seen anything like it and therefore didn't understand what a profound challenge to mainstream art values it actually represented. Not only did the work embody new subject matter, it employed materials and forms that had been entirely outside the sphere of art, including the needle and fiber arts, costume, installation, performance, and other genres that are now acceptable but were not in the early seventies when modernism still held sway.

It was not too long after the exhibition closed that my relationship with Mimi began to go downhill. The difficulties started at a conference at the Corcoran Museum in Washington, DC, which brought together many female professionals in the art world who were unhappy about the lack of representation of women at all levels in the field. Mimi and I presented a slide lecture about *Womanhouse,* during which my remarks were greeted with resounding applause.

Immediately following our presentation, Mimi furiously accused me of manipulating the audience. Now, I have many faults, but being manipulative is not one of them. It's more like "what you see is what you get," which has caused trouble for me more than once. But Mimi was convinced that I had somehow contrived to grab the spotlight and she never forgave me. For months afterward, she would call me early in the morning and berate me for one or another of my supposed sins against her.

Shawnee Wollenman Johnson, "Three Women" performance from *Womanhouse,* 1972. Feminist Art Program, CalArts

Feminist Art Program Workshop Group, "Birth Trilogy" from *Womanhouse,* 1972. Feminist Art Program, CalArts

I now recognize that the plan for us to team-teach was probably overly optimistic considering that we did not know each other that well. Also, she may have been subject to pressures of which I was unaware. After all, it was only because she was married to Paul Brach, who was the dean of the art school, that the program had been brought to CalArts.

Some male faculty members might have been opposed to the Feminist Art Program, though they never said anything to me. Many years later, one of the Fresno girls told me about something that had happened at the year-end show. One of the CalArts people who came up from Los Angeles was the artist John Baldessari, who has since become an international art star. Apparently, he walked up to one of the pieces, a stuffed sculpture of a woman lying prone with her legs spread, and stuck his boot-clad foot into the open vulval form.

This was an indication of the attitudes of at least some of the male faculty toward the Feminist Art Program, a perspective they undoubtedly conveyed to the young women, either implicitly or explicitly. In Fresno, the students in the program were insulated from outside criticism, especially those who had signed up for enough extra credits to constitute almost a full-time course load. But at CalArts, as soon as the students walked out of our door they were subject to the pressures of the school, which functioned according to a whole different paradigm—one that definitely did not emphasize personal subject matter.

I was reminded of this when I read Paul Brach's obituary in late 2007. It featured a comment by Christopher Knight, head art critic of the *Los Angeles Times,* it stated that Brach revolutionized the teaching of art, making CalArts one of the top art schools in America and a training ground for aspiring art stars. It also included Knight's assessment that: "He understood that art school is less about teaching how to make art than about learning what it means to be an artist." This shift resulted in a de-emphasis on skill training and little or no discussion about content, an approach that increasingly came to dominate university studio art education.

Perhaps Mimi knew this. If so, it must have been more difficult for her than I realized. But even if she had asked me to help

Janice Lester, *Woman,* c. 1970–71. Mixed media. Fresno Feminist Art Program

explain the program (she never did), I couldn't have handled it. Although many people think otherwise, I have always been afraid of confrontation, even more so when I was young. So there was no way I would have been able to go to a faculty meeting and face male hostility. Now that I think of it, I was never invited—how odd.

Also, once we took up residence on the new CalArts campus, I hated it. I found its architecture too corporate for an art school. Plus I could not contend with the bureaucratic nature of the institution, even one as unformed as CalArts was then. Although I cannot explain how I had come to this conclusion, at that time I was convinced that bureaucracy was an inevitable aspect of patriarchal institutions. And I wanted nothing to do with patriarchy though, clearly, I was desirous of its support. I know; it makes no sense.

In 1972, by the end of my first year at CalArts, the friction with Mimi had become so intense that I decided to leave as soon as my two-year contract was up. The second year was dismal. Mimi retained the large, airy studio— along with most of the students—and I was in a small, windowless base-ment room with those few students who were sufficiently loyal and willing to forego the more spacious studio space in order to work with me.

Even before I left CalArts I had begun to organize another alternative educational enterprise, the Feminist Studio Workshop, which was to be the first independent feminist art program (all I can say is that I must have been rather irrepressible when I was young). This was also to be a joint venture, but this time, it was devised by myself, the late art historian and critic Arlene Raven, and Sheila Levrant de Bretteville, a prominent designer who taught at CalArts and is now the director of graduate studies in graphic design at Yale. Inspired by the Feminist Art Program, she had initiated a feminist design program at CalArts in 1971.

Throughout the spring and summer of 1973, Arlene, Sheila, and I were busy setting up the Feminist Studio Workshop in the former quarters of Chouinard, which had once been an influential art school. Thanks to a gen-erous bequest by Walt Disney, an alumnus, the school had morphed into CalArts, at which point the building was abandoned. The irony of leaving CalArts only to move into a building that had given rise to the new school was not lost on us.

Because the building had more space than we could use, we invited a number of feminist galleries and businesses to join us. Together, we took up residence in the splendid though run-down structure. Costs were offset

by everyone's rent. We dubbed it the Woman's Building after the edifice of the same name at the 1893 Chicago World's Fair. Like its predecessor, operations were overseen by a Board of Lady Managers. Soon, the two-story building became a beehive of activity as we all worked to get the structure ready for its grand opening, which attracted more than 5,000 people.

As renowned art writer Lucy Lippard stated in her foreword to *From Site to Vision: The Woman's Building in Contemporary Culture,* "The Woman's Building was the capital of cultural feminism, where the spiritual and the political met and rowdily merged. It was an off-center center, defying the marginalization of women's lives and art. In 1973, when it was founded, a women's community was something new and very appealing."[6]

For a short while, I was happy. Yet, even though the Women's Building provided me with a context and a sense of belonging that I had rarely enjoyed, within a year I had resigned. In my defense, let it be said that I was motivated by a burning need to devote myself entirely to artmaking. By then, I had achieved the goal I had set when I first went to Fresno: figuring out how to fuse female-centered content with my visual forms. During my four years of teaching, I had continued to do research and also studied china painting while working on formulating a new type of imagery, one that reconnected with the aesthetic impulses I had put aside in graduate school. Moreover, I had become obsessed with the idea of teaching women's history to a broad and diverse audience through art, notably via *The Dinner Party,* which would completely occupy me for the rest of the decade.

In retrospect, it seems obvious that by resigning from the Feminist Studio Workshop I left my partners "up a creek." Both Arlene and Sheila were far more understanding than I would have been had I been in their shoes. However, one thing my departure demonstrated is that no one is irreplaceable. The Feminist Studio Workshop continued for a decade, producing a generation of gifted women artists who fanned out to institutions across the country, bringing the values and methods of feminist art education to several generations of young artists. And the Women's Building remained open for twenty years, though not in its original location.

Once back in my studio full time, I returned to supporting myself the way I had prior to going to Fresno and receiving a full-time salary: through lectures, workshops, and the occasional art sale. In early 1975, I had an exhibition and did a month-long residency at the College of St. Catherine (now St. Catherine University) in St. Paul, Minnesota. During that time, I held a feminist art workshop for some of the students. Its success prompted

the school to set up a year-long program for which Arlene Raven acted as adviser. However, within a year, that institution dismantled the program, perhaps because of the challenges feminist art education presents.

As Betty Ann Brown writes, "For the principles of feminist art education to be incorporated into widespread educational practices requires a radical shift in the traditional educational paradigm."[7] Such programs are premised on the idea that female-centered education should occupy an equal place in our institutions which—as Brown suggests—would have meant a radical shift in St. Catherine's prevailing male-centric curriculum (not to mention the even more male-centric Catholic Church).

In the early 1980s I did another feminist art workshop at the now-defunct Feminist Art Institute in New York. It is unfortunate that the energy that fueled these various feminist art programs in Fresno, at CalArts, the College of St. Catherine's, and the Feminist Art Institute petered out or were extinguished. I am often asked by young female art students if there are any feminist art schools and I'm always sad to say no.

In addition to the institutional challenges suggested, other factors might have played a role in the demise of these programs. A number of the women involved in these experiments were artists. Perhaps they experienced the same types of conflicts that I did in terms of artmaking versus teaching. Or maybe they just got exhausted fighting obdurate administrations or trying to scrape together funding year after year. Whatever the explanation, we women have an unfortunate history of not being able to sustain the organizations and institutions that we found. However, having abandoned the Feminist Art Program, the Feminist Studio Workshop, and the Woman's Building, I am not in a position to be critical of anyone else.

Even though I stopped teaching formally, I brought the pedagogical principles of those early feminist art programs into my artmaking projects, beginning with *The Dinner Party,* which evolved from a private artmaking enterprise to an atelier filled with assistants. There, I functioned as both artist and educator, using my skills as a facilitator to guide people as they translated my images using a variety of techniques.

Every Thursday night, the entire studio assembled for dinner and discussion. No matter how long it took, I used my circle-based methodology—and when there were seventy-five participants, our conversations went on for hours—asking everyone to speak about their feelings regarding the project or a topic we had decided to explore. In addition to defusing any tensions (at least most of the time), this process proved empowering for

the participants, and often led them to apply what they had learned from me in their own endeavors.

Unfortunately, over the years, there have been many outlandish claims about what went on in *The Dinner Party* studio, generally centering on the idea that I exploited those who worked with me. Despite the protestations of countless participants, such accusations have continued. I have rarely responded to what amounted to deeply hurtful assaults on my integrity. The only reason I have even raised this issue here is that it seems important to explain the ways in which my pedagogical methods influenced the structure of my participatory projects, particularly because I am often asked how I have managed to collaborate with so many others.

Some time ago I was approached by Jane Gerhard, a historian, who had been studying my archives, which are housed at the Schlesinger Library on the History of Women in America at the Radcliffe Institute, now part of Harvard University. She was struck by the contrast between the vitriolic writing about *The Dinner Party* by both conservative art writers and feminist theorists and the thousands of viewers' letters stating that seeing the piece had changed their lives. As a result, she decided to write *The Dinner Party: Judy Chicago and the Power of Popular Feminism 1970–2007.*[8]

I will leave to Jane and other historians the task of separating fact from fiction in terms of the nature of *The Dinner Party* studio and my other collaborative projects. All that I will say is that, from the beginning of my career, I have chosen an alternative path, one that is based upon my values; these involve cooperation, honesty, and generosity. Both my pedagogy and my collaborative projects have grown out of this same paradigm. I realize that some readers will find what I am saying hopelessly idealistic. So be it. In the face of the world's woes (of which I am well aware), one can succumb to despair or choose hope, no matter how hopeless things may appear.

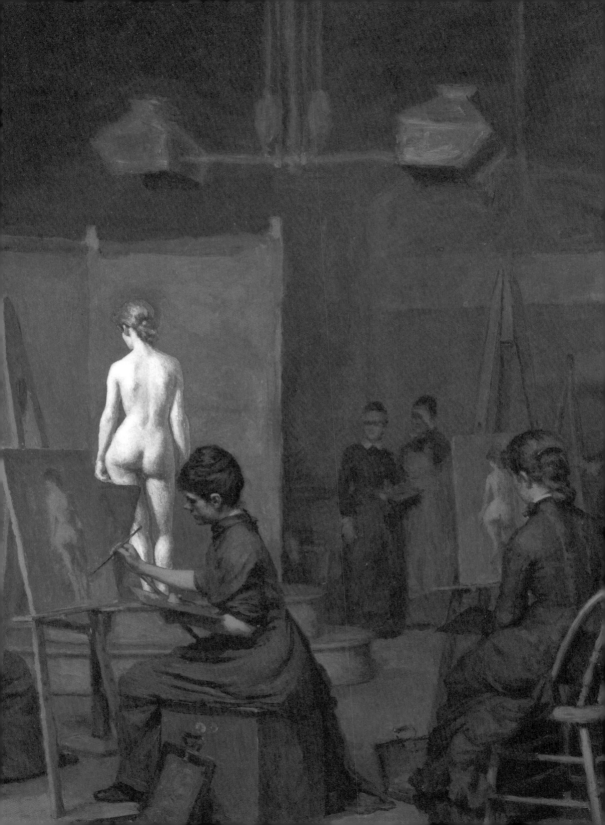

TWO: WOMEN AND ART

When I went to Fresno to initiate the first feminist art program, I continued my research into women's history. I was particularly interested in the history of women artists, a subject that had scarcely been studied since the late nineteenth century, at which time there was a concerted effort by feminists to address the dearth of information about women. My initial inquiry involved poring over out-of-print compendiums of women artists that I found in used book stores around the country, generally for no more than a few dollars—an obvious reflection of the apparent lack of interest in this subject at that time.

The 1970s feminist art movement brought about a surge of research about the many obstacles faced by women artists and the various ways in which they were able to overcome some of them. The documented story of women as artists begins in the Middle Ages. During that period, women (at least members of the upper classes) were educated in convents, sometimes spending their lives there with or without taking vows. From the earliest ages of monasticism, women were involved in making art for noble houses and religious communities. The wealthier medieval cloisters were centers for the production of both sumptuous woven hangings and illuminated manuscripts.

Female artists and patrons were closely associated with textiles—considered one of the high arts of the Middle Ages—until the twelfth and thirteenth centuries. Women, both nuns and lay, are also known to have excelled at embroidery and book production, working as needleworkers, scribes, and illustrators. A number of these book artists have been identified. Ende, for instance, flourished in the tenth century and worked on a collection of manuscripts at a Spanish monastery. She signed her work with the Latin words for "paintress

Alice Barber Stephens, *The Women's Life Class,* 1879. Oil on cardboard, 12 × 14 in. The Pennsylvania Academy of the Fine Arts, Philadelphia

and helper of god." Another example is Claricia, a nun living in a Bavarian convent. We know of her from a signature and what may be a self-portrait in a twelfth-century German psalter (a manuscript of the psalms).

With the secularization brought about by the Renaissance, convents and monasteries ceased to be the major art centers that they had been during the Middle Ages. At this same time, the guild system began to develop. Art practice moved gradually into the guilds, and they evolved into professional organizations whose aim was to protect their members by controlling production and sales and regulating quality. Some records of medieval guilds show both women and men engaged in aspects of cloth and textile production. There were even some exclusively female guilds involved in the creation of silk and linen cloth. Women were also listed as members of other guilds—including painting, glazing, sculpture, and metalwork—though they made up a small percentage of the membership. In these mixed-gender guilds, women often paid lower dues than men, suggesting a lower status.

During this period, families often functioned as economic units, and many of the women who entered the guilds came from families that were involved in art production. Widows of guild members were allowed to run their husbands' shops and to take on apprentices unless they remarried someone from another trade. However, women's participation in art did not necessarily require guild membership. They often worked as assistants to male family members, particularly fathers and brothers.

The increasing secularization of society led to the development of universities, which sharply curtailed women's access to education. Increasingly, the only education available to women was in preparation for marriage. Humanism, the great intellectual movement of the Renaissance, profoundly influenced European thought for centuries. But the few women who were able to acquire a humanist education were those—like the French writer Christine de Pizan—whose fathers supported female scholarship and undertook their daughter's schooling. This same situation applied to women artists, as one of their few possibilities for training was in a family studio; for example, Catharina van Hemessen, who was trained by her father.

At this same time, the idea developed that women were incapable of infusing a design with life, a notion based on Aristotle's concept of the female womb as a passive receptacle. The consequence for female artists can be inferred: their work would be considered lifeless. This assumption

shaped perceptions of female creativity for centuries. In 1492, Leonardo da Vinci created the famous drawing *Vitruvian Man,* reaching back to Greco-Roman civilization for inspiration—specifically the work of Vitruvius, a Roman architect and engineer from the first century B.C.E. The image, which posits *man* as the measure of all things, created a metric for human proportions based on the *male* body that would be used in life drawing classes as well as in the study of anatomy.

The training of artists gradually became more systematized. Students

developed their abilities by copying Old Master paintings and engravings, sculptures, and casts of antique statuary; women were also allowed to do this. But when the male students advanced to anatomy and life drawing—an essential aspect of an artist's education—their female counterparts were left behind because sketching a nude model, particularly a male one, was thought to be unsuitable for women.

A few females were able to become court painters, a position that was first established in the thirteenth century when a European court culture developed and certain artists were given titles, salaries, and privileges. Those who attained such roles had usually been trained in family workshops rather than in the guild apprenticeship system through which most male artists gained their skills. Even though apprenticeships do not seem to have been specifically prohibited to women, it was difficult, given the societal expectations of the era, for women to enter into long apprenticeships unless they were in their own family's workrooms.

For an unmarried woman artist, a court appointment would have to be approved by her father, as was the case for Sofonisba Anguissola who was chosen in 1559 to be court painter to the Queen of Spain. There were exceptions; the seventeenth-century Dutch still life painter Rachel Ruysch seems not to have

Catharina van Hemessen, *Self-Portrait,* 1548. Varnished distemper on oakwood panel, 32 × 25 in. Öffentliche Kunstsammlung Basel

been hindered by either marriage or children—she had ten—while serving as court painter to Prince Johann Wilhelm. The high point for female court painters was in eighteenth-century France, where such luminaries as Elisabeth Louise Vigée-LeBrun and Adélaïde Labille-Guiard were in service to Marie Antoinette prior to the French Revolution.

The principal activity of the female court artist was the painting of portraits. Her purview was seen as the private and the domestic, and her subjects were usually the female members of the court with which she was aligned. Drawing and painting were valued accomplishments for ladies at the court, and women court artists were often expected to provide lessons. In contrast, many male court painters were placed in charge of teams of workers, large studio workshops, or projects that required elaborate organization and support.

Such public activities would not have been considered appropriate for women artists nor could they use studio workshops as instruments of political influence—a common practice among men—who utilized their skills as artists to gain access to the highest

Sofonisba Anguissola, *Double Portrait of a Lady and Her Daughter.* Oil on canvas, 52 × 39 ½ in. National Museum of Women in the Arts, Washington, DC

Rachel Ruysch, *Fruits, Flowers, Reptiles, and Insects,* c. 1745. Oil on canvas, 29 ¾ × 23 ⅞ in. Palazzo Pitti, Florence

Elisabeth Louise Vigée-LeBrun, *Marie Antoinette and Her Children,* 1787. Oil on canvas. 108 ⅜ × 84 ⅝ in. Palace of Versailles

levels of power. For example, Peter Paul Rubens, a classically educated humanist scholar, ran a large atelier where several major allegorical works were executed for Philip IV of Spain (and other rulers).

The most fundamental obstacle to women's artistic ambitions was the denial of the training that would have prepared them to work on the complex allegorical and historical imagery that came to dominate art, particularly after the development of the Italian art academies in the second half of the sixteenth century. These schools were based on literary and scientific academies and associations of humanist scholars who believed that the

ancient world should be taken as a model for society. Humanism also shaped the training of artists in the new academies, leading to the establishment of professional standards along with an emphasis on the intellectual foundations of art rather than on craft and manual skills.

As mentioned, the only way a woman could have access to this new form of art training was if a family member allowed her to work in his studio, which is why, for many centuries, most of the successful female artists were trained by their fathers—for instance the Baroque painter Artemisia Gentileschi, the first woman to create large-scale historical paintings. But even though she was able to forge a successful career, she had to struggle to be paid as much as a man would have been for the same work.

For a long time, Gentileschi's work was either ignored or attributed to male artists. However, she was not the only successful woman artist to have been slighted by art historians. The repeated erasure of women artists has been a strategy to prevent their permanent entry into the annals of art history, as recent feminist scholarship and my own research makes all too clear. As art historians Norma Broude and Mary Garrard write in their introduction to *Reclaiming Female Agency,* "Throughout

Artemisia Gentileschi, *Judith Beheading Holofernes,* c. 1620. Oil on canvas, 78 × 63 in. Galleria degli Uffizi, Florence

history, it would seem, the more powerfully a woman asserted her agency, the more vigorous was its repression."9

By the middle of the seventeenth century, a hierarchy of the arts became a fundamental part of the academies. Painting, sculpture, and architecture were viewed as the important genres of art. Painting was subdivided into higher and lower categories, with history painting at the pinnacle; it was meant to provide both instruction and delight to the mind through the representation of morally uplifting topics. Such genres as portraiture, themes from everyday life, landscape, and still life painting were thought to be of less value. Of course, these were the very categories in which women were able to excel—because they didn't require the study of the nude. Devaluing these genres undercut the value of the women's work, another method of marginalizing their achievements.

After being trained at an academy, male artists became eligible for membership there. Although this was not a prerequisite for a successful career in art, it definitely provided a significant advantage. Over the centuries in which the academies reigned, only a small number of women were allowed to join and then usually on a restricted basis. Family connections seem to have played a part in opening the academies to women; the first three women accepted were the wives or daughters of academicians. But records demonstrate that most of the academies were not eager to include women.

Moreover, when women were accepted, they were viewed as "exceptions" and the admittance of one or two female artists did not necessarily open the door to others. For example, in 1757, Marie-Thérèse Vien (wife of the academician Robert Joseph Vien) was accepted into the French Royal Academy of Painting and Sculpture with the warning that this was not to be construed as establishing a precedent.

The eighteenth and nineteenth centuries brought with them increasingly restrictive concepts of gender, specifically, the idea that—because of women's childbearing capacity—their "natural" place was in the home, site of the domestic labor that was theirs to perform. Consequently, women were expected to subjugate their artistic interests to their household duties, especially after marriage and the birth of children. Thus, in addition to the near-impossibility of obtaining adequate training, women had to be willing to stand up to social censure in order to pursue anything but an amateur interest in the arts.

Throughout the nineteenth century, most of the western world looked to France for leadership in the fine arts. For the professional artist, the

opportunities for study, exhibition, and sales in Paris were unrivaled. The top school, not only in France but in the world, was the École des Beaux-Arts, which was divided into two parts: a school of painting and sculpture and a school focused on architecture. Its associated annual Paris salon provided a crucial pathway to artistic success. The central obstacle for women artists at that time was their exclusion from the school, whose history already spanned two hundred and fifty years.

The academy's curriculum was modeled on arts and architecture from ancient Greek and Roman cultures. As described by Steven Henry Madoff: "Instruction in both art and architecture . . . was sequential, with hierarchical stages traversed before the student could emerge as a productive professional. Early instruction was through mimetic exercise . . . first by observing plaster casts and later through studying the live human form. . . . More advanced levels depended on students becoming affiliated with ateliers."[10] Achieving these things were close to impossible for women. The Beaux-Arts style involved preserving the idealized forms of classical antiquities and passing them on to future generations.

It was not until the late nineteenth century that women artists finally began to break out of these overwhelming constraints. Even if a woman artist achieved fame and fortune during her lifetime, her work was too often forgotten or consigned to the minor leagues. This was true for the previously mentioned French court painters (all of whom were wildly successful in their day) and for the French painter Rosa Bonheur, who achieved fame in the mid-nineteenth century.

Like numerous women artists before her, Bonheur was trained by her father, who was a drawing instructor and landscape painter. When his daughter insisted on following in his footsteps by becoming an artist, he provided her with instruction and also sent her to the Louvre to copy from the masters. It is well known that her father allowed her to bring small animals into the family studio so that she could study them. One can speculate that her decision to work with animals was a way of getting around the fact that women could still not study anatomy from nude models. But even in order to expand her understanding of animal anatomy, Bonheur had to don masculine attire to be able to gain access to slaughterhouses and horse markets. She also had to obtain police permission for this form of dress.

Rosa Bonheur became world famous for her monumental animal paintings. By 1860, she was so wealthy that she was able to purchase a chateau,

where she lived with successive female companions and an array of animals in an arrangement that she described as a "domain of perfect friendship." In 1865, Empress Eugénie awarded her the Legion of Honor, and celebrated her accomplishments by saying that "genius has no sex."

It is also instructive to read a recent evaluation of Bonheur's her painting. I consulted the seventh edition (2005) of Anthony F. and H. W. Janson's *A Basic History of Western Art,* considered an authoritative art history text. H. W. Janson's widely used history of art, first published in 1962, did not include any women artists until the 1986 edition, published after his death. According to the edition I consulted, Bonheur's work "appeals to conservative taste that generally prefers pretentious history painting." I cite this damning judgment in order to demonstrate another way in which the work of women artists has been demeaned—by later male judgment.

For centuries, not only were women deprived of the training that was considered essential for becoming a major artist, they could not enter the public world of men except by donning male attire or, if they were writers, by using a male pseudonym, as did Amandine Lucile Aurore Dupin (George Sand), Mary Anne Evans (George Eliot), and Charlotte Brontë (Currer Bell). Nonetheless, by the end of the nineteenth century, women were fighting their way into the arts. In 1868, the Académie Julian was founded; it was one of the first art schools to allow women to work from the nude. The school offered a high level of professional training and

Rosa Bonheur, *The Highland Raid,* 1860. Oil on canvas, 51 × 84 in., National Museum of Women in the Arts, Washington, DC

produced numerous women artists whose work was accepted into the Paris Salon. In 1897, the prohibition against women at the École des Beaux-Arts was finally lifted.

By then, other women artists had found ways around the ban on life drawing, primarily through private studios where established artists offered classes, including life drawing sessions, some of which were open to women—as long as they had the financial means to pay. Artists such as Berthe Morisot and Eva Gonzales acquired their training from well-known male artists. However, social class played a crucial role in the story of many women artists. Without the access afforded by virtue of their social position or the money to pursue a career in art, few women stood much of a chance.

When female artists were finally allowed to study from the nude, there seems to have been little or no attention paid to the fact that they were expected to simply adapt to what was an entirely male-centered tradition in which women had been neither considered nor included—except as models. The nude female body in art dates back to the most ancient civilizations, when it was worshiped as the source of life and, in some cultures, associated with the goddess. In Greek and Roman art, although there was an emphasis on the male nude, statues of the unclad or partially robed female body figured prominently.

Due to repressive medieval Christian attitudes toward sexuality, the nude figure essentially disappeared. When the body did reemerge, in Renaissance art, it was the male form that was the focus of attention and—as cited earlier—artists learned to draw by studying the male nude. But gradually female models took center stage. By the late nineteenth century, when women were finally able to enroll in life drawing classes, there had been several centuries of art by men that featured the female nude.

From its beginning, this type of painting was an open acknowledgment of male sexual desire as well as men's right to express that desire. The creators of many such pieces are considered the greatest artists in Western history, for instance, the fifteenth-century painter Giorgione, to whom I alluded earlier. His *Sleeping Venus* (1510) is usually credited as popularizing the image of the female nude—and, more specifically, the female nude in a passive pose. Such work would seem to be a perfect visual counterpart to an attitude expressed roughly seventy-five years earlier by Leonardo Bruni: "Woman's soul is . . . sacrificed to her body, whose sole object and purpose is to satisfy man's craving." How women might react to these ideas and images

or how women artists were to relate to this artistic tradition seems to have been neither considered nor addressed.

In 1879, Alice Barber Stephens painted a fascinating picture of a women's life class that raises many of these issues. What are we to make of all these women gazing at a female nude when there were few precedents for a woman artist depicting a naked body? Would she identify with the female model? If so, she implicitly surrenders her position as the artist, which had traditionally been male. And yet, she couldn't claim the rights of male artists who had "looked down" upon the female nude from their position of gender privilege both in and out of the arts.

In 1913, a British artist named Laura Knight created a painting that seemed to perfectly embody this dilemma. She presented herself fully

clothed in front of a canvas depicting the back of a naked female model, who stands before her. The picture seems to ask: am I the artist or the model? The question is a poignant one, intensified by the hesitancy in the painter's stance. Instead of rendering herself actively engaged in work, she holds the brush by her side, pointing downward. Rather than an artist's smock, Knight wears street clothes much like what the model might don at the end of the session.

Even in the twentieth century, women artists like Knight struggled with conflicting identities. As the British art historian Frances Borzello writes in *Seeing Ourselves: Women's Self-Portraits:* "women's conditioning and the paralysing effect of conventional attitudes about female behaviour could prevent women making the most of their talent."[11] These same conflicts can be seen in the work of many of Knight's female contemporaries as they attempted to find their own identities as artists within a tradition of representation that presented women as objects to be gazed upon. The result was a number

Alice Barber Stephens, *The Women's Life Class,* 1879. Oil on cardboard, 12 × 14 in. The Pennsylvania Academy of the Fine Arts, Philadelphia

of paintings of women by women that did not differ greatly from those men produced. Eva Gonzales's *Morning Awakening,* for example, is a beautiful image, but it is nevertheless a portrait of a rather listless woman.

It was not until the feminist art movement erupted in the 1970s that a critique developed that challenged traditional representations of women. Feminist theory introduced the concept of the "male gaze" as an expression of power asymmetry. In terms of visual art, this referred to the male artist *looking at and representing* the female body. This topic has significant implications for women artists: from what vantage point have *they* looked? And what if they portray male models? If a woman's experience in the world tells her that men are the more powerful gender (as would have been the case in the nineteenth century and is even today in many parts of the world), how is she to "gaze" at a male nude? I encountered this exact problem in my own studio in the early 1980s when I undertook a series titled *Powerplay,* in which I explored the gender construct of masculinity.

In preparation for what would become a series of monumental paintings (along with

Laura Knight, *Self Portrait,* 1913. Oil on canvas, 60 × 50 ¼ in. The National Portrait Gallery, London

drawings, weavings, cast paper pieces, and bronzes), I did extensive studies from male models. I can still remember feeling intimidated by the sense of power this elicited—I realized that I could render the male body in any way I chose. Although I had certainly done figure drawing as a child when I attended art classes at the Art Institute of Chicago and in college, the nude models were always women. As a result, I had learned to use the female body as a vehicle of self-expression.

It required some months before I was able to get over the anxiety that working from a male nude engendered. At one point, I realized that the expressive freedom that was so frightening to me was something that male artists had enjoyed for centuries in relation to the female body, an insight that helped me overcome my fears. After all, if they could do it, why couldn't I? As it turns out, my anxieties had a historic precedent. While doing an extensive study of nineteenth-century suffrage posters, Paula Harper had discovered that women have traditionally seemed more comfortable presenting themselves as victims rather than men as perpetrators, a practice that continues today. However, as important as these issues may be, I do not wish to address them further here because there is now an entire body of literature by writers far more qualified than I. Instead, I will continue with the history of women's fight for aesthetic equity.

In 1881, Madame Léon Bertaux founded the first professional organization for women artists in Paris, the Union des Femmes Peintres et Sculpteurs. Women seeking equal opportunities flocked to this

Eva Gonzales, *Morning Awakening*, 1876. Oil on canvas. 32 × 39 in. Kunsthalle Bremen

group, which instituted its own journal as well as the first annual women's exhibition. Unfortunately, this organization was based on the structure and procedures of the earlier academies. This meant that the members' work tended to be quite conservative at the very moment when the old academic system was failing.

In its place, there emerged a new structure of private galleries and dealers into which only a few women artists were able to insert themselves, notably Mary Cassatt and Berthe Morisot. But here too women were at a disadvantage. As Frances Borzello indicates, the wooing of patrons and dealers and the public visibility that were becoming essential parts of life as a professional artist were antithetical to the virtues of womanly modesty that still prevailed.

Meanwhile, in England and America, a number of schools for women were being established, including Moore College of Art and Design, which was founded in Philadel-

Mary Cassatt, *Mother Wearing a Sunflower on Her Dress,* c. 1905. Oil on canvas, 36 ¼ × 29 in. National Gallery of Art, Washington, DC

phia in 1848. Its stated mission was to prepare women to work in the new industries that had been produced by the Industrial Revolution. In 1859, the Cooper Union for the Advancement of Science and Art was founded in New York, and it featured a Female School of Design. Most of these early women's institutions provided design or applied arts training—considered more suitable for women than the fine arts, which continued to be viewed as a masculine pursuit.

The nineteenth- and early-twentieth-century women's movement made it possible for women to own property, to file for divorce without losing their children, to gain some power over their own bodies, to speak publicly, to attend college, to enter the professions that had previously been closed to them and, finally, to vote. These advances benefitted women artists as well. New exhibition opportunities began to appear, notably the Woman's Building at the 1893 Chicago World's Fair, which Susan B. Anthony helped to establish.

The Woman's Building featured art and artifacts from women all over the world, including Mary Cassatt's sixty-five-foot-long mural *Modern Woman,* which consisted of three sections featuring decidedly feminist themes. The side panels represented women in the arts along with young girls pursuing fame. The central panel depicted women picking fruit from the Tree of Knowledge and handing it down to their daughters. Sadly, this important work by Cassatt has been lost to history.

Part of the women's rights platform involved a woman's right to earn a living. The applied arts were perceived as a worthy field for women to enter, which is why so many women's art schools were founded at that time. In 1871, the Slade School of Fine Art opened in London to provide better instruction to those women interested in the fine arts. But even when a woman artist was able to establish herself professionally, her paintings often went unsold. The first purchase of a woman's work by a public institution occurred that same year, when the Liverpool Corporation acquired a canvas by the nineteenth-century English artist Sophie Anderson.

One problem was that few women were in command of enough wealth to form an art collection. And those that were, for instance the many wealthy American female patrons and collectors who flocked to Paris at the turn of the century, showed little interest in acquiring women's work, a dilemma that would plague women's art for many decades. Given this litany of obstacles it is a wonder that women artists persisted, but they did. The bohemian life style that came to be associated with Paris in the early decades of the

twentieth century seemed to act as a magnet, offering women artists better opportunities for training and exhibiting than other European cities—and certainly more than anywhere in America. During this period, a number of women artists became prominent, among them Suzanne Valadon, Marie Laurencin, and Sonia Delaunay. However, their entry into what had been an entirely male-dominated art world was not met with enthusiasm, as Octave Uzanne made clear in his 1910 book *Parisiennes de ce temps:* "Women artists, painters, and musicians have multiplied during the last twenty years . . . and . . . they threaten to become a veritable plague."[12]

After World War I, attention began to shift from France to Germany, primarily because of the Bauhaus, an art and architecture school founded by Walter Gropius, which operated from 1919–1933, when it was closed down by the Nazis. During that time, it was located in three different venues and had a changing leadership, which resulted in a constant shifting of both focus and instructors. Nevertheless, what came to be known as the Bauhaus style had a profound influence on art, architecture, modern design, and studio art education.

The Bauhaus was arguably the first model of the modern art school and its rigorous curriculum was among the most purposeful ever devised. Its purported aim was to reunite art and craft; foster creativity; and to teach students to analyse and appreciate art, develop technical skills, and understand technology. The six-month preliminary course involved painting and elemental experiments. From there, students moved on to three years of workshops that were headed by an artisan (called a "master craftsman") and an artist (called a "master of form"), most of whom were male.

From its inception, the Bauhaus accepted female students and publicly advocated for gender equality. At the same time, according to several sources—including Patrick Hazard, who studies the history of the Bauhaus—Gropius announced early on that there would be a 30 percent quota on female applications, perhaps because, from the beginning, there were more applications from women than from men. Moreover, women were limited in the choice of workshops in which they could participate—as students or as teachers. Nineteenth-century ideology about women's frailty infected the school's policies; certain materials were considered unsuitable for women, who were thought to be too physically weak for some of the workshops. They were therefore funneled into the applied arts, especially weaving.

As it turned out the textile workshop became legendary, in part because of the teaching of Anni Albers, who raised the standards of weaving from

craft to that of fine art. After the Bauhaus closed, she and her husband, Josef Albers, emigrated to the United States. She became the first fiber artist and was one of only a few women—for a long time—to have a solo show at the Museum of Modern Art. Nevertheless, when her husband began to teach at the Yale School of Art the following year, Anni's professional credentials were ignored. At the time, there were no female studio faculty members and no classes in weaving as it was not considered art.

The Alberses were not the only Bauhaus faculty members to flee Germany for the United States. When Gropius emigrated, he brought Bauhaus principles to Harvard, introducing a curriculum that emphasized how art should be concerned with the ordering of visual attributes like color, line, and mass. The human figure, which had been at the center of the academic approach to fine arts, was replaced by the mathematical idea of the grid or rectangle. This change directly challenged the lessons and methods of traditional academic training. Henceforth, abstract, formal principles such as form, shape, color, and line—the so-called "language of art"—came to dominate the teaching of art.

As Howard Singerman explains; "To start with . . . 'visual fundamentals' or . . . 'constructive elements'—to start with varieties of mark making, or the contrasts of shape and texture, or the tensions created between geometrical or free forms across a surface—is to start, not with the body or the world represented, but with the materiality and autonomy of representation."[13] These ideas were clearly embodied in *Language of Vision,* published in 1944 by another Bauhaus émigré, Gyorgy Kepes, often cited as the most influential book on art education in the 1940s and early 1950s. For Kepes and his colleagues, "the task of the contemporary artist [was] to release and bring into social action the dynamic forces of visual imagery,"[14] which he and his colleagues believed to be universal.

The Bauhaus, widely viewed as the most influential art school of the twentieth century, translated modernism—the shift to abstraction that took place in Europe in the years prior to World War I—into a new form of art education. On the one hand, this change was liberating, especially for women artists. Previously, they had to work *within* iconographic traditions established by men, such as history painting or the female nude, fitting themselves in as best they could. With the advent of abstraction, they were free to *invent* their own forms to express themselves, something never before possible.

At the same time, questions were raised that have not been adequately addressed. What content would replace representational imagery? Could

a concentration on the "language of art" be sufficient? Or would this prove to be a dead end for art? Also, was abstraction really universal, as Kepes had postulated? This idea gained great currency at the time but, later, such universalist assumptions would be challenged by postmodernism, which viewed them as suspect and socially constructed.

The abstract and theoretical nature of the Bauhaus curriculum helped to pave the way for the unruly practice of art to be sufficiently tamed so it could take its place in academia. To give some sense of the challenge in bringing studio art education into universities, think about the bohemian nature of the Paris art world or a typical art school where most artists were trained at this time, such as Black Mountain College, where Josef and Anni Albers first went when they fled Germany (prior to going to Yale).

Founded in 1933, the school was located in the beautiful North Carolina mountains near Asheville, far from many of the restrictions of society. It is not difficult to understand why stories of Black Mountain are legion, all of which attest to its being a pretty wild place. Although the Alberses taught there, the curriculum was primarily based upon the philosophy of John Dewey, a philosopher and educational reformer who originated what came to be known as progressive education. In contrast to the highly intellectual approach of the Bauhaus, Dewey believed that education could only take place through the stimulation of a student's inherent powers, advocating that the focus should be on learning to think and to work cooperatively with others.

At Black Mountain, which was an independent, coeducational, inter-disciplinary, four-year school, there were no required courses; instead, students prepared a plan of work with their advisers. Classes—which met at the discretion of the teachers—included recitations, lectures, tutorials, and seminars. Attendance was voluntary. Albers was Black Mountain's first art teacher but, over the years, the school attracted a faculty that included some of America's leading artists, poets, and designers. The liberating, collaborative atmosphere acted as an incubator, nurturing the talents of many young artists and poets who went on to launch the New York avant-garde of the 1960s, notably the painter Robert Rauschenberg, the influential composer John Cage, the dancer and choreographer Merce Cunningham, and the poet and author Robert Creeley.

Although women participated as both teachers and students, Robert Creeley noted that the school was markedly male-oriented, and artist Dorothea Rockburne, who attended the college in the early 1950s, said that "it

was a strange and wonderful place, but it was very sexist . . . you would talk, and it was like you were invisible. . . . Except as a sexual object."[15]

For many years, besides Black Mountain, the most important alternative to traditional academic art training in the United States was the Art Students League of New York. Established in 1875, the school included women from the outset, not only as students but as faculty and policy makers on its governing board. Rather than a formal curriculum, the school provided studios where students could train with established artists. Among its alumnae is almost every major woman artist of the second half of the twentieth century—including Georgia O'Keeffe and Lee Krasner, wife of the important abstract expressionist painter Jackson Pollack. For those who are unclear about the definition of this postwar movement, it combined emotional intensity with the anti-representational aesthetic of the European abstract movements.

By the time abstract expressionism developed, the center of the art world was shifting from Paris to New York. The work of the abstract expressionists was predicated on a type of hyper-masculinity that made life difficult for many of the women artists of Krasner's generation. The general attitude at that time is perfectly exemplified by a comment made to Krasner by the prominent artist Barnett Newman at the Cedar Tavern, where the artists hung out: "We don't need dames." One explanation for this crude sexism might be traced back to the historical identification of art with femininity.

In an article titled "Of Men, Women and Art: Some Historical Reflections," Mary Garrard quotes an 1836 instructional manual for young men in which the author argued that men should not take too great an interest in the fine arts because they had a connection with effeminacy.[16] This taint, which continued to hover over the arts, was reinforced by the fact that early college and university art departments had begun as teacher training schools in which most of the students were women. Also, psychological and educational testing from the 1930s to the 1960s suggested that artists were the most "feminine" of professional groups.

The abstract expressionists weren't the only men who tried to make women feel that they had no right to enter their domains. From the time women first obtained the right to university education, they encountered the attitude that they didn't belong. I often tell the story of Elizabeth Blackwell: during the two years she was in medical school in Rochester, New York, she was ostracized by the local community and often spit upon by other women who didn't think that females belonged in medical school.

Although I long to believe that such behavior is a thing of the past, it seems more than likely that it has just become more coded. As recently as 2007, researchers quoted in *Handbook for Achieving Gender Equity through Education* found "the persistence of a chilly climate for women in the 21st century" in post-secondary education, which they defined as "overt and subtle gendered communication patterns and behavior . . . that disadvantage women."[17]

Moreover, when women obtained the right to higher education—as with women artists gaining access to the art academies—little or no thought was given to the problem of an entirely male-centered curriculum. In *Still Failing at Fairness,* the authors ask: "what if your identity is misrepresented, misremembered, or just plain missing from the school curriculum?"[18] The absence of information constitutes what influential art educator Elliot Eisner calls the "null" curriculum, i.e. knowledge that teachers intentionally or unintentionally leave out. The consequence—especially in relation to race and gender issues—is that students assume that the omitted information is irrelevant or unimportant.

Early American colleges and universities were founded on the model of British institutions like Oxford (to which women were not admitted until 1920) and Cambridge (out of thirty-one colleges, only three currently admit women). Certainly, those universities gave no thought to women when they were founded as male institutions, and by the time female students were allowed, the male-centered curriculum was pretty well set in stone.

It is easy to see this near-complete lack of awareness if one examines the highly touted Great Books program, some form of which is used in over one hundred American, Canadian, and European colleges. The first course to use it as a foundation was taught at Columbia University in 1919, and it spread to other institutions, notably the University of Chicago. When Robert Hutchins became its president in 1929, he acknowledged that: "Books one thought entitled to belong . . . have been superseded; and this process of change will continue as long as *men* [italics added] can think and write."[19]

Presumably, no one questioned Hutchins's use of the male gender in this sentence just as no one seems to have challenged the scant number of women writers included. In the sixty volumes that comprised the Great Books program published by Encyclopædia Britannica in 1952, the only women were Jane Austen and George Eliot. In 1990, there was an effort to include more female and Hispanic authors and for the first time there were

also works by black authors. Mortimer Adler, who had established the Great Books Foundation with Robert Hutchins, protested the changes.

None of the editions included *The Book of the City of Ladies,* written by Christine de Pizan in 1405, which attempts to counter misogynist Renaissance attitudes, or Mary Wollstonecraft's 1792 *A Vindication of the Rights of Woman,* which argues that the democratic principles advocated as the "rights of man" by Jean-Jacques Rousseau must be applied to women if the human species is to advance. Another omission is *The Second Sex* (1949) by philosopher and author Simone de Beauvoir, even though that book was published in a multitude of languages and continues to be a foundational text in the development of feminist thought. The absence of such writers makes it clear that from the point of view of those who put these literary compendiums together, women's struggle for equity and justice do not qualify as sufficiently important to merit inclusion.

And to the stale argument that the writers I've just cited are not significant, my response is: who decides? Moreover, how does such a "null curriculum" affect female students when they enter the hallowed halls of academia? In answer to this last question, allow me to cite my own experience as an undergraduate. I took a class called Intellectual History of Europe, which was taught by a renowned historian (whose name escapes me after all these years). At the first session, he promised that he'd discuss women's contributions to history at the last meeting of the course. I waited all semester. Finally, the day arrived. The professor strode into class, mounted the podium, and declared in an authoritative voice: "Women's contributions: they made none."

Although I have told this story before as one explanation for my decision to create *The Dinner Party,* I tell it again to make a different point. I was devastated by my professor's assessment, which made me feel like a freak. If no woman had ever made an important contribution, how could I be so audacious as to think that I might make a place for myself in art history, especially given that so few paintings by women graced the walls of the Art Institute of Chicago through which I wandered every week? Even though we have come a long way from the time I was young, in my opinion, we haven't come far enough.

Unquestionably, as I mentioned in the Introduction, there's been some progress; women's studies courses now exist all over the western world and issues of gender have entered the intellectual discourse. At the same time, women's studies programs are often beleaguered and underfunded.

And they remain on the periphery of the core education instead of being integrated into the curriculum as a requirement for all students, male and female alike. Until that happens, as Eisner pointed out, the university curriculum implicitly conveys the idea that men's accomplishments are inherently superior to those of women, which contributes to the disadvantaging of women.

The same might be said about the Eurocentric focus of our educational system; again, there is a built-in prejudice about whose culture is most worthy of study. This struggle continues. Even though by 1990 additional women and some African-American and Hispanic authors were added to the literary canon, there was fierce resistance by conservative scholars (like the philosopher and academic Allan Bloom and the previously cited Mortimer Adler); hence, the campus culture wars.

The points that I have been making about university curriculum also apply to studio art courses, despite the fact that most art students continue to be women. As of 2007, undergraduate women students outnumbered males by a ratio of 60:40 and even at the graduate level, there was more female enrollment. But in terms of faculty, white male artists still have a better chance of obtaining jobs in their field than anyone else similarly educated.

This situation has its roots in what happened to art education in the 1930s, when degree programs in studio art were first instituted at the University of Iowa by Princeton-educated Lester Longman, then slowly spread to other institutions of higher learning. What Longman introduced was something new: the autonomous and comprehensive study of art within a university environment. The institution of a master's degree as a professional credential for artists split the study of art along gender lines; male students were encouraged to pursue graduate studies in studio art while women were—as Lucy Lippard pointed out—counseled into art education, art history, or graphic design.

After World War II, gender issues were exacerbated on university campuses as well as in the wider society. During the war, women made up one-third of the wartime workforce. With the war's end, many of them surrendered their jobs with great reluctance, perhaps feeling that they had no choice in the face of what the writer, activist, and feminist Betty Friedan would later dub the "feminine mystique," that is, the widespread notion that women could only find fulfillment through homemaking and child rearing.

This set the stage for preference to be given to returning veterans, both in the work world and at colleges and universities. In 1950, Dana Vaughan, then

dean of Cooper Union (which, readers may remember, had allowed women to enroll from its earliest days) acknowledged that educational institutions faced the problem of making a choice between male and female applicants of equal qualifications. Preference was given to men on the basis that women would drop out of any career path in favor of marriage and motherhood.

Federal aid in the form of the G.I. bill made it possible for veterans to enroll in universities. Although this opportunity was available to both male and female vets, inexplicably, only 2.9 percent of women signed up for it. The G.I. bill could also be used in fine arts programs. The government was demanding that arts programs professionalize, become accredited, and credential their graduates. This accelerated the development of degree programs around the country, which produced an intense need for more teachers. Practicing artists began to be hired based upon their professional reputations, among them many of the abstract expressionists.

The preponderance of these artists had studied at private art schools, which meant that they had limited or no academic credentials. Moreover, even though all other art educators are expected to have some degree of education training, no such requirement was established for those teaching at the university level. At first, the bulk of these artists (most of whom were men) were designated as artists-in-residence but they gradually assimilated into regular faculty positions. They trained an entire generation of veterans who, upon graduation, were first in line for teaching jobs; the government required employers to give preference to veterans. As these newly minted art school graduates took up their posts at colleges and universities around the country, many of them took aim at the historical identification of art as a feminine pursuit.

In this effort, they were abetted by those who had taught them, many of whom had brought their macho styles and attitudes to the schools where they'd been hired; for instance, the California School of Fine Arts (an unaffiliated art school in the Bay Area), which became the center of the West Coast abstract expressionist movement. Though overshadowed by the New York school, the California style was equally innovative and significant for art history. Among its faculty were the postwar painters Clyfford Still, Ad Reinhardt, and Mark Rothko—all considered major practitioners of this movement. They mentored a group of abstract painters, mostly male, who fanned out to colleges and universities all over the West.

In the late 1950s, the famed artist/teacher Hans Hofmann was hired at UCLA when I was a student there. Although Hofmann is reputed to

have encouraged students to find their own paths, that is not my memory. I can distinctly recall *not* taking his class because I recoiled at the sight of the derivative abstract expressionist work being done by his students, who were of course primarily women. (As discussed in my autobiography, *Through the Flower,* most of the male teachers tended to view their female students primarily as possible bedmates or wives rather than potential serious artists.)

When I graduated and entered the Los Angeles art scene, I had no understanding of the history that I have been outlining. Thus, I was baffled by both the sexist attitudes and the emphasis on masculinity among the male artists who flaunted their gender in posters, advertisements, and swaggering behavior. In fact, the very nature of the artist was defined by the phrase, "the artist, he . . ." and no one even blinked at the fact that solo shows were called one-man shows, even if the artist were a woman.

As I said earlier, this situation caused some women artists to sign their first name only with a de-gendering initial and others to do what I did initially, which was to excise any hint of gender in my work. Of course, because I was still ignorant of women's history, I did not realize that there were many women before me who had used a similar strategy (George Sand in literature and the twentieth-century painter Grace Hartigan, who signed her work with the initial G, for example).

When I was a child attending classes at the Art Institute of Chicago, I had an incredible teacher named Manny Jacobson, whose classes I took for many years. He believed that critiques were not appropriate until young people moved into their teens. Before that, he encouraged his students to express themselves freely. Students were to be offered validation, support, and once in a while a few words to help struggling children clarify what they wanted to say. When we were teenagers he began to provide more guidance, but it was still always connected to the student's personal content rather than to an abstract set of principles.

When I started college, I was required to take a number of courses that focused on the "language of art" and I hated them because they seemed entirely divorced from my creative needs. I also disliked long technical explanations unless they were about techniques that were relevant to my aesthetic interests. Only then could I concentrate on acquiring the information I needed for my work.

This lack of focus on content often leaves students adrift, especially young women. A case in point: in the early 1990s, a male friend of mine

who taught in the art department of a Santa Fe college asked me to meet with one of his female students who seemed to be floundering. I went to her studio, a small space filled with hanging, eviscerated forms that reeked of anguish. After looking at them for a short while, I turned to the young woman and asked her who had molested her. She burst into tears, saying in a muffled voice between sobs, "When the art faculty looked at my work, they said nothing about its meaning. Instead they suggested that by hanging the figures from an I-beam, they would be improved."

One might ask how I could ascertain the subject matter? The answer is that I am able to read content in art, probably because my own work is content-based. Moreover, I have looked at the work of innumerable young women who have struggled to make art about the sexual abuse they experienced. As a result, I can identify such subject matter, along with other content, that grows out of the realities of women's experiences. Also, I have steeped myself in women's history, which means that I have a context in which to view women's art that many of my peers do not possess. Consequently, they look at such work through the only lens they have, i.e. the history of male art. When it doesn't fit, they either dismiss it or offer irrelevant critiques such as the one I described.

My point is that university studio art curriculum as it exists today is biased against women, though perhaps not intentionally. Rather, it is an outgrowth of the fact that this curriculum has been created by men in relation to what they have deemed important. It would seem that addressing women's needs is long overdue.

Over the years, I have worked with hundreds and hundreds of women. Although it is a generalization to say this, I believe it is true, if not for all, then for many: female students become motivated if helped to find their personal content. Then and only then can they start down the path of visual art. (The same can be said for some young men, particularly those whose cultural experiences are outside the mainstream of art.) My own success as a teacher is based upon my ability to help students find their personal voices, an approach that is quite different from the usual university studio class.

Many people argue that artists cannot be trained to be artists, that they can only be trained in formal principles and techniques—a position that Walter Gropius held and many others have reiterated. It may be accurate that if one is not truly an artist, no amount of training will change that fact. However, I believe—and my pedagogical methods have proven—that one can help most art students find their own paths.

"As the editors of Bitch magazine once suggested, we will live in a post-feminist world when we achieve a state of post-patriarchy, a goal that is nowhere near being achieved, at least not in large parts of the world. Until that time, it might be a good idea to stop promulgating such a BIG LIE."

THREE:
THE BIG LIE

Throughout the 1980s and 1990s, I was immersed in studio work and consequently unaware of the developments in academia as women's studies programs took root in institutions around the country. In 1996 I collided rather dramatically with academic feminist theory when art historian Amelia Jones mounted an exhibition at the University of California–Los Angeles Armand Hammer Museum titled *Sexual Politics: Judy Chicago's* Dinner Party *in Feminist Art History,* which was intended to contextualize *The Dinner Party* in twenty years of feminist theory and practice. It also included the work of fifty-five other feminist artists.

I can still remember my shock when members of the UCLA women's studies department threatened to picket the exhibit because they felt that *The Dinner Party* degraded women through its supposedly "essentialist" imagery. At that time, I didn't even know what essentialism was, though I quickly learned about it. In the early 1980s, some feminist art historians had begun to argue that *The Dinner Party* was, as Amelia explained in the exhibition catalog, "paradigmatic of a naive and putatively 'essentialist' arm of 1970s art." She defined essentialism as "the unifying presentation of women's experience as 'essential' or biologically determined."[20]

Obviously, the relationship between nature and culture is complex and we are a long way from understanding exactly how biology and environment interact to produce human personality. At the same time, despite recent feminist theorists' assertions that gender is a shifting construct and in contrast to the art world's keen interest in gender-bending imagery, the truth is that for most women in the world, their biological sex shapes and constricts their lives. In fact, it was because the women represented at *The Dinner Party* table were female that they were unknown

Judy conducting studio critique at Indiana University (IU), 1999

or under-recognized for their achievements. This was one of the points I was attempting to make through the imagery on the plates.

Moreover, I couldn't understand how hundreds of thousands of viewers around the world had realized that the work was a celebration of women while others in the bastion of academia could come to such a wrongheaded conclusion. By the early 1990s—perhaps as a reflection of beliefs circulating in the larger culture—many studio art departments began promoting the idea that we now lived in a post-feminist world, one in which feminism and, consequently, feminist art were passé. However, what I was hearing from young women suggested that once they emerged from the cocoon of the university, they confronted a very different reality.

For instance, I vividly recall meeting one young curator who had mounted an exhibition at the Norton Simon Museum in Pasadena that included my work among a preponderantly male roster of artists. She confided that in her previous job as assistant to a prominent male artist, he sexually harassed her. Additionally, many of the artists in the show had made unwanted sexual advances. She concluded her remarks by saying that nothing had really changed in the art world, a statement which suggested that the notion of a post-feminist world was a big lie, one that I will discuss later in this chapter.

My reentry into academia was initiated by Sergei Tschernisch, who was then the president of the Cornish College of the Arts in Seattle. In 1998, he invited me to present their annual commencement address, something that I'd never done before. The graduation was completely wild. The students were dressed in an array of costumes and each of the departments presented their teachers with gifts that were both funny and charming. All in all, it was a riotous event. In my remarks, I shared my experiences about the gap that I had encountered between art school and the art world, explaining how unprepared I was by my own university art education. I don't really know how my talk was received, but I got the impression that the farthest thing from the graduates' minds was what they would encounter on the other side of the diploma.

Some months later I was invited to present another commencement speech, at the Art Academy of Cincinnati. A few weeks prior to making the trip to Ohio, I had a phone conversation with a student at the school. As is my habit, I inquired about her experiences there. She told me about a life-changing class she had taken on women's way of seeing. That's the good news. The bad news was that the class was only offered once every three years and was in fact the *only* class that focused on women's issues. It is

distressing that, despite the fact that women make up the majority in most undergraduate art programs, a class about women was such an oddity—I mentioned this situation in my remarks.

Shortly before commencement, I met with some of the female faculty. They complained that there was an anti-female bias at the school. As if to demonstrate this condition, at the end of the graduation, there was an awards ceremony at which all the honors were given to male students. Sometime later, I received an extremely defensive letter from the school's president touting the achievements of some of the earlier women artists who had studied there—as if that made any difference in terms of the current atmosphere.

That same year, Donald and I got a call from Peg Brand, a feminist philosopher who was teaching art and philosophy at Indiana University–Bloomington. She and her husband, the late Myles Brand, were coming to New Mexico and wanted to see us. Although we had never met them, I was familiar with Peg's writing, which included some insightful comments about my work. I was eager to meet her and invited them to dinner.

When we moved into the Belen Hotel, Loretta Barrett, my literary agent at the time, had a leather-bound guest register made for us. When Myles signed the register, he listed his address as simply "Indiana University." "Oh," I said, "Do you teach there too?" "Not exactly," he replied, "I'm the president." What he didn't mention was that he was the head of the whole eight-campus university system.

Despite my opening gaffe, we had a great evening. During dinner, I mentioned my interest in returning to teaching and some of my thoughts about studio art courses as they pertained to women. Peg was very receptive to my ideas. Unbeknownst to me, she had started out as a studio art major and had been driven out of her college art department by the sexist attitudes of her male professors. She took refuge in the philosophy department, which was more welcoming to her. Myles made a comment that night that stayed with me over the course of the ensuing years—he suggested that if I intended to start teaching again, I should make sure that I only took jobs at institutions of a certain level. Those words would subsequently come back to haunt me.

I soon received a formal offer to teach at IU–Bloomington during the Fall 1999 semester, which I eagerly accepted as the school was reputed to have a good studio art department. Over the subsequent months, Peg and I made plans for my residency. I was particularly interested in addressing the gap between art school and art practice, the subject to which I had alluded

in my speech at Cornish. Many art students found this transition difficult, but it was especially challenging for women since many of them have little or no idea how to generate the money, space, or time necessary to set up a life as a professional artist.

Consequently, I proposed doing a project class that would allow students to experience the different stages of professional art practice—from identifying personal subject matter and formulating images to mounting an exhibition, which inevitably involves a myriad of challenges. My hope was that, by traversing the gamut of difficulties between creation and exhibition, the participants might become better prepared for the rigors of professional life.

Some months before the semester began I paid a visit to the Bloomington campus, where Peg held a gala dinner at the impressive university president's house. It was my first exposure to the lifestyle of a university president and the demands it makes on a presidential spouse. Although Peg joked about it, calling herself the "first spouse" or "spouse girl," I would come to understand how awkward a situation she was in due to the conflicting demands of her own career and Myles's prominent position.

Nearly twenty women from a number of departments and campuses gathered to welcome me and to discuss how they could build programming around my residency. There were also representatives from various women's studies departments who attested to the support that Peg had provided. Before her arrival, many of their departments were beleaguered; having a prominent feminist as the "first lady of IU" had been very beneficial to them.

As the evening unfolded, I could not help but notice the difference in faculty from when I was a student. Even though I didn't believe that we had attained post-feminist nirvana, there did seem to be many more women in positions of power and influence. I thought maybe things had improved since the 1970s, when there were few women in high-level roles on campuses. But then several studio art professors mentioned that everything was not altogether rosy in their neck of the woods, especially not in the photography department. However, the atmosphere was buoyant and when the evening ended I felt quite encouraged.

Unfortunately my optimism was short-lived. The next morning Peg and I had a meeting with the chair of the art department, who happened to be a photographer. Almost as soon as we arrived, he started yelling at me. He insisted that there was gender equity at the school, which totally contradicted what I had heard the previous evening. His hostility was

palpable and reminded me of what I'd encountered on occasion from male faculty during my visits at too many universities over the years. His behavior, like theirs, seemed to embody what was reported by Steven Henry Madoff: "Many schools are still struggling with artists who found their niche on their faculties . . . and then stopped growing—an unexpected perversion of tenure, which was meant to secure and promote radical thinking. . . . They perceive everything as a question of turf."[21] Obviously, I was encroaching on his.

I tried to tell the guy that nothing would make me happier than to discover that discrimination against women was a thing of the past—and not only at his university. However, it seemed that I could not dissuade him from his antagonistic stance. This was puzzling, because my salary was not coming out of department funds. Furthermore, Myles had decided to fast-track a space that would be used for the duration of my class and then be turned over to the art department. What really stunned me was that the fellow seemed to feel no compunction in expressing his animosity in front of the university president's wife.

Sometime after this unfortunate exchange, I read an issue of *Art Journal,* a publication put out by the College Art Association (CAA), the major American art professionals' organization. The subject was studio art education.[22] Studying these articles, which were written by a range of studio art faculty and administrators, one would surmise that the chair of the Bloomington art department was right, that things had indeed changed. The publication led the reader to believe that both gender equity and diversity had been achieved in art departments around the country, or at least that serious efforts were well under way. As part of the application process for my IU class, however, students had been asked to write short statements about why they wanted to enroll, and the experiences they described suggested a less sanguine reality. Their accounts were characterized by a near-total disconnect between professors and some of their students:

> *"My experiences . . . have shown me that academics are more interested in developing the strictly technical aspects of their students' work and they tend to shrink from any conversation having to do with artistic life."*
> *"I have noticed constant questioning by 'educated' male artists who did not take my medium seriously . . . (Also) the college does not offer classes that deal with feminism in art . . . (and I want to) learn from my history as a female artist."*

"I am a woman. . . . I want to produce feminist art and . . . express what it feels like living in this society as a female . . . and not be labeled a 'Feminazi.'"

"It is time for me to learn the history of artists who were women. I need to know what it means to do work that reflects who I am. . . (as it) becomes more apparent that the experiences . . . in my work are those of a woman, I have encountered an unexpected sort of energy from men. Suddenly my work is labeled as 'feminist,' as if that were something negative."

"Upon doing a paper addressing the position of women in the arts . . . including a discussion of the Feminist Art Program, I was told by my instructor that the feminist art movement had 'phased out long ago' and my interests in it were 'passé.' Nonetheless, I intend to study and write about women artists and feminist art issues even though it makes me feel alienated and unguided in graduate school."

These conflicting testimonies indicate that, for many female students, conditions were far from ideal.

In late August 1999, Donald and I set out for Bloomington, hauling a trailer full of clothes, art supplies, and portable studio equipment so that I could set up a temporary work space. We also packed up our six slightly sedated cats, who were going to spend the semester with me because I had decided to do a series of watercolors about life with our feline family and wanted the kitties around so that I could closely observe their habits. Peg had arranged for me to rent a spacious, light-filled, university-owned house on the edge of campus for an extremely modest cost. Its only drawback was its proximity to the football stadium—whenever there were games, I became a virtual prisoner in the house because cars were parked everywhere, even blocking my access to the street.

Other than that, the house was great and on a big lot set back from the street. Peg and some of the president's staff were there to greet us when we arrived. They helped unload the truck, then stayed to assist with the unpacking. Donald set up my studio in the basement, which a former tenant had converted into a cavernous, den-like space with knotty pine walls. He stayed for a few days then flew back to New Mexico. This left me with plenty of time to work in the studio—my only interruptions were teaching and near-weekly dinners with Peg and Myles.

Despite the fact that Peg had played a pivotal role in bringing me to campus, she was hesitant to take the class. I didn't even know she was interested

until the semester began. She kept attending the sessions, at first under the pretext that she was making sure everything was going well. Once it became clear that she wanted to participate, both the students and I urged her to do so. Even though she had presumably stopped making art many years before, she continued to feel a longing to paint, which is why she ended up joining the project shortly after it began.

Although the class was open to both sexes, only women applied. This disappointed me, as I had hoped to see if my pedagogical methods could be useful to men. As it turned out, they wouldn't be tested in that way until the following year. However, students from all eight campuses did enroll; they ranged in age from women in their early twenties to sixty-year-old returning students who had already entered into professional practice.

Unfortunately, once on their own, some of the more established artists had discovered that they were unable to work—at least not in any regular way. A number of them felt stranded without the support of professors and peers; others felt overwhelmed by the problem of earning enough money to support themselves while finding enough time for their work; some were unable to figure out how to finance and set up their own studios and buy materials. Their dilemmas exemplify my earlier point about the gap between art school and art practice, especially for women. Instead of resolving these challenges, they reenrolled at the university, which just postponed the problem.

The IU project class began as all my courses do, with introductions followed by self-presentations, during which each student shows her work and talks about herself and her artistic goals. Through this process, people identify their interests and concerns, which helps them to locate subject matter they wish to explore. Actually, I believe that many artists work with personal content but it often goes unrecognized because of the nature of contemporary art language.

From my own university studio art education, I learned to "talk in tongues," that is, to make art that was virtually unintelligible to viewers because the form disguised—rather than revealed—the actual subject matter. Increasingly, understandable content in art has come to be seen almost like an infectious disease, something to be avoided. To whit, in an extremely influential essay, "Against Interpretation," Susan Sontag argued that, "Whatever it may have been in the past, the idea of content is today mainly a hindrance, a nuisance, a subtle or not so subtle philistinism."[23]

In the Introduction to *Art School,* Steven Henry Madoff commented that the contemporary "art-for-art's sake stance . . . has generated a fear of narrative content . . . that is not serving us well in the twenty-first century. Modernism defined universalism partly through form, devoid of social content, but this has become a repetitive formula, an armor without a body, ultimately decorative."[24] In fact, in my opinion not only is content important, it should be expressed clearly so that it can be understood by viewers.

The first step toward achieving this in my classes is taken with the self-presentations, which are often very honest and open. In addition to initiating a process of sharing, they help to create a sense of connection between group members. Once artmaking begins, the group provides encouragement as the students move beyond their perceived limitations. This experience of group support promoting individual achievement is one that few women have—unless they participate in sports. Of course, this support is exactly what the 1970s consciousness-raising groups provided their members, though artmaking was not their goal.

During this phase of the IU project class one student, Yara Clüver, showed a series of landscape photos, saying that she intended to continue with them, but it soon became obvious that she was preoccupied with family problems. I suggested that she focus on those as the subject matter of her art. Her husband had developed Crohn's Disease, an autoimmune, inflammatory disease of the gastrointestinal tract. Their daughter also suffered from digestive problems that were preventing her from nursing. A feeding tube had to be inserted into the child's body so that she could get nourishment.

Once freed to address the issues with which she was actually concerned, Yara was able to utilize her considerable skills as a photographer to transform her life challenges into powerful images. Her photos presented her family's naked bodies—the birth-induced stretch marks on Yara's torso, the ravages her husband's bouts with Crohn's disease had wrought on his frame, and the baby taking in her mother's previously pumped breast milk through a feeding tube.

However, in order to produce this moving work, Yara had to struggle with her own resistance to letting others know about her life; like many people, she viewed it as a private matter. And it might have been. But what was going on at home was making all else pale in comparison. Consequently, her landscape photos were lacking in effect. They didn't reflect her real concerns.

Even though working with personal subject matter may be therapeutic, the process of making art is quite different from therapy. Healing is not the goal, though it can be an outcome. The purpose of mining one's experiences in an art class or studio is to find meaningful subject matter that has the potential to be transformed into expressive visual images. Unfortunately, in the present system of university studio art education, students are often dissuaded from seeing art as a form of communication, which is what I believe it to be. Hence my emphasis on comprehensible imagery.

After the IU self-presentations, I worked individually with the students. Some of them found their subject matter early on or came to the class

already knowing what they wanted to explore. Others were slower to find their content, so I would help them think about their interests until they identified the subject matter that inspired them. Then I would assist them in formulating a project that drew upon their particular skills. Because they were moving from content to form, they could employ whatever technique or combination of techniques seemed most appropriate.

Almost all of the students—including the older women—displayed a lack of confidence. Perhaps the authors of *Still Failing at Fairness* provide an explanation for this situation: "Sitting in the same classroom, reading the same textbook, listening to the same teacher, boys and girls receive very different educations. From grade school through graduate school, female students are more likely to be invisible members of classrooms. Teachers interact with males more frequently, ask them better

Yara Clüver, *Built to Suck*, 1999.
Photographic triptych

questions, give them more precise and helpful feedback. . . . Girls learn to wait patiently, to accept that they are behind boys on the line for teacher attention. Boys learn that they are the prime actors shaping . . . life."[25]

One advantage of an all-female class is that there are no male students to grab the limelight—the women get all the attention, which can boost their confidence if the teacher is supportive. Moreover, according to the same book, "In the typical college classroom, 45 percent of students do not speak; the majority of these voiceless students are women."[26] This dismal fact helps to explain the need for a pedagogy that includes everyone and

Judy Chicago with IU Bloomington students, 1999.

employs the strategic use of silence to make sure that all the students find the courage to speak.

In addition to a lack of confidence, most of the IU students suffered from an inability to formulate realistic ideas. Their conceptions tended to be either overly grandiose and hence beyond their reach technically or financially or too vague to be achievable. We discussed all these problems with an eye on overcoming them. Before long, everyone was focused on their respective projects—although we explored the possibility, there seemed to be no interest in doing collaborative work. I met with the class each afternoon to discuss their progress and to help with any difficulties.

At one point a few of the students began to struggle with me, probably because I was pushing them to think through their ideas more thoroughly and communicate them clearly (i.e. *not* to 'speak in tongues'). In response, they either became angry or changed their plan, insisting that I tell them whether their new concept was valid. I tried to point out that an idea is just the beginning, that most are only as good as the investment you are

prepared to make in them. You can begin with almost any intention. One of my favorite stories about Josef Albers proves my point. When he was asked why he had chosen a square as the primary format for his paintings, he responded, "One had to put color on something."

It was precisely when the students had to begin investing weeks of work in their projects that they began to falter, a rather common occurrence among women, who, as I've suggested, often lack confidence in themselves and their ideas. In one instance, I literally stood behind a young painter and urged her to walk straight ahead, all the while insisting that she not veer to the left or the right but just keep moving forward. My intention was to demonstrate physically that you had to make a commitment to an idea, then keep working until it was realized. Only then could its value be ascertained.

Once the students were over that obstacle, they were on their way. Not that there weren't bumps along the road and tears, which seem to accompany whatever women do, at least in my experience. I tried to urge them on whenever they became uncertain and to keep them on course whenever the going got tough as it inevitably does in the creative process. An idea can seem so great when it's in your mind but as it takes physical form a yawning gulf often opens up between conception and creation.

This is where a facilitator-type teacher can be especially crucial in helping students accept that their perception of their ability may be at odds with their capacity (in terms of talent, time, or money) to visually express their ideas. All budding artists must go through this experience as they build proficiency. Instead of giving up, students need to be encouraged to conceptualize a project that they can handle, to work harder, and to keep trying—over and over again if necessary.

Early in the semester at Bloomington, the class paid a visit to the I. M. Pei–designed university art museum, which was where the students would be exhibiting their finished creations. Particularly for the younger women, conceptualizing their work in terms of how it would look in a public space was a new experience. Kathy Foster, the curator at that time, helped the students to think about what it meant to do a museum show. She also proved to be invaluable when it came time to set up the exhibit. In addition to discussing installation issues, we talked about signage, announcements, and publicity—all important aspects of planning a show.

Because a number of the students had never been in an exhibition, I wanted to prepare them for the possibility that they might encounter the

type of criticism, rejection, and/or indifference that sometimes greets contemporary art, especially if it is content laden. Although it is difficult for any artist to deal with a myriad of reactions to his or her art, it is my experience that this is particularly true for women, who often find it difficult to handle criticism and tend to take it personally.

Another challenge for most of the participants was the amount of time required to complete their projects, especially as the opening drew near. Allocating time for work—a basic concept of professional practice—is always difficult for women. who often have to balance multiple demands. But learning what it means to work at a professional level is essential for anyone who hopes to make a go of it as an artist.

SINsation Postcard
Announcement. IU
Bloomington, 1999

Not everyone succeeded in their artistic goals. One of the older women wanted to deal with some persistent and troubling body issues. She had cast her body in plaster, but she kept covering up the form with cloth, probably because she felt ashamed of how she looked, as many women do. She and I argued about it. Finally I threw up my hands, feeling that she had a right to determine the level of self-exposure with which she felt comfortable. In other cases, students outdid themselves, creating images that were far beyond anything their earlier work had suggested was possible.

Peg had arranged for a film, *No Compromise,* to be made about the class by Susanne Schwibs, who works in IU's Department of Communication and Culture. Filming started early, when the students first gathered in the large empty space that would slowly be transformed into a bustling studio. The documentary provides considerable insight into my teaching methodology

which, as the title suggests, could also be called "tough love"—a combination of high expectations along with generous support and guidance. The film also documents the class's exhibition, which was titled *SINsation,* a takeoff on the controversial 1999 *Sensation* show of young British artists from the Saatchi Collection at the Brooklyn Museum.

Some of the works in our show were pretty controversial themselves. For instance, one charming young woman, Amy Saunders, created a life-size, plaster sculpture of a male figure—complete with erection, upon which she hung a towel. The witty title was *Towel Rack,* though I am not sure that everyone enjoyed the pun. She also created an installation consisting of a series of bold, red digital prints that incorporated a photo of her vagina. Over these, she painted simple images based upon various degrading slang expressions like "pussy," "muff," and "beaver." Exhibited nearby was her journal, which chronicled both her painful childhood and her positive experiences in my class.

There were several other sculptures. One was a full-size image of a woman ripping open her body to expose bruised innards, symbolizing the years of abuse that the artist, Dar Mitchell, had endured. Another involved a giant hoop skirt suspended from the ceiling, from

Installation view, *SINsation.*
IU Bloomington, 1999

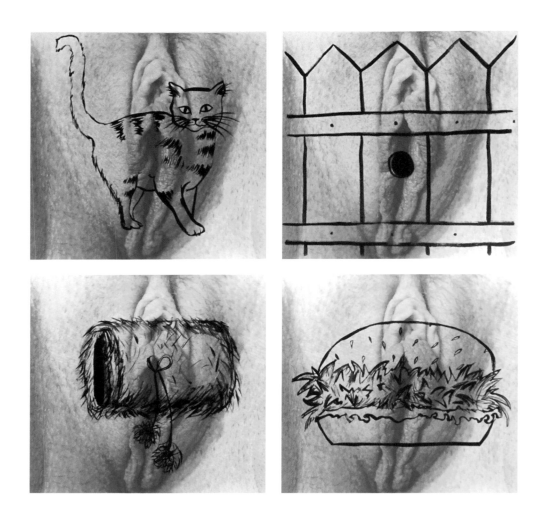

Above: Amy Saunders, *Dealing with Ongoing Sexist Attitudes,* 1999.

Opposite: Dar Mitchell, *Untitled,* 1999.

the center of which descended a uterine form composed of immobilized roses. There was also the aforementioned plaster body cast by the woman who had insisted upon obscuring the form with layers of cloth. As a result, it looked like an ossified mummy, though the artist had added another figure ascending from it, as if in flight.

Three large relief images of women—two in textiles, the other in sheet metal—graced one long wall. Paintings depicting Jan Zunkel's maternal heritage (with its constricting gender expectations) was juxtaposed with an antique armoire that seemed to overflow with a cascade of shoes. There were some striking images painted in oil on surfaces made of collaged paper and matte medium and a touching though somewhat naive series of watercolors depicting one student's Jewish wedding. Peg's contribution was an amusing parody of one of Willem de Kooning's *Woman* paintings, reconfigured so that viewers could have a photo taken with their own faces substituted for the original head, which had been carefully cut away.

The opening of *SINsation* was a huge success; many hundreds of people attended. Most viewers seemed bedazzled by both the range of work and its excellence. I walked around the show with Myles, who later wrote to say that he "was overwhelmed by what I was able to accomplish with these students in a short period of time." Subsequent teaching projects would also result in successful exhibitions, which I will describe later in order to demonstrate what my content-based pedagogy has produced. As they say, the proof is in the pudding.

As part of my IU residency, I team-taught a graduate seminar with Peg. Early on, we decided it was important to include an art historian in the course, which was titled "Feminist Art: History, Philosophy, and Context." But locating a collaborator proved to be difficult. At that time, the head of the art history department on the Bloomington campus was reputedly right of Attila the Hun. Given his political leanings, it came as

Jan Zunkel, *Untitled,* 1999. Mixed media installation

Peg Brand with her parody of a Willem de Kooning "Woman" painting, 1999.

no surprise that the guy was hostile to feminist ideas or that no one from his faculty would work with us—to do so would have amounted to professional suicide. We finally found Jean Robertson, who taught at the Herron School of Art and Design in Indianapolis, a member of the IU system.

Although a listed prerequisite for the class was a knowledge of feminist theory, I was frustrated to discover that we would have to give the students more basic grounding in feminism (which Peg graciously provided) before we could begin to consider the task of defining feminist art, which was the purpose of the seminar. To this day, there is little consensus among artists, writers, critics, and historians as to what exactly constitutes a feminist art practice. I believe that one difficulty lies in the fact that feminist art is content based; most previous art movements are defined by a singular style. Whatever the hurdles, they are complicated by the fact that some artists who are ardent feminists insist that their work—though abstract—should be included in this definition, even though few viewers would be able to discern any feminist content.

Other artists, such as Tracey Emin, whose work is openly concerned with gender issues refuse to call themselves feminist artists, perhaps because the term has developed such negative connotations in the art world—as has the term feminism in general. To further complicate matters, one prominent New York critic, while acknowledging that feminism has had a profound effect on contemporary art, has argued that there is no such thing as feminist art. Nevertheless, the term has entered the art-world lexicon and we thought it would be interesting to engage the seminar students in a dialogue that might lead to greater clarity about its definition.

Perhaps our expectations were unrealistic given that the art history graduate students had barely even been allowed to do research on women artists, much less venture into the new intellectual territory that had opened up since the advent of feminist theory. For instance, the distinguished artist and critic Mira Schor (a former student of the CalArts Feminist Art Program) wrote a groundbreaking article, "Patrilineage,"[27] that critiqued the continued practice of referring to a patrilineal rather than a matrilineal tradition in relation to women's art. By way of example, consider an article in a prominent art magazine about Elaine Reichek, whose work draws on the tradition of embroidered samplers. There are many precedents for Reichek's art in both conventional embroidery and the work of feminist artists including Miriam Schapiro's "Femmages," which often incorporate fabric, not to mention my own extensive use of needlework in a number of projects.

Yet, instead of considering Reichek's stitched images in relation to the history of feminist art, her work was placed in a male context that includes artists like Andy Warhol. This makes absolutely no sense in terms of the imagery or the technique. And it's a perfect illustration of Schor's point. Perhaps critics think that the best way to give credence to a woman's work is to compare it to a man's. But this is the wrong approach. Rather, women's history, feminism, and feminist theory must be integrated into mainstream curricula. Only then will there be a more appropriate historic context in which to evaluate what women do.

Another reason for my dissatisfaction with the graduate seminar was that most of the students seemed reluctant to put forth any new theories in their writing. The first-draft abstracts for the final papers were, to my mind, pretty dull. Perhaps I was anticipating a level of risk-taking that is more common among artists than academics. After all, in order to create, an artist must take chances; one faces a blank canvas or an unformed lump of clay and is forced to make decision after decision based only on one's intuition. Perhaps it is different for academics in the sense that they are trained to "prove" every point by citing previous research. In one session I blurted out that I was not satisfied with the abstracts because they rehashed old ideas. In response, one student said that "going out on a limb intellectually is not how one obtains tenure."

One conclusion that might be drawn from this experience is that I am better suited to studio teaching than to that type of class, which might be true. However, some time later Peg told me that she and Jean were team-teaching the feminist art seminar again, which pleased me. Perhaps the repetition and development of this class will eventually encourage some students to become less timorous.

There was one unexpected and positive outcome from the IU seminar class, though. At some point in the semester, Terry,[28] a theater major, proposed organizing a group of theater students to restage both the *Cock and Cunt* play and Faith Wilding's "Waiting" as part of the class exhibition. He also wanted to work with what turned out to be an all-female group to create some new performance pieces—again, no men signed up when the call for participants was circulated. For some unknown reason I just assumed that Terry would be able to use my methodology without any training, which turned out not to be true, at least not in terms of the original performance pieces. I didn't think that anything fresh was brought to the new staging of either the *Cock and Cunt* play or "Waiting"—perhaps the

politics of housework and female passivity were not as relevant to a younger generation—but several of the newly created pieces were quite potent and informative about the difficulties young women were facing.

As mentioned, by the time I arrived at IU, post-feminism was all the rage, particularly in academia. As Andi Zeisler and Lisa Jervis put it in the introduction to *Bitchfest,* "all of a sudden, there were books about

postfeminism, references to it in film and literary criticism, even an entire website called the Postfeminist Playground where a group of women wrote about sex, culture, and relationships from a standpoint that assumed a world where the gains of feminism were unequivocal and its goals roundly met."[29]

But the IU students' performances conveyed a different story. The most telling piece involved two women dressed in black leotards, one sitting on the stage, the other entering and exiting wearing a clown wig. While circus music played in the background, the clown character kept reappearing and dropping balloons in the lap of the seated performer, who blew them up. Each of the balloons was labeled with a word that evoked a source of pressure: parents, education, friends, career, relationship, and finally, baby.

Once that last balloon was dropped in her lap, the seated performer made it clear that it was impossible to balance them all—a seemingly perfect metaphor for the predicament these young women were facing. Apparently, they were being encouraged to believe that equality had been achieved, that they could do and be what they wished. But their life experiences were contradicting this rosy view. Soon thereafter, I tried to share what I'd learned from the students' performances, but with an unfortunate result.

In the spring of 2000, I visited Smith College to receive an honorary doctorate and present the commencement address. I

Balloons performance, 1999. *SINsation.*
IU Bloomington, 1999

was struck by the beauty of the setting, which was verdant and pastoral. Donald and I strolled down Paradise Road and past Paradise Pond, slowly taking in the atmosphere of a university that offered its all-female student body four years in what seemed like heaven to me—a school that made women the focus in an absolutely gorgeous environment.

Graduation day brought warm, beautiful, sunny weather and the ceremony was nice as such festivities go. Prior to our trip, I had had a phone conversation with Smith's president at the time, Ruth Simmons, the first African-American woman to lead an Ivy League college. I wanted some guidance from her about my commencement address. She advised me to speak honestly about some of the lessons I'd learned during my life. For that reason, I decided to talk about the IU performance piece and what it had taught me about the problems young women were having balancing the conflicting demands in their lives. At one point I said that even though it was not fair, women still could not "have it all," that they had to make hard choices if they really wanted successful careers.

A few days after the Smith commencement ceremonies, I received an e-mail from Peg Brand saying that she had heard a show on National Public Radio about commencement speeches and that my talk was mentioned quite favorably by the interviewee, a man who had written a book about the best graduation speeches of the last twenty-five years. My pleasure at his response lasted about an hour, until Donald received a teary phone call from his mother, who lived outside Boston. The *Boston Globe* columnist Eileen McNamara had viciously attacked my remarks. As soon as I read her commentary, I e-mailed Smith's provost; I knew Boston was too close to the college for the piece to have gone unnoticed. I asked if the administration was upset by the article, but he reassured me that they had invited me to speak my mind and that is what I had done.

However, as has often been my experience, negative press sometimes brings unexpected consequences. For example, there can be an unacknowledged reluctance to maintain contact with the person who had (intentionally or not) generated the reaction. On a more positive note, there was a full page in the *New York Times* (May 30, 2000) devoted to quotes from various commencement addresses, including mine. I was right up there with people like (then) Secretary of State Madeleine Albright, which made me feel a lot better—for a little while. Soon afterward, at an opening of one of my exhibitions, we ran into some old friends who informed me that several Smith alumnae had told them that my speech was quite contentious, and had added that I

had supposedly advised the students that they had best stay at home. To our friends' credit, upon hearing this, they responded, "I don't think so," rightly assuming that this would not be advice that I would proffer.

This brouhaha raged on for months. At one point, Ruth Simmons sent me a copy of the Smith College magazine. It contained a number of letters to the editor from mothers who expressed outrage about my daring to suggest that conditions for their daughters might not be as favorable as they had been encouraged to expect. Ironically, in that very same issue, there was an essay about female lawyers and the conflicts that they developed in their efforts to balance work and family life—this must have gone unread by the outraged parents of the graduates.

Apparently, like many people, they held what the *Newsweek* columnist Anna Quindlen described as "a charmingly naive belief"[30] that women have achieved equality. This conviction is also undermined by the facts cited in a much-referenced article by Anne-Marie Slaughter, "Why Women Still Can't Have it All." She reports that out of "a hundred and ninety heads of state; nine are women. Of all the people in parliament in the world, 13 percent are women."[31] Her main thesis is that an absence of family leave policies forces women like her—the first female director of policy planning at the State Department—out of demanding careers. She says, "I could not stop thinking about my 14-year-old son, who had started eighth grade three weeks earlier and was already resuming what had become his pattern of skipping homework, disrupting classes, failing math, and tuning out any adult who tried to reach him."

My reaction to the piece was, "What did she expect? If a person wants to be part of the public conversation and influence policy, maybe it's better not to have children. And if you really want a family, then that should be your priority, because children's needs cannot be made to accommodate the demands of a high-profile job." Like Slaughter, I lament the fact that so many highly trained and competent women leave the public arena because—as her statistics prove—there are not enough women shaping the world's policies. But the situation will not change until women recognize that it is not yet possible to "have it all." Everyone has a limited amount of energy.

Many years ago I spoke at a private girl's high school in Connecticut. After my talk, one of the students asked me if had children. When I said no, she asked why. "Because I didn't want them," I answered, which left her flabbergasted. She had *never* heard a woman say such a thing. I am not arguing that people shouldn't have children if that is what they want. Nor

am I suggesting that only women be responsible for child-rearing. But it seems to me that life is about making choices. Not having children must become an acceptable choice if women are going to enter the public sphere in enough numbers to begin to change it, which is what Slaughter is arguing (and I certainly support).

I must admit that the controversy surrounding my Smith commencement speech was confounding. Why were people so upset with me? I had simply reported on what I'd observed—that young women were being offered a view of life that would prove untrue once they left the comforting embraces of family and school. Why are so many people intent on believing and promoting a false picture of reality? It certainly doesn't help their daughters. The young women end up confused or, worse, trapped in the consequences of choices based upon the false premise of a post-feminist world.

As the editors of *Bitch* magazine once suggested, we will live in a post-feminist world when we achieve a state of post-patriarchy, a goal that is nowhere near being achieved, at least not in large parts of the world. Until that time, it might be a good idea to stop promulgating such a *BIG LIE*.

"People who have taught in MFA programs know the sinking feeling of encountering more purpose-made, over-intellectualized art . . . whose makers speak glibly about the biennials, the major markets, contemporary theory, and institutional critique."

—James Elkins

FOUR:
FROM THEORY TO PRACTICE

Over the years, I have structured my teaching projects around students' personal subject matter (as in the Fresno program or the IU project class) or around a theme (as with *Womanhouse*). Although both approaches can work, it seems important to reiterate that most undergraduate art programs do not address the issue of content at all—to the detriment of many students' artistic growth. Some institutions try. For instance, at the Santa Fe University of Art and Design, the faculty selects themes to be addressed in the foundation classes, which is fine if their choices allow space for individual subject matter, a diversity of self-expression, and the use of multiple media (as was the case with *Womanhouse*).

To illustrate how this lack of focus on content can affect young artists, allow me to recount my experiences at Moore College of Art and Design in Philadelphia, the only women's art school in the country. I first visited in the late 1980s, when I presented a public lecture and student workshop. Because it was a women's college I expected an enthusiastic reception, especially at the workshop, which was in a fairly intimate setting. Instead, I was greeted by stony silence. I soon discovered why—Moore's fine arts program had been colonized by an all-male faculty. They had apparently been filling the students' minds with the idea that I was their enemy rather than their advocate. Consequently, the teachers sat smugly by as the young women attacked me, an unnerving experience to say the least.

My visit was capped with these parting words, delivered by a male professor who accompanied me to the elevator: "I wish I were a woman, a black, or a chimpanzee so that I could benefit from affirmative action." Although I never imagined that I'd return to such an unwelcoming place, in 2004 I was invited back to receive their Visionary Woman Award. By then the school's presidency was in the hands of an impressive woman named Happy Fernandez, whom I'd met after a talk I'd given sometime earlier at the University of

Pennsylvania. She told me of her efforts to bring the school more in line with its original mission as an institution dedicated to female empowerment and education. She was the reason I returned; I wanted to support her.

When I spoke to Happy prior to my trip, she explained that one of her first tasks had been to try and loosen the grip of the (still) almost all-male fine arts faculty, a task made exceedingly difficult by their tenured positions. She had made some progress through a combination of retirement incentive packages, new administrators who wouldn't put up with the habits of some of the older professors, and younger female faculty. But, she admitted, it was a difficult process and one that was not yet complete.

Happy asked me to do two workshops while I was on campus to accept the award. They were to involve critiques with art students—juniors in the morning, seniors in the afternoon. In both sessions, the students complained about the lack of emphasis on content at the school. Apparently, their first two years of training focused almost exclusively on technique. Only in their third year were the students supposed to have miraculously fused their technical abilities with personal subject matter, without any help in discovering what that might be. And because of a lack of guidance or encouragement, they often lost their way.

There were between twenty and thirty young women in each workshop. There was no way that I could critique all their work in the allotted time, so I suggested an approach that hopefully allowed everybody to feel represented. Prior to my arrival, each group of students was to vote for six people to be critiqued whose work seemed to embody issues and ideas that reflected their shared concerns.

Before the morning crit even began, I encountered the same problem as I had in Fresno, that is, the young women introduced themselves in tiny, inaudible voices and by their first names only. In my opinion, any school devoted to the education of women must see to it that the students learn to present themselves properly. Speaking clearly and loudly enough to be heard and claiming space—both physical and mental—are things that continue to be a challenge for women. Using the circle methodology, I was soon able to transform the quiet, soft-spoken class into a lively group that eagerly contributed opinions about the work of those selected for critiques.

Until we reached the last student, that is. This young woman presented a series of paintings depicting individual females alone in barren spaces. Floating around the heads of each of these isolated figures were maxims like: "There have never been any great women artists," "Women are only

meant to bear children," "Women have never contributed anything to history," and other such outdated phrases. The students remained silent. This was strange, as they had just responded sympathetically to work that was less adept technically and/or less focused in terms of content. I was disconcerted.

Didn't they relate to these paintings? I asked, thinking that, surely, some of them must have heard similar sentiments expressed by family, friends, boyfriends, or right-wing pundits. No, they insisted, they had all been told that they could do and be what they wanted and they had *never* experienced any difficulties. "Great," I said, "that means that the women's movement was successful in that it has opened up a lot of space for you younger women, which is what it was intended to do. However, you need to recognize that even if you have been fortunate, there are many other women in the world whose opportunities are exceedingly limited by exactly such attitudes."

Slowly, the young women began to admit that they found the paintings quite threatening because they didn't *want* to believe that these attitudes still existed, nor did they feel prepared to deal with such biased views. One girl told us about having worked during summers in her father's business and at an art gallery. She was shocked to discover that neither place was receptive to her (or her ambitions) and she'd had no idea how to react. In addition to being ill-equipped to deal with such obstacles, she and the other students had received a clear message from the faculty that feminist art was passé (reminding me of some of the application statements by my IU students). This meant that if a student was interested in female-centered subject matter, she had best avoid (or hide) it. That helped to explain the group's reluctance to engage in discourse about their classmate's openly feminist paintings.

The issue of content also emerged in the afternoon session. Because this was a senior seminar, I had anticipated that the art would be more evolved, but it turned out to be far more constrained (I'm not sure why). Moreover, it took longer for my circle technique to take hold. But I just waited the girls out, allowing the silence to become more and more strained. Finally, we began discussing the work of the first student. After a few tentative comments broken by long pauses, another student would pipe up, but it was slow going.

Then one of the young women admitted that the reason they were so quiet was that they were used to the male faculty discussing their work

among themselves while the students acted as silent witnesses. It also emerged that critiques often became competitions among the men. I was appalled. Once the ice was broken by this revelation and they realized that I truly expected them to express their opinions, they became more animated. But I still had to call on some of the students in order to ensure that all their voices were heard.

The girls reiterated that subject matter was rarely addressed at the school and evinced puzzlement about how they were supposed to know what content to include in their art when they got to their third year. I've previously discussed how easy it can be to help students find their individual voices, so I shall only state how frustrating I found it that, even at a woman's college, there seemed to be an insufficient effort to tailor the curriculum to the students' needs. Moreover, the faculty's hostility toward feminist art only exacerbated the problem, particularly because young women's art often centers on issues of female identity.

The afternoon ended on a disappointing note, at least for me. The final student's work was poor and I couldn't understand why she had been selected. I wondered about the faculty's role. I did my best, but decided to cut the crit short. During the session, the other students became overly protective of the girl, perhaps thinking that the weakness of her art made her especially vulnerable. Later, one of the deans described an ongoing problem at the school, an atmosphere in which the girls felt they must support or "rescue" the least talented among them. We concurred that this was not a healthy situation and that it was particularly destructive to young women who wanted to go on to graduate school, where high aesthetic standards prevail and personal feelings are rarely taken into consideration.

The disheartening end of the afternoon workshop left me dreading the upcoming supper with some of the student leaders. For some reason, most of them were not fine arts majors but were in the applied arts or art history departments. However, they turned out to be an impressive lot—forthright, lively, and a lot of fun. Even though they were generally positive about the school, after awhile they began to voice a number of criticisms about the low level of expectations there. Some of the young women even stated that their high school teachers were more demanding than the faculty at Moore.

Such treatment seemed to hearken back to the 1960s, when female art students were patronized (or propositioned) because their (male) teachers did not take them seriously. To their credit, most of the students recognized that this type of treatment did them no favor. High expectations would bet-

ter prepare them for the transition from the coddled environment of their university to the intensely competitive art world. This led to a discussion about the fact that Moore had little or no women's studies program and that the one course on women and art was available only in the upper division. It was astounding to me that at the only all-women's art institution in the country the curriculum did not provide students with a grounding in women's history and feminist theory.

I tried to communicate my dismay during drinks with President Fernandez and then, in my remarks at the awards ceremony. Perhaps a public forum was not an appropriate venue for my approach, especially because Ed Rendell, the (then) governor was in attendance. But my words were well intended and, some months afterward, I ran into one of the deans who told me that some of the students had begun to ask for content-based critiques. That made me feel as though my efforts with the young women had been worthwhile. Even though this was personally gratifying, it did not address the absence of a women's studies curriculum at a woman's art school.

Four years earlier, in the fall of 2000, when I taught at Duke, I had encountered a different intellectual lack, which really startled me because it was a first-rate university. However, even though its women's studies department is reputedly one of the best in the country and the school's president at the time, Nan Keohane, was an avowed feminist, there seemed to be a marked lack of feminist consciousness among the female student body, a subject to which I will return.

I had seen an ad for a visiting artist position at the nearby University of North Carolina at Chapel Hill (UNC) and applied. The art department was eager to hire me to teach a graduate seminar, but the pay was slightly less than half of what I had received at IU. Fortunately, they were able to make an arrangement with Duke for me to teach one class at each school—they are about twenty minutes apart by car—which doubled the salary.

Shortly before I left Bloomington, I received a phone call from Rick Powell, a well-known scholar in African-American art and, at that time, the chair of Duke's art and art history department. During our conversation, it became apparent that our ideas about what I should teach were miles apart. I had assumed that I would offer a studio course of some kind, but he explained that their studio art department was actually quite small and there was no graduate art program.

His thought was that I should present a lecture class on my art and philosophy—for at least one hundred undergraduate students. According to

him, there was considerable interest in my work in the art, art history, and women's studies departments. Although this was flattering, the notion of speaking about myself twice a week for an entire semester brought on something akin to existential nausea because such an approach was definitely not consistent with my pedagogical methods. After an animated discussion, Rick and I compromised on a course that would be called "From Theory to Practice: A Journey of Discovery."

The class would be structured as an enquiry into topics that had been the focus of three of my major collaborative projects: women's history (*The Dinner Party*), birth and creation (the *Birth Project*), and the Holocaust (the *Holocaust Project: From Darkness into Light*). There would be no more than thirty students in the class, and a graduate student would assist me. Each of the themes would be introduced by a discussion of my art and that of other artists who had worked on similar subject matter. The students would then engage in readings and research to aid in the development of their own projects.

In early May 2000, Donald and I made a preliminary trip to North Carolina to see the two universities where I would be teaching. Our first day was spent at Duke, which has a beautiful campus in Durham. That evening Rick and his wife, C.T., took us out to dinner. During our conversation, it became clear why Rick had initially wanted me to conduct a large lecture class. He hoped that many students would enroll, thereby demonstrating to the administration that there was an avid interest in art on campus.

At that time, the arts were rather unappreciated at Duke. In fact, faculty members could not acquire tenure without a Ph.D., which were rare or nonexistent among studio and performing artists. At other universities, a master's degree and professional achievements were sufficient qualifications for tenure. This situation is changing now, as sympathies build for Ph.D. programs in studio arts. This subject seems necessary to address, so allow me to make a digression.

According to James Elkins, the editor of *Artists with PhDs*, it is possible that "the best universities and art schools will increasingly be looking for candidates with one of the new, PhD level degrees. . . . It may even happen that the PhD degrees become the standard minimum requirement for teaching jobs at the college level."[32] In 2003, at a conference session in Los Angeles about the subject of Ph.D.s in studio art, the audience—primarily composed of university art administrators—had dismissed this contention and challenged the notion of art students writing 50,000-word dissertations (one of the requirements of a Ph.D.). Still, by 2012 there were 127 Ph.D.

programs offered in the United States and Canada, which makes it clear that the idea is definitely gaining momentum.

But what exactly constitutes such a program and who is qualified to evaluate the candidates for it? There does not seem to be consensus on how to answer these questions, especially regarding the issue of assessment, as there are so few artists who have a studio Ph.D. degree. As to the qualifications for that degree, some people argue for a mixture of research and artmaking with differing emphases, an interdisciplinary approach for instance, even though it seems hard to imagine how a long research paper on an academic subject could be integrated with a body of visual art. In another model, research and artwork are understood as separate but equal endeavors. Still another proposal is for the art to be scholarly and the scholarship creative (whatever that means).

Unfortunately, a good deal of contemporary art already seems boring, overly academic, and incomprehensible. A preponderance of doctoral programs may only make this situation worse. As Elkins states in his conclusion, "People who have taught in MFA programs know the sinking feeling of encountering more purpose-made, over-intellectualized art, whose raison d'être is determined by the institution, whose makers speak glibly about the biennials, the major markets, contemporary theory, and institutional critique."

The most promising approach would be to require a research project to support a body of art, which would become the basis for the degree. Incorporating preparatory research is of course an approach that I have used in my own projects and in my teaching because I believe it is beneficial to become immersed in one's chosen subject matter prior to making art. However, this wouldn't solve the problem that institutions like Duke have faced, whereby an artist has to do non-art work in order to qualify for a degree.

As a visual artist and a published writer, I have experienced how different visual and written communication can be. When I am in my studio, I suppress the verbal thought processes that come to the fore when writing. It is not that I believe that the two are incompatible; in fact, I have often incorporated words into my images, but that seems quite distinct from composing a lengthy written document that is supposed to analyze, amplify, or reflect upon the art. Such a paper would require a high level of psychic distancing. I often say that I am happiest when I am "in" my art, meaning that my intellectual processes are at one with my intuitive actions. Being in two mental places at once or going back and forth between the intellectual and the intuitive can definitely disrupt the creative process.

I cannot help but wonder why Ph.D. programs are spreading so rapidly; money springs to mind as one explanation. In the U.K., where these programs are popular, universities receive government funding based on the number of students they have. Ph.D. students generate more money than those in M.A. or M.F.A. programs. In the cash-strapped educational systems almost everywhere in the Western world, such a program of advanced degrees could be an appealing moneymaker regardless of the quality of the art produced. But this movement is gaining adherents, which probably means that it's only a matter of time until doctorates in studio art are widespread—a prospect that makes me shudder.

A few months after our initial trip to North Carolina, Donald and I again set off across the country towing a trailer full of my belongings. In short order, he set up both the studio and my sparse living quarters in a rented apartment in Chapel Hill, not far from UNC. After he left, I gradually got into a rhythm working on my cat project, *KittyCity,* most of the time and teaching at Duke Tuesday and Thursday afternoons and at UNC on Wednesday evenings.

Early on, I assumed that most of the twenty-eight students in the Duke class would do text-based work because there were only a few art majors (or minors) in the group. And we were meeting in a classroom rather than a studio setting—not that the facilities in the art department were much to speak of. However, as soon became clear, I had underestimated the ingenuity of the students as well as the power of the self-presentations. Over the years, I have witnessed their impact many times. But that was mostly in groups made up of art students and artists. At Duke, the students had a range of majors. Somehow, the combination of the self-presentations and the apparent lure of the subject matter (which highlights the importance of selecting themes that are meaningful to the students) stimulated almost all the students to undertake visual projects. Evidently, the potential satisfaction that stems from making art was irresistible.

I have often wondered why so many people are drawn to art, even those who have limited talent and little chance for success in the field. More older women than I can count have told me how happy they are to finally have time to do what they've always wanted, that is, to create. I try to respond politely while thinking how much better it would be if they found other ways to become involved, for instance, by becoming collectors and thereby providing more support for artists who have devoted their entire lives to their careers.

I am reminded of what Bill Ivey, the former head of the National Endowment for the Arts, once told me in a conversation about the large number of artists and the tiny distribution system that constitutes the art world. He and his colleagues at the NEA discussed giving artists a stipend similar to what is given to farmers—*not* to grow crops. In other words, to subsidize *not to make art* because of this exact problem. Still, the deep gratification that can come from artmaking is powerful; it certainly has been for me and, seemingly, for my Duke students as well.

But at the beginning of the semester, I didn't know that this would be the case. After the self-presentations, the class divided into two sections. Although I had hoped that there would be more men, there were only two in the class and they ended up in the same group. At Duke my teaching assistant, Laurel Fredrickson, and I planned to meet alternately with each team so that everyone would have a chance to interact with both of us.

Each of the three topics would be approached through lectures, readings, and smaller group discussions that would provide a grounding in the subject matter. The students would then amplify the readings with their own research. They would do three month-long projects, one on each of the subject areas, making regular appointments with Laurel and/or me to discuss their progress.

In addition to a series of contemporary essays, I assigned several books. Among them was *Women and Art: Contested Territory,* coauthored by me and British art writer Edward Lucie-Smith.[33] The book compares images of women in Western art by male and female artists, arguing that women artists have created a body of "oppositional art" in that it opposes the prevailing—and better known—representations of women by men. The students were exposed to a poignant example of such art a few weeks later when we made a trip to the Duke art museum. The curator who toured us probably didn't realize how relevant her comments were. For instance, she pointed out how the male gaze was clearly exemplified by some of the paintings on display, almost all of which were by men.

In contrast, there was a wonderful "oppositional" self-portrait by the sixteenth-century painter Catharina van Hemessen, which is reproduced in Chapter Two. Though small in scale, the self-possessed image was made even more singular by the inscription: *I, Catharina van Hemessen, painted myself, aged 20.* This phrase seems to be an attempt to counter the feeling of surprise that a contemporary would have felt on encountering the work and learning its author was a woman at a time when a woman artist was

still a rarity. It was quite startling to see in the context of so much male-centered art.

Additionally, the museum collection manifested what Martin Rosenberg and Frances Thurber, the authors of *Gender Matters in Art Education,* meant when they wrote: "Since the power to represent their particular point of view in . . . art . . . has been overwhelmingly male, they have been able to represent their views as universal."[34] What is so irritating about this claim of universality is that there is an immense body of art by women that dates back several centuries. Unfortunately, not enough of it has made its way onto gallery walls.

I also assigned *Teaching to Transgress: Education as the Practice of Freedom* by bell hooks, a widely published African-American feminist scholar famous for her analysis of the interconnectedness of race, class, and gender. My purpose was to demonstrate another type of pedagogy, one that, like my own, was intended to empower the participants. In this book, hooks described her university experiences in a way that resonated with me: "The vast majority of our professors . . . used the classroom to enact rituals of control that were about domination and the unjust exercise of power." Like hooks, I had reacted against this model of teaching, choosing instead to try and make the classroom (as hooks describes it) "a democratic setting where everyone feels a responsibility to contribute."[35]

When I asked the students in the first discussion group what they wanted to talk about, they said "feminism." Although I inwardly groaned— my purpose here was to teach art, not feminism—I reluctantly addressed their request by referencing bell hooks's *Feminism Is for Everybody.* This book provides one of the clearest explanations of what feminism is (and isn't): "Feminism is a movement to end sexism, sexist exploitation, and oppression." She also articulates the real goals of feminism: "Imagine living in a world where there is no domination, where females and males are not alike or even always equal, but where a vision of mutuality is the ethos shaping our interaction . . . realizing our dreams of freedom and justice, living the truth that we are all 'created equal.'"[36]

In the alternate group there seemed to be a consensus about discussing another feminist issue, the objectification of women. When I asked the students why they had chosen this topic, they cited *Women and Art,* saying that, unlike the images of women by male artists with which they were familiar (and like those they had seen at the Duke Museum), many of the female artists had presented women as *subjects*. This resonated with them

because of the unnerving experiences some of them had had at Duke. Like the Smith girls, these students had been inculcated with the idea that we live in a post-feminist world. Many of them had gone to small schools or all-girl high schools, where a sense of equality had been reinforced. However, when they arrived at Duke, they were treated in ways that challenged that assumption (so much for the idea that everything has changed).

They complained about being viewed as objects by the male students, being judged by their looks rather than their intellectual abilities, and being dismissed when they tried to express their ideas in class. One girl spoke about sitting on the floor, engrossed in reading, in a bookstore near the school. When she got up to leave, she realized that a man was hovering over her, masturbating. Terrified, she ran off, then reported him to the manager, whose response was to walk her to her car rather than to call the police. Another young woman related that the first time she went on a date at Duke, she was nearly raped. As a result, she felt frightened to walk around the campus by herself and found herself withdrawing from social activities.

Some of the students mentioned that when they first arrived at the school, their pictures were placed in little black books that were circulated among the male students, who competed for the "triumph" of being the first one to "get" them, i.e. take them to bed. Consequently, they "dampened themselves down," as one student put it. Or conversely, they became convinced that they could only gain attention by objectifying themselves and expressing their power through their sexuality.

This notion of female sexuality as power or "power feminism" seems to have taken root in the early 1990s—just like the notion of post-feminism—and quickly made its way into the popular men's magazines. One male writer coined the phrase "do me feminism," which supported a woman's right to get laid and a man's right to lay her. Little did I know that these ideas reflected those of an entire generation, something I would only learn later from the popular book *Female Chauvinist Pigs* by Ariel Levy,[37] which describes young women making themselves into sex objects under the misguided notion that they're not only being brave and funny, but feminist.

As Deborah Siegel points out in *Sisterhood Interrupted,* "In a world that has changed . . . but not enough, empowered young women can easily experience confusion around the question 'What is power?' Sexual power is not the only . . . power, and alone, it is far from enough."[38] Ariel Levy summed it up when she wrote: "The freedom to be sexually provocative or promiscuous is not . . . freedom. . . . And we are not even free in the sexual

arena. We have simply adopted a new norm, a new role to play: lusty, busty exhibitionist."[39]

Having these discussions with my Duke students caused me to experience an intense sense of déjà vu. It was almost like being back in the early 1970s. Although "power feminism" was a new (and distorted) idea, other aspects of their stories were all too familiar, especially the sexist behavior that was causing identity confusion, destroying hopes, eroding self-esteem, and diminishing the students' sense of self. But how could this be? This was Duke, where there was a strong women's studies department and a feminist president. What, I wondered, was the point of women's studies courses if the principles of feminism were having such little impact on the lives of the female students? I have often quipped that the trouble with too many women's studies courses is that the (female) students study women as if they weren't one. Apparently, my joke wasn't funny.

In an article titled "Woman to Woman: Understanding the Needs of Our Female Students," authors Mary Ann Gawelek, Maggie Mulqueen, and Jill Mattuck Tarule state: "Although school supposedly is a learning environment where one's sense of competence should grow, more often than not, women students seem to experience it as a place where their sense of competence diminishes."[40] What my students were describing seemed like poignant (and painful) examples of this process.

I left that class as unnerved as I had been thirty years earlier when I first began to hear stories from my students demonstrating that, even if the right to higher education had been won, many female students were not able to take advantage of the educational opportunities afforded them. What I mean is that if young women are being *disempowered* by their university experiences, then they will be unable to realize their potential, a waste of their talents as well as a loss in terms of their future contributions to society.

This was brought home to me at the next group meeting. Despite the museum visits, the readings, lectures, and discussions, when I asked the students what they wished to talk about, they again focused on personal issues, particularly their difficulties in getting their male partners to respect their right to sexual pleasure. As noted in "Woman to Woman," "For women, beginning with the personal is often a freeing and novel experience . . . [but] challenging women students to move beyond the personal to the theoretical empowers them to own and feel pride in their opinions rather than discounting them."[41]

At one point I asked the young women if they thought that male students would be having comparable discussions in their classes; the question seemed to take them aback. After a period of silence, one girl said that she imagined that the boys probably talked more about ideas. I then directed their attention to one of their assigned chapters from Gerda Lerner's *The Creation of Patriarchy,* and suggested that her insights might apply to them: "women always and to this day lived in a relatively greater state of unfreedom than did men. . . . Women's lack of knowledge of our own history of struggle and achievement has been one of the major means of keeping us subordinate."[42]

I was careful not to blame them or make them feel guilty. Rather, I was trying to help them cope with the contradictions they were facing, that is, the idea that equality had been attained in contrast to the overt sexism they were encountering, not to mention the null curriculum—the idea that what schools do not teach may be as important as what they do teach. Sitting in classes that focused on men's achievements (with a few women thrown in), coupled with the negative ways in which they were being treated called into question the institutional and societal stance about female equality. It was confusing. And confused students cannot concentrate. They are physically present but intellectually absent. Or they engage in an intense inner struggle, seemingly exercising their minds while wrestling with these crucial issues. As a result, the personal tends to overpower all other concerns.

This situation places immense pressure on women to accept the patriarchal status quo, even if it means that, as Lerner suggests, they have to act against their own best interests. As Charlotte Templin writes in "The Male-Dominated Curriculum in English": "It is by a process of complex social dynamics that the tastes and preferences of males have been institutionalized in the university to the point where even most women . . . unquestioningly accept them."[43]

So what is the solution? It is actually quite simple. There needs to be an honest and hard look at the curriculum of our educational institutions with an eye to creating a more diverse and equitable program. One of the schools that has attempted this is Wheaton College in Norton, Massachusetts, now coed but originally established as a women's school in 1835 by the feminist Mary Lyon (1797–1849). In 1980, the administration launched the Balanced Curriculum Project. The goal was to establish a learning environment in which the pursuit of a strong liberal arts education—that integrated the history of women and feminist thought—was facilitated for women and men

with a sensitivity to gender issues on the part of all faculty, staff, and students.

From the beginning of the gender-balanced curriculum project, Wheaton recognized that gender does not exist separately from race, class, and other identity categories. As a result, the faculty voted overwhelmingly to create courses across the curriculum to ensure that the education of the students emphasized the study of race/ethnicity and its intersections with gender, class, sexuality, religion, and technology. Until such an approach spreads to all of our universities, too many young women will be forced to struggle needlessly with antiquated concepts of what it means to be female. And they will encounter equally out-of-date attitudes among their male peers that will result in strained relationships.

Early in the semester, Rick Powell told me that Duke students were exceedingly smart, and he was right. Once I'd introduced them to feminist ideas, they seemed to grow stronger by the day. Not that I believed that everything in their lives would change right away. A moment of enlightenment is often followed by fear or retreat. Or a woman might struggle to make the leap from a theoretical scenario to real life, such as having the courage to tell a boyfriend that you are entitled to sexual satisfaction.

In addition to being smart, my students were also ingenious in figuring out how to create art in such an inhospitable environment. Except for the few art students, who were able to use the studio facilities, the rest of the group had to work in their apartments or dorm rooms. But they were not deterred. Somehow they managed to produce a lot of interesting work, which we discussed while I stood on the desks of our cramped classroom with their art

Class critique with Judy Chicago, in the course "From Theory to Practice: A Journey of Discovery." Duke University, Durham, NC, 2000

positioned on the tables or leaning up against or pinned haphazardly to the walls.

Before I knew it, the semester was almost over. These were very busy weeks because the students decided that they wanted to do an exhibition, which presented a series of challenges, beginning with where their show might be held. Unlike most other universities, Duke did not have a student art gallery, nor could the campus museum be of much help as the staff was occupied with establishing the Nasher Museum, an ambitious institution that opened in 2005. In the meantime, Duke's existing museum was cramped and had no room for a student show. We considered a campus coffeehouse but its brick walls were covered with brightly-painted murals— not an appropriate background for art.

The coffeehouse was, however, a good setting for the presentation of plays by two of the students. The first one was roughly based upon David Mamet's *Oleanna,* which involves a power struggle between a university professor and a female student who accuses him of sexual harassment. When first presented, the Mamet play ignited considerable controversy because it attempted to justify the professor's actions. In the Duke version, both characters were lesbians, which made for some interesting interaction with the audience because they discerned some negative overtones in the play's interpretation.

The second performance, "The Postcard Project," dealt with the achievements of fifty post–World War II women. Some, like Eleanor Roosevelt (1884–1962), were well known; others were less so, like Eleanor Flexner (1908–1995), the first professional historian of the nineteenth-century women's movement. Her book *Century of Struggle*[44] brought attention to what is sometimes a nearly forgotten chapter in American history. The play's two organizers printed the various biographies on 5,000 postcards, modeling their design on the milk cartons that feature pictures of lost children. Because of a mix-up about university mailing requirements, the students were faced with the collapse of their initial distribution plan. They ended up passing out the postcards all over campus and putting up fliers on every available bulletin board, which took a considerable amount of time. Fortunately, this brought them a good-sized crowd of both women and men and afforded an important learning experience in that the students discovered how to, as they say, turn lemons into lemonade.

Despite the fact that many of the cited women were actually quite renowned, most of the audience had never heard of them, which underlined

the ongoing erasure of women's achievements. One nice note was that a number of male audience members expressed gratitude for the opportunity to participate in a feminist activity because, as they complained, they were too often excluded.

The coffeehouse performances were a big success, which reinforced the students' desire for an exhibition. Fortunately, the director of the John Hope Franklin Center for Interdisciplinary and International Studies had access to a large, unused basement in the building that housed his program. It was perfect. Though unfinished, the space provided sufficient room to set up separate areas for each of the themes the students had explored. They worked extremely hard, though there were some moments when I was afraid that relying on online communications with each other would hamper the completion of the actual physical work that is required to mount an art exhibit.

Donald arrived in the middle of the installation period, bringing his prodigious skills to bear. As I mentioned, he is a whiz at all things technical; moreover, he can work like a maniac, which was a big help during the long hours it required to get everything ready for the opening. In the end, it all came together in a show that, according to many campus people, was beyond anything anyone had done before at the university.

As I stated in my introductory wall text for the exhibition, "when one makes art, one becomes involved in an integrated struggle to give physical form to one's ideas." Although there were (and are) many things that we cannot change in this world, I discovered long ago that the creative act allows for a sense of symbolic mastery. Donald and I once attended a talk by esteemed Canadian author Margaret Atwood. At the end of the evening she read some unpublished writing, and one of her texts struck me as an incredible account of the power of the creative process. She described being inside a small tent with transparent walls. Outside there was an intense howling, an agonizing sound that she could not stop. All she could do to hold the howling at bay was to write on the inside of the walls—to write and write and write.

My Duke class allowed the students to "keep the howling at bay" through creative activity, if only for a semester. Moreover, it gave them the opportunity to put on an exhibition, which provided them with a great learning experience and a strong sense of accomplishment. Admittedly, the show was the work of undergraduates, many of whom had limited art training. But they were all exceedingly engaged. Consequently, what some

of the pieces might have lacked in technical competency they more than made up for in passion.

The class had decided that every student should be represented by either visual or written projects. Works of art were displayed on the walls or on pedestals, while text-based projects were bound and placed on tables in each of the three rooms. When viewers entered the exhibition, they were greeted by a section on women's history. A ten-part series of photo and text panels dealt with the tragic deaths of such famous women as the American jazz singer Billie Holiday. Across from this installation was a large dollhouse called *Herstory House.* Its rooms honored various women, including luminaries like the French author Christine de Pizan and the abolitionist and feminist Sojourner Truth. Their excerpted writings were reproduced on tiny placards that also featured portraits of the women.

A second area was devoted to the subject of birth. A large painting titled *Dr. Deity* portrayed a doctor holding up a newborn child to a cheering audience. The prone body of the birthing mother could only be partially seen, her thighs and belly still covered with the blood of birth and the placenta, a commentary on the takeover of childbirth by the medical profession. In the center of the room were

Francine Chip, Kathy Weiner, Ruth Ann Waldo, and Virginia Schwartz, *Women's History House,* 2000. Course exhibition, "From Theory to Practice," Duke University

 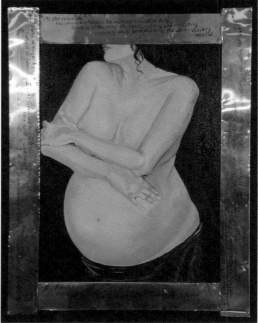

a series of five small goddess figurines on pedestals, wittily titled *Spice Girls*. Their creator had incorporated different spices into the sculptures, which emanated a range of pungent aromas.

Directly across from these tiny carvings was a hilarious multipanel, cartoon version of the Annunciation that included an image of the Virgin Mary talking to God on the phone about her impending impregnation. "What do you mean I don't get to have an orgasm?" she complained. "You must be kidding." This interchange was followed by several other cartoons, including one titled "Immaculate Bang."

There were several other pieces that, though modest, were quite effective. One of the young men wrote a wonderful essay about his shocked response to the video of a home birth that the class had viewed together. Cleverly, he had turned his written text into a visual image whose design in black, white, and gray constituted a portrait of a pregnant woman. Additionally, a two-part photo installation documented our country's peculiar standards concerning breast-feeding—some states allow it in public, others don't. This information was

Above left: Sarah Hunsberger, *Dr. Deity,* 2000. Mixed mediums.

Above right: Cathy Weiner and Francine Chip, *Birth,* 2000. Mixed mediums.

Course exhibition, "From Theory to Practice," Duke University

The horrible fuschia carpet swayed whichever way my six-year old hands pushed it, making all sorts of interesting designs. I must have been six, because it was right after my youngest sibling, a brother, was born. When my sister entered this world, I had only three years of life behind me, and though I was precocious, I didn't really understand what was going on. But with my brother, it was different. Something sparked and I got curious. As my hands carved intricate designs in my parents' bedroom carpeting, my mom leaned over her bed changing one of my brother's dirty diapers. I asked, "Mom, how many kids did you want to have?" She replied, "Three." "How many did dad want?" I continued. "Three." she replied. I can still remember thinking how lucky it was that God put three babies in my mommy's tummy, and I hoped that my wife and I would be so lucky one day. I wondered what if God put more or less than I wanted, and I worried. Of course, I stopped worrying as soon as my dad called me downstairs for some ice cream, but the whole notion of birth was so foreign to me. • I suppose that I should feel lucky for at least having known that babies came from within the mom's tummy. It seems that many six year olds know less than that; some are told that a grand white stork with a little blue or pink bundle hanging from its mouth flies high in the sky and drops the care package into the arms of a mother. The mother, upon catching it, names and loves it as her child. Why keep kids so clueless? Why didn't I know that fertile and responsible people can chose how many children they want? Why do we hide the actuality behind the "joys" – bundle of joy, the joy of birth, and so on? • I have noticed among my peers that this is a trend that continues far beyond childhood. As we got older, birth still remained a mystery. As a teenager, I learned about the birds and the bees, conception, but I did not learn about the actual birthing process. I went to a public high school that was rather progressive as far as suburban preppy high schools go. We had a full health class curriculum, and a real incentive to learn – my teacher would give us lollypops if we were being particularly attentive. We spent one semester on ourselves and self-esteem, one on pregnancy and birth, and one on having a family. The family project was the most fun – we got married and had a cabbage patch kid baby to take care of for two weeks. But, more importantly, we did have that semester on pregnancy and birth. • During that time, we learned about safe sex, birth controls, that the man should be just as much involved in pregnancy as the woman, the science behind the baby forming, and a little about actual birth. In reality, though, our lesson on the birthing process only included a one-day documentary video that wasn't too enlightening. My class cringed at the first sign of fluid; we got through it, and left with a feeling of utter nausea. As we walked out of class that day, I turned to one of my friends and said, "Thank God for waiting rooms!" We laughed and thought nothing more about the delivery process. • For some guys, that attitude is okay. As involved in the pregnancy as we might be, we are not the ones to give birth; the life does not grow inside us and we do not push it into the world. For me, though I personally don't want to be in the proverbial dark, I can still get by thinking that the video was lewd. Young women who plan on having children should not share this thought. My mother had some pictures taken of my brother's birth – nothing really graphic, just after shots of the slimy looking baby. When I told her about this project, she even joked about the photos, saying, "Oh, you can bring in those really nice pictures of Mark being born. That would be lovely art I think." All this plays into the notion of the birthing process being this thing that women just have to get through. It is a little bloody, a little frightening, and certainly a little painful, but it passes and the mother has this little baby in the end. • Andy Warhol would have been proud of my father's home movies – hours of baby Allen swinging back in forth in a mechanized swinger that clicked each time it passed the pivot. My family has had and used video cameras since as long as I can remember and even before that. Though there is footage of my mother pregnant with me, my parents did not tape my, my sister's, or my brother's birth. Perhaps they saw it as something not to show off, and it was not something that my mom wanted to document. Though this trend may be changing – more mothers want their deliveries taped – most girls still don't know exactly what the delivery entails. • So, we grow up thinking that birth is just this quick easy process. When Ross's first wife on NBC's top-rated sitcom "Friends" gave birth or when Murphy gave birth on CBS's "Murphy Brown," there were a few jokes and then, poof, a baby in their arms. Media images fast forward the birth process, hide what the truth may be, and still society's perceptions. Because of the sort of taboo that often surrounds the process, we see young people like Amy Grossberg and Brian Peterson – the college students who delivered their baby alone in a Delaware motel and disposed of it in a nearby dumpster – thinking that they can deliver a baby with no doctors, midwives, help, or practice. Obviously, they didn't think that when Amy went into labor, some magic stork would come, drop a baby, and her pregnancy would be over, but they were very uneducated about the birth process. Had they known more, perhaps their child would be alive in an adopted family, and perhaps they would have not served jail time. This instance is especially scary because Brian and Amy were generally educated people. They both were from upper middle class suburban towns and went to what is acknowledged as a good high school. How does an instance like this happen, especially since birth is everywhere? • If someone has enough friends or practices minimal amounts of eaves-dropping, he cannot go a day without hearing, "Happy Birthday." There are aisles at drug stores devoted solely to cards for the occasion, and entire industries are created around celebrating someone's birth. But, when we celebrate a birthday, we aren't really celebrating birth. If we were to celebrate birth for real, my mom would get the gifts, not me. All I did was follow gravity and slide out with the help of forceps. I didn't even do a good job because I came out jaundiced and had to be placed in an incubator before my mom could really bond with me. But every August third, we celebrate me. Birth is everywhere, just not real birth. • Recently, I saw a real birth. As I sat rocking back and forth in the classroom with the lights dimmed, I could feel my palms getting balmy as they rubbed against one another beneath my desk in a nervous motion. A young woman, a training midwife, came in to show my class the recording of her child's birth. She sped forward to the good part, the part where we were two minutes and counting. I could hardly turn my gaze from the screen as I held my breath. Thankfully, she muted the volume, but we could see everything. In an ultimate thunder of pushing the baby slid out and welcomed the world. I could breathe again, and was forever changed. The woman was clearly in pain during the delivery, but the emotion and power surrounding the process seemed to render the pain insignificant. After the birth, her face lit up and she came to life, seemingly free of any discomfort. Like that, she was a mother. I still found myself relieved that I didn't have to go through the delivery process, but I was jealous that I would never understand what it was to give birth, have the baby grow inside, and push it into the world. Seeing the process on the giant projection television made it very real. Of course, the woman didn't do it alone. She was surrounding her husband, friends, and two midwives, but she did it bravely and naturally. • For me, this video bridged the gap from myth to reality. I knew the science behind it and I saw the gooey pictures of my brother, but now I understand, as best I can until I witness my own child's birth, the whole process of delivery. All different cultures have their birth myths, but most people nowadays are wise enough to know there is no stork or whatever. Still, though they know the myths are false, they do not know the truths. In order to make birth truly a joy, we must be educated on the realities of it, or there will be countless other children carving carpet drawings, asking innocent questions, but believing the naïve answers they conceive.

On Birth, by Allen Loeb

Allen Loeb, *On Birth,* 2000. Course exhibition, "From Theory to Practice," Duke University

Faran Krentcil, *Annunciation,* 2000.
Multipanel illustration. Course exhibition,
"From Theory to Practice," Duke University

humorously communicated by small images of breasts that were pasted onto a map of the United States to identify the more liberal states.

Holocaust images were displayed in the last room. I would have expected this subject to be the most daunting and difficult for the students, but somehow it produced the best work, perhaps because the students had already dealt with two other topics and felt more confident. Or maybe they were just inspired. Whatever the explanation, the final section of the exhibit contained the most pieces and was also the most impressive.

Before the show opened, it was visited by a dean and an assistant provost who somehow entered the show from the back and therefore viewed the Holocaust work first. They kept saying that they could not believe what they were seeing in terms of quantity, quality, and meaning. A site-specific installation created by two of the students that dealt with some of the ethical challenges of the genome project in light of the widely documented abuses of Nazi science particularly resonated with them.

But there were other intriguing pieces, too, including one video installation. Two of the students had videotaped another student in the class who was the daughter of a Holocaust survivor. Her father had been interviewed by the Shoah Foundation, the Steven Spielberg–backed undertaking that records the testimony of survivors around the world. The students had borrowed the father's tape, then recorded the daughter addressing some of the same issues her father had discussed. The tapes were played simultaneously on two TVs, making for a fascinating but painful intergenerational family dialogue.

Next to this installation hung a small metal box in the shape of a Jewish star. When opened, the box revealed a beautifully embroidered image of a child survivor, along with photographs of other children who had survived the camps. Their pictures were juxtaposed with additional photos chronicling some of the horrors that the children had witnessed and/or endured. Nearby this small but beautifully executed piece was an ambitious sculpture created collaboratively by four of the students.

Suspended from the ceiling hung a series of colored glass triangles reminiscent of the triangular badges worn by prisoners in the concentration camps that denoted their supposed crimes against the state—like being a Jew, a political prisoner, or a homosexual. Below them was a large wooden box ringed with barbed wire, inside of which was a group of slate stones, each inscribed with one of these categories. The stones rested in a bed of dirt and rocks, underneath which could be seen a broken mirror, bringing to

mind the 1938 *Kristallnacht,* or "Night of the Broken Glass," which ushered in the Holocaust.

One of the most visually sophisticated and intellectually challenging of the works was a large poster fashioned by two of the students, both of whom were Jewish. It was structured around a yellow graphic that combined a Jewish star with a Nazi swastika, an image that I feared would be troubling to some viewers because of the implication that these two symbols were equivalent, which I'm sure the students did not intend. But they *did* intend to raise a number of ethical questions dealing with the memorialization of the Holocaust.

Each side of the poster listed eighteen questions. The number eighteen is an important symbolic number in Jewish culture because the Hebrew word for life is *chai,* which has a numerical value of eighteen. In large letters, the left side of the poster asked: "Why 'Never Forget?'" This phrase about never forgetting is almost a mantra at the 150 Holocaust centers in America. Below this question were other queries, including: "One more memorial, one more sign—and there are hundreds of them—does it really matter?"; "Do Jews exploit the 'crimes' committed against them?"; "Do the graphic images of bodies piled up (in Holocaust museums) do anything except make the viewer cry or be sick to his or her stomach?"

On the right side, under the inquiry "Is the Holocaust unique?" were grouped such queries as: "Isn't the Holocaust just one in a long string of inhumanities?"; "Is there a way to reconcile the Holocaust's

Dr. Richard Powell viewing work by Lindsey McCracken. Course exhibition, "From Theory to Practice," Duke University, 2000

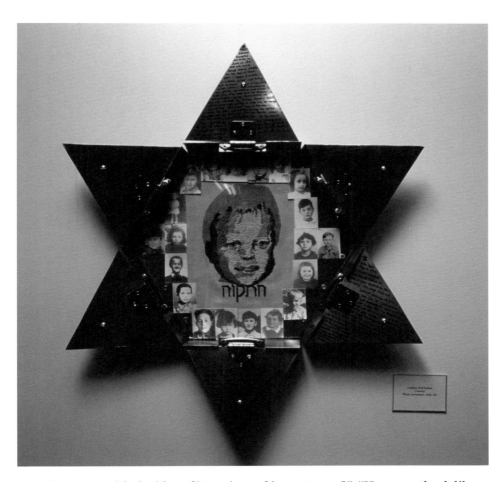

uniqueness with the idea of its universal importance?"; "How was the deliberate mass murder of the Jews different than the genocide faced by the Native Americans in the 1800s in the 'only good Indian is a dead Indian' America?"; and "If the Holocaust is not unique, why is it memorialized more than any other genocide?"

In order to understand how provocative these questions are, I would like to describe a conference that was held in 2000 called "Representing the Holocaust: Practices, Products, Projections," sponsored by the Berman Center for Jewish Studies at Lehigh University, which coincided with an exhibition of the *Holocaust Project* at the Zoellner Arts Center on the same campus. It brought together artists, art historians and critics, museum professionals, scholars, and survivors from all over the world. Considering the fact that some scholars and many survivors still

Lindsey McCracken, Detail, *Untitled*, 2000. Mixed mediums. Course exhibition, "From Theory to Practice," Duke University

I, **Sarah Breisblatt**, am a 19 year old Conservative Jew who has been raised on the Holocaust. My grandparents escaped the Holocaust, but many of our eastern European family members did not. Throughout my life I have visited memorials and museums with my family, and we have acquired all sorts of Holocaust memorabilia. Although my parents' intention was to make sure I would "Never Forget," I have some questions regarding why society, both Jews and non-Jews, should remember the Holocaust.

Why "Never Forget?"

One more memorial, one more sign – and there are hundreds of them – does it really matter? • Does Holocaust education support author Dennis Prager's idea that "the hatred of the Jews has been humanity's greatest hatred?" • Do Jews exploit the "crimes" committed against them? • Does Judaism foster a nationalistic type of mindset through its exclusive, cultic traditions, the belief that the Jews are the "chosen people," and their monetary donations to the country of Israel, which has subsequently been named the "Jewish Homeland?" • Should non-Jews be blamed for the animosity they feel towards Jews because they are not the "chosen people?" • Is the assertion that Jews are not victims but rather victimizers, proposed by the deniers of the Holocaust, hard to conceptualize after contemplating how Israel was transformed into a Jewish state practically overnight and how many Palestinians suddenly lost their country and their rights? • Many countries learn about and remember the Holocaust differently. If there were one, international "way" to teach the Holocaust, would that help prevent the horrific crimes that many nations still commit against each other and their own citizens? • If all we do to make ourselves feel better about the crimes committed by and to humanity is create memorials, how can we expect to keep these crimes from reoccurring? • It seems that Jews unite over the Holocaust because they were a primary target of the "final solution" and because they are often the first ones associated with it, but does that mean that Jews must always have the only say in how it is memorialized and taught to others? • During the Warsaw ghetto uprising the Jewish community held a candlelight vigil in New York City's Central Park. How could the Jewish community in America just stand around and light candles for the victims of the Holocaust while the concentration camps were still functioning throughout Europe? • Emotionalism seems to be crucial to the way in which the Holocaust is remembered, but why is Auschwitz usually represented by the face of a child – why not the mother of the child, why not a woman? • Do the graphic images of bodies piled up do anything except make the viewer cry or be sick to his or her stomach? • After a visit to one of the 140 Holocaust museums, do people self-reflect or think about the potential evil of humanity, and how long do these last before daily life takes over? • How can a person, especially a Jew, avoid desensitization to the Holocaust when the images and stories of the horrors committed by human beings are over-memorialized? • Is it effective to "Never Forget" the Holocaust by trying to make it "Always Remember" through the excessive amount of memorials and classes that focus on its dates, stories, and heroes? • Why do the movies and television mini-series about the Holocaust often make the viewer emotional and sympathetic towards its victims and survivors, but the daily news footage of countries participating in modern genocides are just news stories to be forgotten because nothing can be done about them? • For many it is taboo to discuss the Holocaust unless it is in a class of some sort, but why is it acceptable for its story to appear in everything from books to memorials to museums? • How do Jews who have become desensitized to the Holocaust because they have been bombarded with its images, stories, and memorials since they were young fulfill the goal "Never Forget" when they hear another survivor's story, view another graphic image of bodies piled on top of each other, or see another memorial with the names of children killed at one of the concentration camps, and feel little or no emotion?

I, **Allen Loeb**, am a 20 year old Reform Jew who never understood the importance of learning about the Holocaust until now. My father's father escaped from Germany when he was ten years old at the very beginning of the war – his family was allowed to leave because my great grandfather fought for Germany in WWI. Though my family has this story, though I went to Hebrew School, and though I have visited Holocaust memorials, I have never understood what separates the Holocaust from other genocides.

Is the Holocaust Unique?

Isn't the Holocaust just one in a long string of inhumanities? • Is there a way to reconcile the Holocaust's uniqueness with the idea of its universal importance? • Samuel Belzberg, Simon Wiesenthal Center's principle financial banker, once told a reporter, "It's a sad fact that Israel and Jewish education and all the other familiar buzzwords no longer seem to rally Jews behind the community. The Holocaust, though, works every time." Why does the Holocaust have this effect? • Why does it seem that more emphasis is placed on the Holocaust than any other genocide throughout history? • The Twentieth century has witnessed other holocausts in Cambodia, Laos, Tibet, Rwanda, Bosnia, Armenia, and the Soviet Union. Do these differ from "The" Holocaust in scope, setting, expectation, proportion, intention, intensity, duration, methodology, and consequences? • How was the deliberate mass murder of the Jews in the Holocaust different than the genocide faced by the Native Americans in 1800's "the only good Indian is a dead Indian" America, and are there other examples of a state trying to destroy an entire people, regardless of age, sex, location, profession, or belief? • Though the Nazis took all Jewish property and goods, the Jews were killed for what they were, not what they had. Have other perpetrators conducted genocides for no territorial or political gain? • In her essay "Not Facing History," Deborah Lipstadt notes, "When a non-Jewish mother who was accompanying her young son through the exhibit reached the part of the exhibit devoted to Christian rescuers, she turned to him and said, 'If we had been there this is what our family would have done.' Her optimistic certitude aside, in that small interchange her child learned something about the responsibility of the bystander and, even more significantly, about his mother's expectations for herself and for him." Are there different lessons to be learned about the responsibility of the bystander from the Holocaust than from other genocides? • If the Holocaust is not unique, why is it memorialized more than other genocides? • Did other genocides have state-sponsored, rational, well thought out systems for killing, and why should this matter? • Killings in the Holocaust took place on a biological, not religious basis; a person was killed if he had one or more Jewish grandparents. Is persecution based on existence, not belief, unique? • Some historians believe that the Nazis might have won World War II if they hadn't used such a large portion of their war resources for the Jewish annihilation. Is it unique that the perpetrator used resources that could have helped the war effort for killing? • Jews were killed all over Europe. Were other genocides as geographically vast? • The Nazis considered the Jews to be an anti-race, Satan, bacteria, contaminators of culture, and the mortal enemy, and they also saw their own actions as "morally correct" to save humanity. Were other genocides considered a necessary thing to do to save humanity? • Isn't the feeling of uniqueness a "mere result of one's own traumas" (Emil Fackenheim)? • Was the mass-murder of the Jews a direct result of the war or was the war a convenient way to facilitate mass murder of a race? • Are the cultural and psychological effects on the descendents of the murdered the same among the Holocaust and other genocides? • Was the Holocaust unprecedented in Jewish history; does it occupy too large a position in contemporary Jewish consciousness?

believe that it is impossible to represent the Holocaust in any artistic mode (despite the existence of Holocaust art all over the world), discourse on this subject has been fraught with peril. As a result, there's been a near-total lack of agreement on aesthetic standards for Holocaust art.

At one point during the proceedings, there was a presentation by a young Dutch art critic who contemptuously stated that "moral art is bad art," thereby dismissing most of the art that was being discussed at the conference. To understand how radical this view was, it seems important to note that for decades, Holocaust museums in the United States and western Europe have emphasized the moral lessons of the Holocaust, lessons that the young Dutch critic insisted had been rejected by his generation. Like my students, many younger scholars were apparently questioning some long-held tenets about the Holocaust, particularly the idea of its uniqueness, which has been a central component of Holocaust education for decades.

The student poster suggested that the oft-touted phrase "Never Forget" rang increasingly hollow as it became evident that if the Holocaust's lessons had ever been learned, they seem to have been forgotten. Tragically, it is the Nazi genocidal policies that seem to have been

Lindsey McCracken, Detail, *Untitled*, 2000. Mixed mediums. Course exhibition, "From Theory to Practice," Duke University

remembered—and repeated again and again (think Cambodia, Rwanda, or Darfur). In the face of this subsequent history, it does seem understandable that young people might reject the notion that teaching the lessons of the Holocaust will somehow help us avoid future tragedies.

The Duke exhibition premiered on a Thursday night. The students acted as the guards. Hundreds of people attended the opening. The exhibit was originally slated to be open on Friday and Saturday, then conclude on Sunday. As scheduled, it closed at the end of the weekend. But the administration was so impressed by the work that they arranged to have the show open again for another month after the Christmas break—with security provided by the university. Everyone said that they wanted to give students and faculty across the campus the chance to see the exhibit.

Needless to say, the students were overjoyed by the school's decision and deeply gratified by the widespread appreciation for their work. In addition, a number of faculty members told me that the students' displays exemplified precisely the type of interdisciplinary thinking that Duke was trying to promote in a new, revamped curriculum (an unanswered question was whether these changes would be better geared to the needs of its female students).

What made the Duke exhibition, like IU's *SINsation* before it, so successful? In the last chapter, I cited Steven Henry Madoff's comment about the fear of narrative content that typifies a good deal of contemporary art. Add to this the opacity of meaning that characterizes so much recent work and it is not difficult to argue that both of these exhibits might have enjoyed an enthusiastic reception because the meaning of the art was communicated so clearly.

As pleased as I was that the exhibition turned out so well, for me personally one of the highlights of my time at Duke took place a few days after the opening, right before Donald and I set out for home. Nan Keohane, then the university president, and her husband, Bob, held a dinner party for us. Some weeks earlier, I had received an unexpected letter from Nan in which she recounted how, in 1979, she had stood in line to see *The Dinner Party* at the San Francisco Museum of Modern Art. Since then, she had been an "avid admirer" of mine. I was extremely flattered as I had heard quite a bit about her, especially from Peg and Myles Brand.

The evening was wonderful, filled with good food and good company. At one point Nan proposed a toast to feminism to which all the guests, both male and female, joined in. Now that was something that doesn't happen too

often. But as much as I admired her, I could not help but wonder why she had not been able to more thoroughly translate her ardent feminism into an institutional atmosphere that was more geared to its female students. If she couldn't do that, what difference did it make to have such a woman in power?

On the other hand, given the nature of Duke as an institution, perhaps it wasn't possible for her to do more. The school was initially a men's college and even though it had gone coed in 1972, it was clearly still a male-centered institution at heart. Shortly before Nan stepped down as president in 2004, she instituted an initiative aimed at examining the situation of women on campus. (Of course, had she asked I could have given her an earful.)

In 2003, three years after my residency, I was offered an honorary degree, which was a big deal because it is rare for Duke to give this award to anyone who hadn't either attended the school or taught there for many years. On the day before the graduation ceremonies, Rick and C.T. held a wonderful garden party at their home in my honor. In attendance were many of the people I had met during my tenure at the university, who warmly welcomed me back.

Despite my conflicting feelings about Duke, it was with both pleasure and satisfaction that I received the degree from Nan. There is a long way to go in terms of transforming the atmosphere and curriculum of universities like Duke so that they are truly welcoming to women, but it is a symbol of how far we've come that a female university president can bestow such an honor upon a woman artist whose career has involved as much controversy as my own.

Two years later I was invited back to Duke to speak, this time by the wife of the provost, who was concerned about the ongoing negative atmosphere for women there. Apparently, she hoped that—as had happened with my class—I might impart some beneficial insights to the female students. In my lecture titled "A Letter to Duke," I expressed my appreciation for the institution while outlining what I had found to be a deeply troubling situation for women on campus. Afterward, many faculty members came up to thank me for my remarks.

No one could know that less than six months later, rape charges would be leveled against some of the members of the lacrosse team, igniting a storm of negative press. Sadly, this scandal was all too predictable given the rampant sexism on the campus. Hopefully, the situation stimulated some long-overdue discourse at the university. Some years afterward, I read

Tom Wolfe's book, *I Am Charlotte Simmons* and was amazed at how closely his insights paralleled my own. There were striking similarities between his narrative and the experiences that my students had described, as well as the concerns the provost's wife had expressed.

Although Duke is unquestionably a stellar institution, it will require a lot more than a visiting professor's insights or a novelist's words to overcome the school's past as an upper-class, male-centered university. Still, I hope that someday soon, the university will realize its potential to be a truly great institution, one that makes its many benefits available to *all* of its students, irrespective of gender, race, or class.

FIVE:
WHAT ABOUT MEN?

O ver the last thirty years, the subject of men in a feminist environment has been vigorously debated. The consensus is that when men are present they tend to dominate the classroom, a phenomenon I discussed earlier. This propensity explains why some feminists have refused to allow them in their courses.

As I understand it, this was the case for the late Mary Daly, a philosopher who was forced out of her tenured teaching position at Boston College in 1999 because she would not accept male students in some of her courses. Her contention that men would inhibit classroom discussion had already been proven by research. For example, in 1985, Harvard Graduate School of Education lecturer Catherine G. Krupnick published a widely reprinted essay, "Women and Men in the Classroom: Inequality and its Remedies." After a year of reviewing videotapes of classes at Harvard, she concluded that: "male students talked much longer in the predominant classroom circumstance [particularly when] the instructor is male and the majority of the students are male." In that situation, she found that "male students spoke two and a half times longer than their female peers."[45]

In contrast, "the presence of female instructors apparently had an inspiring effect on female students. They spoke almost three times longer under instructors of their own sex than when they were in classes led by male instructors." Not only did the professor's gender influence student behavior but, more important, men and women evidenced distinct communication patterns. In single-sex classes, women "took turns in a egalitarian way, and each spoke for more or less equal amounts of time. . . . Male groups appeared more contest-like, with extremely uneven amounts of talk per man." In mixed groups, "the male competitive style won out."[46]

Judy Chicago with student Clay Smith, Western Kentucky University, Bowling Green

Most educators agree that active participation encourages learning. Because discourse in a mixed-gender classroom has been shown to be based on a male style, the most assertive students (who are usually men) win out, which disadvantages everyone else. The only way equality can be achieved is through an alternative pedagogy, like the one that I employ. Some teachers hesitate to call on everyone because they don't want to put shy students on the spot. As empathic as this might appear, it only ends up reinforcing patterns of male dominance.

Despite the fact that my pedagogy counters this tendency, there was definitely a time when, like Mary Daly, I was convinced that if men were present women could not be themselves. Even I felt constrained around men, so how much more difficult must it be for young students to speak freely? Consequently, when I set up the first feminist art program in Fresno, it never even occurred to me to allow men in the class. Men were invited to our year-end exhibition, however, because I have always believed that visual art is one of the few modes of communication that allows us to transcend barriers such as gender, race, ethnicity, sexual preference, culture, nationality, and geography.

The same held true when we created *Womanhouse*. Although there were no men in the CalArts program, once the exhibition opened to the public they were definitely made welcome (except on the opening night, which was for women only). At the same time, as documented by Johanna Demetrakas's film of that installation, a number of men were made intensely uncomfortable by the open expression of a female perspective, perhaps because it was then so new. But other men were fascinated—and why not? It is not considered unusual for women to be interested in and supportive of male art. Why shouldn't the converse be true?

While my early educational programs were only for women, this was never the case with my collaborative projects. Even though most of the participants in *The Dinner Party* studio were female, two of the key people were men: Leonard Skuro, the head of ceramics, and Ken Gilliam, an industrial designer who devised many of the systems that underpinned both the creation and exhibition of the piece. Also, there were a few male needleworkers and researchers as well as a number of men in Johanna's film crew—her documentary *Right Out of History* chronicled the process of making *The Dinner Party*. This meant that there were always some men around the studio.

Irrespective of gender, everyone was required to participate in the weekly discussions in which feelings, both positive and negative, were

expressed. Early on, it became apparent that most of the men had given little thought to issues of gender whereas many of the women had been in consciousness-raising groups or had read some of the feminist literature that was then flooding the market.

At one point, I asked the men in the studio if they would like to form a separate discussion group; they weren't interested, though they did participate in the Thursday-night sessions. Men's groups were springing up around the country then. But the phenomenon was short-lived, in part because the groups did not have feminist leadership. As a result, the men tended to operate in a traditional, competitive manner and were unable to develop the type of bonds that formed in women's groups, which encouraged self-revelation and emotional intimacy.

Because my next collaborative undertaking, the *Birth Project,* incorporated needlework, it was natural that most of the participants were women. At that moment in history, women were the primary (and most accomplished) stitchers. But even then there were some male volunteers, notably the late, gifted Stephen Hamilton, who designed all the exhibitions as well as the accompanying book. By the time I did the *Holocaust Project,* I was finally able to be myself in the presence of men. This might help to explain why I was able to have Donald as my primary collaborator.

By 1999, when I returned to teaching, I no longer viewed the world exclusively through a gender lens. Previously, I could have been a poster child for bell hooks's contention in *Feminism is for Everybody* that: "many feminist women held to the misguided assumption that gender was the sole factor determining their status."[47] Thanks in part to theorists like hooks, I had come to understand that sexism intersects with gender, race, and class (not to mention culture, ethnicity, and sexual orientation) to shape identity. My thinking was also influenced by my eight years of work on the *Holocaust Project,* which caused me to see women's oppression as part of a larger picture of injustice for many creatures—both human and nonhuman—on our planet.

Furthermore, even though I have enjoyed considerable support from a wide audience of women, there have always been numerous women, particularly in the art world, who have evidenced the most intense hostility towards me. At the same time, over the course of my career, there have been individual men who gave me staunch support. As a result, I came to realize that I had been attributing to gender what was actually a question of values. Not that I became less of a feminist; rather, my perspective gradually

broadened and became more inclusive, which is why I wanted to open my classes to men as well as to explore the larger issue of men in a feminist environment.

In my research for this book, I was surprised to learn that there have been many men who have supported feminism, dating back to the historic 1848 Women's Rights Convention in Seneca Falls, New York, where a series of then-radical demands were drafted. The language and structure of the Declaration of Independence provided a framework for Elizabeth Cady Stanton, the early feminist thinker, and her coauthors. They argued that, as citizens, women should have the right to vote, to own property after they were married, to gain access to higher education, to enter the professions of their choice, to speak publicly, and to retain custody of their children in the event of divorce.

Among the men who both supported and attended the convention was Frederick Douglass, a former slave and an abolitionist and author. That same year he addressed a women's suffrage convention with this statement: "This cause is not altogether and exclusively woman's cause. It is the cause of human brotherhood as well as human sisterhood." He was not alone in attending the meeting in Seneca Falls. Between thirty and forty men were there, a fascinating bit of information that is rarely mentioned. (In fact, in Douglass's biography on Wikipedia, there is no reference whatsoever about his attendance at the convention or about his active support of women's rights.)

This omission is not singular. Michael Kimmel and Thomas Mosmiller tell a revealing story in the preface to their 1992 book *Against the Tide,* a documentary history of men who supported women's struggles for equality. When they told female friends and colleagues about the subject of their book, the responses were often bemused. One woman even commented: "Men who supported feminism. That will surely be the shortest book in history."[48]

Actually, not only were men involved in the suffrage movement, men participated in the struggle to open higher education to women. In fact, several women's colleges—like Vassar and Barnard—were founded by (and named after) men. Another man who supported feminism was Thomas Wentworth Higginson, who is often cited as a mentor of the great American poet Emily Dickinson. What is seldom disclosed is that he was one of the most visible male supporters of the women's rights movement in the nineteenth century, which perhaps sheds some light on his efforts to promote Dickinson's work.

In 1910 Max Eastman, writer and editor of the *The Masses,* a socialist magazine, organized the Men's League for Woman Suffrage. The board was populated with the era's most prominent social activists, such as the philosopher and educational reformer John Dewey and Columbia University economist Charles Beard, who was widely regarded as one of the most influential American historians of the twentieth century.

League activities included organizing men's contingents to march in suffrage parades, mass meetings for suffrage leaders, rallies and suffrage dinners for hundreds of guests, and benefit theatrical performances and balls. It is instructive to note that when the men marched in parades or participated in demonstrations, they were routinely jeered and occasionally assaulted. The most common theme in the public reaction to men's support of feminist causes was the questioning of their masculinity, as if supporting women made them less manly.

In my own life, it is impossible to recount the number of times both women and men have commented on how supportive Donald is of me, usually with the implication that there is something unseemly, even unmanly in his behavior. Rarely has anyone commented upon my support of him, however, probably because this is something that is expected of women.

In 1919, on the eve of the ratification of the Nineteenth Amendment, which granted women the vote (after seventy years of effort), the feminist newspaper *The Suffragist* reported: "It has been said that the suffragists have only themselves to thank for the victory that marks the end of a long struggle, but while the fight has essentially been woman's own, there have been hundreds of men . . . who have so truly understood the aspirations that lay at the bottom of woman's endeavors, that they have stood shoulder to shoulder with her."[49]

And yet, I would wager that few of my readers will be familiar with the history of men's participation in the women's movement. I certainly wasn't. Even Kimmel and Mossmiller were surprised to discover over one thousand documents indicating men's active support for women's rights. The reason for the exclusion of this information from our standard histories is certainly worth pondering. Perhaps it does not serve the cause of male dominance to publicize the many eminent men who have challenged its continuation. An unfortunate consequence of this silence is that men who find themselves uncomfortable with the lack of gender equity in the world are deprived of role models.

I am sure there must be others who wish that these facts were more widely known. Had I been aware of them in the 1970s, though, they would probably not have changed my decision to limit my classes to women. At that time, single-sex courses were a necessity—for both me and my students. But when I went back to teaching, I would have appreciated knowing that my interest in integrating men had a long history. Moreover, I could have shared this information with my male students, including those at the University of North Carolina, Chapel Hill.

There were seventeen graduate art students in that seminar, ranging in age from the early twenties to the late forties. Half of the students were male; this provided the first real opportunity to discover whether my pedagogical methods could be applied to more than the occasional fellow. I was also curious to see what impact their presence would have on class dynamics. As usual, at the initial meeting we started with introductions. Then I asked the students what they wanted from the class. The general consensus was that they hoped to do group critiques. These had been lacking in their previous seminars and as a result, they felt somewhat isolated because they had not had the opportunity to see each other's work, which was important to them.

All of the students had private work spaces, so we discussed the idea of doing studio visits. The semester had just begun, however, and few of them had any new pieces. We therefore decided to learn about each person and their art through slide talks. Because they were graduates, most of them already had bodies of work. Sharing them would hopefully provide enough knowledge about each person's background, intentions, and artistic goals to lead to informed responses once the studio visits started.

Almost as soon as the self-presentations began, the male students began to dominate the discussions—even when the work we were looking at was by one of the women. What happened to my much-touted circle methodology? Wasn't that supposed to prevent this very occurrence? Yes, but this was the first time I had tried to encourage a free-flowing exchange of ideas in a mixed-gender classroom. Going around in a circle ensures that everyone speaks, but it's not always the best way to stimulate spontaneous discourse. At the same time, I was not about to let the men take over.

At a class break, I managed to get a group of the female students alone and told them how distressed I was by the fact that they were not speaking up. I said that if this didn't change, I would have to set up a separate female group, which I really didn't want to do. Fortunately, the situation improved,

though from time to time I still had to specifically call on some of the women (as well as some of the quieter men).

Many weeks were spent looking at slides and building a sense of connection between the students, which gradually led to both increasing honesty and a growing sense of group support. I encouraged my students to be candid in their reactions to each other's work. This is sometimes difficult to do, especially in graduate school. After all, students are in competition for the teacher's attention, grades, and opportunities. Alternately, students can be overly protective of each other (as had happened at Moore), something I also wished to avoid because it doesn't promote artistic growth.

After each person presented his or her work, I encouraged the class to ask questions and to give their personal responses as part of a group critique. Perhaps I should take a moment and explain the place of critiques ("crits," as they are commonly called) in university studio art programs. Undergraduate students take whichever general courses are required along with art, art history, and increasingly, critical studies classes. In these, they are introduced to contemporary art theory, which now plays a major role at many schools.

Once students fulfill the basic core requirements, they begin to focus on the area of art in which they are most interested, such as painting, sculpture, printmaking, photography, or now video, digital, and media arts. By the time students reach graduate school, they are usually involved in creating individual bodies of work, which are then exhibited as part of the requirement for a master's degree. Their production is usually overseen by their graduate committee, which is generally composed of faculty members, but sometimes professors from different departments or even someone outside the university.

Schools also invite working professionals (like me) to do graduate seminars—these almost always involve critiques. At some universities and colleges, a student show is part of the requirement for a degree, in which case ongoing critiques will have been part of the curriculum. Crits are central to art school education. They are done either one-on-one with the professor or in a group setting. Ostensibly, they are intended to provide feedback, advice, and guidance to the students as they develop their work.

But as I mentioned in relation to my visit to Moore College, they often fall far short of the mark. In *Art Critiques: A Guide,* James Elkins points out that "There may be up to five thousand institutions in the world that grant the equivalent of B.F.A., M.F.A., and Ph.D. degrees in the visual arts,

and if each one of those holds just five critiques a semester (and surely the number is much higher) then there are at least fifty thousand critiques each year. And yet there is no standard literature on critiques; nothing about how to run them, what they're supposed to accomplish, what standards they might employ."[50]

Unfortunately, critiques can sometimes be extremely brutal, as was evidenced in the film *Art School Confidential,* which was supposedly based on what occurs at Yale. As Howard Singerman put it in *Art Subjects,* "I cannot . . . let the cruelty of current art training go unremarked . . . cliques of students and sometimes faculty . . . control the local circulation of discourse, wielding it as a weapon. And then there is simple neglect: those students who just are not 'interesting' enough, who do not quite understand the questions being asked or cannot perform the identifications and transferences necessary to install the discipline and its demands at the site of the superego, fall through the cracks of teaching."[51]

Another insightful comment about the way critiques are practiced appeared in the same *Art Journal* issue on studio art education that I cited in Chapter Three. In a satirical essay, the sculptor and art professor Richard Roth described a weekly graduate critique in a highly selective painting program. At this particular crit there were eight students, three male painting faculty, and one visiting female artist from New York. One young woman showed six paintings, figurative work in a variety of styles painted on old movie screens.

At the beginning of the critique, the student was asked if there was anything she would like to say. Her response was that she loved to paint. This inspired one of the professors to state: "Your love of paint comes through loud and clear. . . . I really like the way this cerulean pushes against this fluffy ochre. It's exerting a hell of a lot of pressure. Its absolutely palpable. And this negative space is alive with 'thingness.' There are real honest expressions of paint's special properties (and) that black . . . that black is blue."

Though Roth's article was intended as a parody, as he confirmed in a private correspondence, it drew upon his experiences at a number of art schools in order to describe the sometimes ludicrous tactics designed to avoid talking about art in any real way. The student whose work was being critiqued spoke about her paintings only in terms of their material properties—there was no reference to her intended subject matter. The professor used the occasion of her brief comment to wax eloquent, but without saying anything that might be helpful to her.

Earlier I mentioned that in addition to critiques, visiting artists are a staple of graduate art programs. But the value of these visits can sometimes be dubious. For instance, Singerman recounted Chris Burden's 1976 appearance at Ohio State University, where he performed a piece that "began the moment I arrived at the airport and lasted the entire time I was in Columbus. . . . During the course of the piece, I acted distant and aloof, and had as little interaction with students and faculty as possible. The University had scheduled a particular time in the gallery for what they believed to be the performance. . . . I sat on a chair behind [a] screen. . . . I read the audience descriptions of the pieces I had done in the last six years. . . . The following day I was supposed to have a question-and-answer period with students. But I remained elusive, answering elaborate speculations with a simple 'yes' or 'no.' My intention . . . was to make my personal presence almost superfluous by revealing little or no information about myself that was not already available publicly."[52]

The purpose of these somewhat dismaying examples is to differentiate my approach from what is all too common in many art schools. I would never reject interactions with students if I was a visiting artist (think Moore) and during critiques, I always start out by asking the students about their intentions, their content, and their audience. Generally, I wait until the students are finished to offer my own comments but sometimes I open up a larger dialogue, especially if the content is obtuse or problematic. This was the case with one of the UNC seminar students whose subject matter was exceedingly clear (and offensive) to many of the women. The piece was a full-scale wooden image of a woman tethered to a wall whose lips had been covered with a wooden plate.

Though he had attempted several versions of the mouth, the sculptor explained that he didn't like any of them. Finally, in a pique of frustration, he had smashed it with a hammer. Then, for some reason he couldn't articulate, he felt obliged to cover the evidence of his emotional outburst. He admitted to feeling guilty about the image and wondered if he should have destroyed the entire piece, or at least not shown it.

The discussion of his work soon led to a conversation about the representation of women, which segued into the issue of censorship. The young man told us that a female curator had excluded the piece from an exhibition of his work because she was offended by it. Although I understood and was sympathetic to her negative reaction, I was surprised by my own response. When I was younger, I undoubtedly would have become equally outraged. Instead, as

I explained to the class, I had come to understand that when one makes art, many subconscious impulses come into play. Although some of these might not be "politically correct," they are still part of the human psyche.

Even if aesthetic impulses are chauvinistic or distasteful, I do not believe that it is healthy or appropriate to censor them. What would be preferable is the establishment of a level playing field, which does not now exist. By and large, women have been prohibited from the same range of expression evidenced by this young man's work. It is not that women don't feel subconscious rage at men, it is just that there have been many psychological barriers to its expression.

Although talking about the representation of women and censorship might seem far afield from a critique of student work, it was actually relevant to what the young sculptor was doing. In fact, addressing his work only in terms of form and materials would have given short shrift to his stated concerns. What was important, I told my male student, was for him to recognize the impulses that he had expressed and to try and understand them, if only in order to take responsibility for them. Other viewers were likely to react in ways similar to the curator or my female students.

Subconscious attitudes can only be addressed if they are exposed to the light of consciousness, which can happen if such impulses are translated into visual form. At that point, artists must choose whether they wish to face what their work has revealed and if they want to deal with it or not. This particular class session opened up many avenues of discourse for the rest of the semester about the role of gender in art, the differences between male and female approaches to artmaking, and the need to be sensitive to them.

At one point, we began to discuss the students' intentions as artists. I was quite surprised to hear that most of the students assumed that "all artists are alike." I could not figure out where they had gotten such a wrongheaded notion; different artists have varying aims. Some want to be famous, others want to make enough money to be able to work uninterrupted in their studios (more of a rarity today due to economic pressures, including student loans), still others are content to pursue their work as a sideline, and then there are those who are unclear about their goals. It is this latter group that often gives up making art once they are out of school. What I tried to stress with the class was the importance of clarity, because it is an important component of success.

The issue of their respective intentions led to a conversation about art as a form of communication. My own interest in accessible artmaking dates

back to the early 1970s, when I began to do slide presentations about my work all over the country. I vividly recall one such lecture in North Dakota. At that time, I was working on the *Great Ladies,* a series of abstract paintings of historic women that anticipated *The Dinner Party.* After my talk, I asked the audience their opinion of my work. I was startled when they said that they found the subject matter fascinating, but that without my explanation they would not have understood the pictures.

This exchange had a profound effect on me, and inspired me to make my imagery more understandable. I integrated this approach into my pedagogy, emphasizing the importance of making art *about* something relevant in a way that could be comprehended by the viewers. Although issues of audience response are rarely addressed in graduate school, I feel strongly that artists need to think more about this issue, which is why I raised it in the seminar.

Any discussion of audience inevitably leads back to the question of content, which continued to be a focus of the UNC seminar, probably because it was one of the first times that the students had been asked to address this. During the self-presentations, one student revealed that she had recently gone through the horrific experience of seeing her next-door neighbor murdered by her boyfriend. She spoke about feeling impelled to deal with this trauma, especially after revisiting the experience at the murder trial of the accused. For her, making art was a way of healing and of conveying what had happened in the hopes that it might help others to avoid the same fate. However, from looking at her slides, which revealed a series of murky photographs mounted on large steel panels, it was apparent that no one would never know what her work was about.

I believed that I could help her, not only because I had contended with a great deal of difficult subject matter myself, but because I had worked with so many young women as they struggled to give form to personal pain—their own or others'. I suggested that she write down what had happened in a journal of her choice. She mentioned that she was a bookmaker, so I recommended that she create a book in which to record her memories.

By composing a narrative, she might be able to create some emotional distance from what had clearly been a traumatic experience, thereby establishing the psychic space necessary to make art. If she could start this process, then I would be able to help her formulate imagery that accomplished her intentions. But she would have none of it; instead she became angry at me for "pushing her too far" and started crying. I didn't mind the tears, but

after class she wrote me an accusatory letter, telling me that I "could not begin to know how hurtful and damaging" my questions were. In response, I told her that I had no intention of hurting her; that I was only trying to be helpful.

In hindsight, I admit that I might have overestimated this student's emotional strength. Or maybe she was lacking in two things that are essential in making art: the courage to face one's feelings and the willingness to struggle in the face of rejection, frustration, and hardship and to keep going, no matter how hard it might be. Courage is not something that is customarily asked of women; in fact, quite the contrary. I have often joked that girls should be sent to "courage classes" to help them face the rigors not only of artmaking, but of life.

After many weeks of self-presentations and content-based critiques, the students felt that they were ready for studio visits because they all had new work to share. One of our first visits involved the student who had been trying to deal with the trauma of witnessing the murder. In the intervening time she had begun making a series of scepters, and imagining the rods as bestowing protective power on whoever held them. She indicated that she would have liked to have given one to her neighbor. Although it was clearly a fantasy that such an object could have prevented the tragedy, it was one with aesthetic potential.

By the time we visited her space, she had assembled a group of large sculptured and painted wands. They were somewhat awkward, almost frilly. But there was something about them that reminded me of work I'd seen by other young women, for example, some of the art made in the Fresno program or in *Womanhouse*. They felt authentic, far more authentic, in fact, than the metalwork she had done before.

However, the young woman expressed the fear that they were "too girlie." Apparently, one of her male professors had reinforced this anxiety, and had urged her to abandon the scepters in favor of continuing with the steel plates and photographs. To the class's credit, they challenged his position, insisting that the rods were far more interesting than the earlier work and even encouraging her to "go ahead and be girlie." I was glad to see that our discussions about gender seem to have helped the students realize that it is not always the case that "girlie" is frivolous while more massive objects, like steel plates, are inherently more significant. Unfortunately, despite this positive feedback, the young woman followed her professor's advice and went back to doing the inert photographs on steel, about which I said very little.

Shortly before the end of the term, she said to me, "Oh, you were so easy on me at the last studio critique because you were afraid I would cry again." I tried to jest with her, saying that I couldn't win—first she had chastised me for not being nice enough and now she was telling me that I was too nice. By then, I had realized that she was going to resist any input from me. And she was not the only one. Some of the other female students also seemed resistant to me; I can't entirely explain why. Perhaps they felt intimidated by me, which would have been unfortunate, because I was on their side. Or maybe their resistance can be explained by a dilemma described by many female faculty members—a devaluation of their authority. Particularly with female students who have been brought up to expect women to defer to men and not to be authorities themselves.

Another problem was that, with one or two exceptions, the men's work seemed stronger than most of the women's, at least in terms of its realization and power. In general, the women's work appeared weak, unfocused, and, most important, there was just not enough of it. It was as if its production had taken place in fits and starts. Perhaps this was due to the typical female problem of having to juggle too many responsibilities that end up interfering with focused studio time. Or maybe it's because many women (myself included) are raised with the idea that female power is negative, even threatening. In the 2008 presidential primary campaign, this idea reared its ugly head in some of the cartoons, comments, and statements about Hillary Clinton. The reprehensible "Hillary nutcracker" toy/tool was a rather perfect illustration of the old misogynist saw about strong women being "ball-breakers."

For women of my generation, these attacks were not the least bit funny. In fact, they were deeply offensive, because many of us had faced repeated accusations of being "castrators" when all we were doing was pursuing our respective careers. The popularity of that particular "Hillary" object demonstrates that this prejudice is alive and well. But what does it have to do with art, one might ask? As it turns out, quite a lot. I speak now from my own experience in the studio as well as from my decades of working with women.

During the 1980s, while engaged in the *Birth Project,* I created a fourteen-foot-long sprayed work on fabric titled *Earth Birth,* which was an image fusing the female body with the earth. Its power terrified me; in fact, I couldn't show it to anyone for several days. Finally, I realized that I had internalized the notion that female power was destructive. As a result,

rather than feeling proud of what I had created, I felt ashamed. It seems rather evident that if one is made to feel that one's power is frightening, it can inhibit creativity.

Combine this with the low self-confidence many women have, and it is not difficult to see why some of their art lacks power, scale, and—even more to the point—a sense of authority. Men see evidence of their importance in museums, monuments, and halls of power. As a result, most male artists feel no compunction in extending their ideas into massive scale, whereas many women diminish the potential impact of their work by making it too modest in size. Of course, it just could have been the luck of the draw; perhaps the male students in this particular class were more gifted than their female counterparts. Not that all the women's work was wanting. Toward the end of the semester we viewed an ambitious installation by an exceedingly talented female student.

Earlier, in describing her planned installation, the student had deemed it her adult woman's attempt to provide for her inner child. She even referred to these two sides of her personality by different names and expected others to determine which of them she "was" on any given day—presumably conveyed through her clothes and the way she wore her hair. If anyone addressed her by the "wrong" name, she would burst into tears.

I was sufficiently disturbed by this behavior that I consulted her graduate adviser. He told me that the young woman was like a Method actor in that she became so identified with her work that she couldn't separate herself from the role—an explanation that I did not find entirely satisfactory. It was with some trepidation that I went to this student's studio with the class. As soon as we arrived, she launched into a lengthy explanation about what she was doing, which didn't help the group understand her work as her comments were full of what I call "art-ese."

A couple of examples taken from a typical exhibition's wall text and an art magazine review will convey what I mean. "[The] sculptural works entail uncanny juxtapositions of organic and inorganic materials, growth and decay, and past and present that speak eloquently about Australia's postcolonial legacy and the increasing degenerations of cultural identity." "The literal distance afforded by the aerial position skirts pitfalls of sentiment by endowing the images with a kind of topographical aloofness." Graduate students seem to be particularly prone to this type of language, perhaps because they want to appear more professional than they actually are. The only useful remark uttered by my student was

one that she made rather offhandedly about trying to "create another reality."

The first thing we saw was a child-size table. It was constructed on a crazy angle, with the legs akimbo and the tabletop rakishly skewed, as if it had been tipped over but stopped in midflight. The wooden top was scratched with graffiti-like phrases that seemed to make no sense.

We then walked into a small room that had been constructed inside her studio. On the floor, bisecting the space, were two long lines of piled flour. High up on one wall were a series of large letters that were composed of multiple photographs of a woman, naked save for a white chef's apron. Again, the words were unclear. Except for the photos, which were in color, everything in the room was either white or gray. Beneath the letters, a series of small boxes was mounted to the wall and another set was affixed to the opposite wall. These were intended to be opened, then shut again to hide what was inside: more nonsensical letters and tiny objects suggesting secrets of some kind. An adjoining wall featured a shelf covered with flour and filled with empty wooden frames of various sizes. Painted differing shades of gray, the frames leaned against the wall at odd angles.

A television set was playing a video of the slow, steady sifting of flour. This was accompanied by the low sound of the sifter, which was unceasing and, after awhile, incredibly irritating. There was another series of photographs, some shot close-up, others from farther away. All of these pictures were of my student, her mouth open and caked with flour. Large spoonfuls of flour were being forced into her mouth.

As I looked at the photos of the flour-caked open mouths and the spoons pressing into the flesh of the lips and listened to the endless sound of sifting, my student's words came back to me: "I'm trying to create another reality." Suddenly, I realized what her installation and her behavior were about. She wanted her adult artist side to recreate the reality that she had experienced as a child, a reality of abuse masked by an illusion of normalcy, hence the neutral tones of the room and the objects within it.

The photographs were metaphors for what she had endured, the flour-filled spoons a symbol of whatever had been thrust into her body—be it phallus, fist, finger, or inanimate object. The caked residue on her face symbolized the remains of whatever physical release had been achieved through the violation of her innocence. The endless sifting sound seemed to refer to the way time goes so slowly for children, more slowly than for adults because children have such a short reference span in which to measure the passage of the days.

When a person has lived for twenty years or more, it is easy to conceive of a year as one-twentieth of your life. But for a five- or six-year-old a month is a long time, a year endless. As endless as the unremitting sound of the sifting flour—it just went on and on, which is how her abuse must have felt when she was a child. The photos of flour being forced into her mouth were a brilliant way of expressing the torment that she had endured.

My years of looking at work by women, along with an understanding of women's life experiences, made it possible for me to decipher my student's imagery. Even though it took a little while, I was able to understand the content, which was essential to being able to provide any relevant critique. However, I soon realized that many of the students were not comprehending the work at all—especially the men.

I tried to help them realize what the installation was about and why it was so poignant. As understanding dawned, some of the women began to cry. Several of the male students expressed gratitude that I had been able to aid them in breaking through a state of mind that they described as "not having a clue." The longer we sat in the installation, the more excruciating the experience became for everyone.

A few of the students attempted some critical dialogue, but the installation was so well conceived and executed there seemed little to say. Perhaps the small boxes containing "secrets" did not work so well and it might have been better to pile the flour along the edges of the room rather than in the middle of the floor. Regardless, this piece was far and away the most well-realized and sophisticated of any created during the semester.

Even though the work was initially unintelligible to most of the students, it was not through any lack of clarity. Rather, as I've tried to point out, the students' lack of comprehension was a consequence of the art curriculum, which had not trained them to read content nor provided them with an adequate education about the history of women's art. Consequently, they had no aesthetic framework in which to place the installation nor any understanding of the frequency of sexual abuse as a theme in women's art, especially since the advent of feminist art.

Is it any wonder that this gifted young woman told me that her grad school experience was so disappointing that she planned to repeat an M.F.A. program at another institution, adding that I was the only teacher at UNC who had understood her work?

The high quality of her installation contrasted with the work of one older fellow. During the initial self-presentations, he had shown several

videos whose subject matter was also abuse. All he had said about his childhood was that his father was a violent man who beat his mother. In addition to fearing him, he had internalized the notion that it was unacceptable for a man to express any emotion other than rage—something he'd been struggling with for many years.

Perhaps he had learned his father's lessons too well, because incoherent anger was the only emotion that his work conveyed. Toward the end of the semester, he showed two new videos, both better than the original work but still murky in content and clumsy in terms of visual form. At the end of them, in a torrent of words, he described a childhood full of terror brought about by his bed-wetting, his morbid fear of disclosure, and his consequent isolation from other children. Because he often lost control of his bladder at night, he could not stay over at friends' houses. And he was petrified about what would happen if his father discovered his shameful secret.

When he finally finished talking, I remarked that we had actually seen three pieces—two videos followed by a spontaneous performance—and that the performance was by far the best work. It had an expressive power that was lacking in the videos, which seemed contrived. After a few moments, several of the female students agreed, and then mentioned that they appreciated his honesty but wondered why his videos did not possess the same level of vulnerability.

The male students were uncharacteristically quiet, something that I pointed out by asking if the subject matter had made them uncomfortable. Slowly, with long silences between comments, several of the men began to speak about how they just don't talk about such things among themselves. Several of them stated, "That's what women do." More than one fellow remarked that such openness from another man caused them to remember their own painful childhood experiences—that they had never told anyone about, and were not sure they wanted to, even now.

But why should men feel prohibited from such self-disclosure? According to some of the essays in *Men Speak Out*,[53] from the time boys are very young, they are taught not to cry or express hurt. As bell hooks explains in *All About Love,* "boys must be tough . . . they are learning to mask true feelings. In worst-case scenarios they are learning how not to feel anything ever."[54] And judging by what happened in my seminar class, it seems that when a man does express emotion, other men sometimes use silence to communicate their displeasure, much as the young women at Moore had done. After considerable urging, several men in the class began to offer their

support, saying that even though the video artist's content made them nervous, they recognized that what he had to say was really important—and potentially groundbreaking, at least in art.

This same originality characterized the work that was done by the male students in my next teaching project at Western Kentucky University in Bowling Green, where Donald and I team-taught. *At Home in Kentucky* dealt with the subject of the home and domesticity thirty years after *Womanhouse* but included both women and men. Although I will discuss the project more thoroughly in the next chapter, I want to focus here on what happened with the male students in *At Home,* who constituted about one-third of the class. First of all, rather than inhibiting the self-presentations, the women's candor seemed to give the men permission to be more forthcoming about themselves, as was uniquely evidenced the day after the presentations ended.

Josh Edwards, a sculpture major, took me aside and asked to address the whole group, although he didn't say why. Once everyone was assembled he confessed that he hadn't been entirely honest during his presentation, which had focused on his performances and installations. Most of these had to do with manipulating the audience, a fact that would cast some doubt upon the veracity of what he was about to say.

Josh then announced that, four years earlier, he had been raped by a woman. Needless to say, this statement took me aback. Like many people, I had assumed that women could not rape men. But Josh explained that at the time (he was then eighteen), he was shorter and less developed than his date, who was a gymnast and quite strong. "Alcohol was involved," he said, "a good deal of alcohol." And even though he wasn't explicit, he implied that she had overpowered him. His response was physical. According to him, this made it worse because he felt "betrayed by his body."

He described his attempts to confide in some of his male friends, but they could not accept the idea that a man could be raped by a woman. He had therefore "stuffed his feelings," an action he had previously ascribed to his upbringing. Like many men (including the student in my UNC class), Josh had a father who did not like his sons to express any emotions, and they were not to cry at any cost. Josh had been doing research on the subject of male rape and had come across a small number of men who claimed to have endured this same trauma. Although there is a dearth of research on the subject of male rape by women, rape victims of both genders seem to be affected similarly—they experience anxiety, shame, humiliation, anger, and self-blame.

The students were absolutely mute in the face of Josh's disclosures, perhaps because they were as taken aback as Donald and I. Later, he and I discussed Josh's testimony. Could a woman really rape a man? It seemed impossible, but what if it were true? If we doubted him, we would be acting as indifferently as those people who question women's claims of rape, and that seemed entirely wrong. On the other hand, if he were lying, why would he do such a thing?

Josh's confession presented a quandary. If he was telling the truth, it challenged many dearly held presumptions about gender, particularly the notion of an aggressive male sexuality and the lack of a comparable aggression on the part of women. If rape is a crime of power—as has been persuasively argued many times—then what will stop women from raping once they acquire a level of power equal to that men now possess?

Moreover, if the story *were* true and if Josh decided to deal with it through art, it would be entirely new content akin to what had taken place in *Womanhouse,* when there was an unleashing of radical subject matter that had not yet become part of the art discourse. On the other hand, what if it was a performance piece aimed at manipulating both the students and the teachers? In the

Stefanie Bruser, Joshua Edwards, Katie Grone and Lindsey Lee with assistance of Justin Mutter, *Rape Garage,* 2001. In *At Home: A Kentucky Project*

end we decided that we didn't want to risk invalidating any student's experience, so we chose to support Josh and see what happened. As it turned out, it was a wise decision. Josh worked with three women to create the powerful *Rape Garage,* where his picture and story became part of the imagery. It was probably the first time that such a violation had been documented through art.

New iconography also emerged in the startling *Adolescent Bedroom,* created by Josh in collaboration with two other young men including Galen, a son of the English professor who was instrumental in bringing us to WKU. The room featured an unmade bunk bed, clothing scattered on the floor, and a wall covered by macho posters—these instantly marked it as a boy's space. On opposing walls there were a series of graphite-drawn, life-size male figures locked in mortal combat, which became more robotic in appearance as the battle between them escalated. This fight to the death symbolized a type of murderous sibling rivalry that has rarely been discussed—much less expressed—in art.

The two closets in the room reflected some of the issues with which the three young men were concerned. The first, the *Pro and Con Closet,* was filled with photos from adult magazines, fashion

Joshua Edwards, James Lee and Galen Olmsted, *Adolescent Bedroom,* 2001. In the exhibition *At Home: A Kentucky Project.*

Detail, *Adolescent Bedroom*, 2001

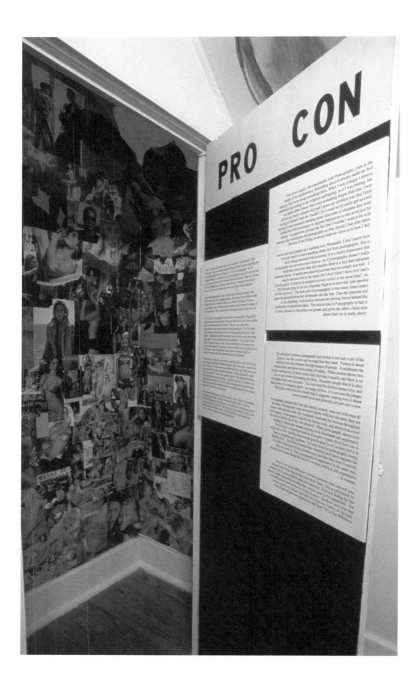

Joshua Edwards, James Lee and Galen
Olmsted, *Debate Closet,* 2001. In *At Home:
A Kentucky Project*

magazines, and art books. These led the eye up to a rather crudely drawn image of an idealized couple making love. Inside the open closet door were text panels presenting the students' varied perspectives on pornography. Josh was completely opposed to it while Galen was somewhat ambivalent and tried to draw a distinction between erotica and pornography.

The third student, James, had been brought up in a fundamentalist Christian family. He had a more positive—and surprising—attitude. Because he had been deprived of any sex education whatsoever, he had turned to porn to learn some basic information about what went on between a heterosexual couple. The idea of pornography as a sex manual was novel and something I'd never contemplated. At the last minute, someone suggested installing a black light, which both fit the ambiance of the small space and helped cover some of its technical flaws.

Joshua Edwards, James Lee and Galen Olmsted, *Off-Limits Closet,* 2001. In *At Home: A Kentucky Project*

The *Off-Limits Closet* was filled with objects that the boys considered to be taboo because of their gender, e.g. lingerie, perfume, makeup, a hula hoop, and a flute (this surprised me because some of the world's greatest flutists are men). The entrance to the closet was sealed off by the type of yellow tape that is usually found at construction sites. As far as I know, the *At Home* project was the first time that men were able to openly express their feelings about domesticity through visual art. Traditionally, male artists have explored this subject by presenting women engaged in a variety of pursuits like sewing or bathing. In addition to providing a new aesthetic outlet, *At Home* opened up several new areas of subject matter: male rape, murderous sibling rivalry, men's conflicting attitudes toward pornography, and gender-appropriate pursuits.

Even though I was glad that my teaching methods seemed effective with male students, their success presented me with a dilemma that I do not know how to resolve. Because women receive neither the same rewards nor the same level of support as their male peers, I feel that I must maintain a focus on the needs of female students. As mentioned, in order to deal with the problems unique to women, it is sometimes necessary to teach them in a segregated environment. This is not ideal if one values inclusiveness. How can I make sure that women students get their needs met while simultaneously running an equitable classroom that addresses the concerns of the men?

Although I do not know the answer, I was encouraged by what happened in the UNC seminar and at WKU. I was also heartened by reading *Men Speak Out.* In its foreword, Jackson Katz admits that the book could not have been written a generation ago. There are now men who are concerned with the ways in which our oppressive, sexist system not only wounds women, but boys and men too. It is this system that bell hooks has labeled the "culture of dominance."

As hooks argues, "Cultures of dominance attack self-esteem, replacing it with a notion that we derive our sense of being from dominion over another."[55] If this system is ever to change, there are many problems that will have to be overcome. Among them is the continued tendency among some feminist professors to reject male students. One of the essays in *Men Speak Out* addresses this very issue. In "Engendering the Classroom: Experiences of a Man in Women's and Gender Studies," Kyle Brilliante chronicles the ways in which he and another male student were made to feel as if they did not belong in women's studies classes, so much so that his col-

league dropped out of not only the class, but of college. Brilliante writes, "By prohibiting men's involvement as women's studies students . . . women in women's studies programs make themselves the only ones knowledgeable and capable of fulfilling feminism's goals in our daily lives. . . . If feminism is a movement that teaches us to identify and end oppression—in all its manifold forms—then feminism is not solely a single-gender interest."[56]

In this inspiring book, men attest to the ways in which feminism has awakened their consciousness and helped them to change. Reading their comments made me hopeful that before too long, there will be more men who will want to enrich their lives, their relationships, and their art with the insights and freedoms that feminism offers. But in order for this to happen, women will have to welcome men into feminist classrooms and men will have to learn new ways of behaving and interacting with women. This transformation might best be summed up by saying that in order for men to walk through the doors of consciousness and into a world of equality, they will have to be willing to leave male dominance behind.

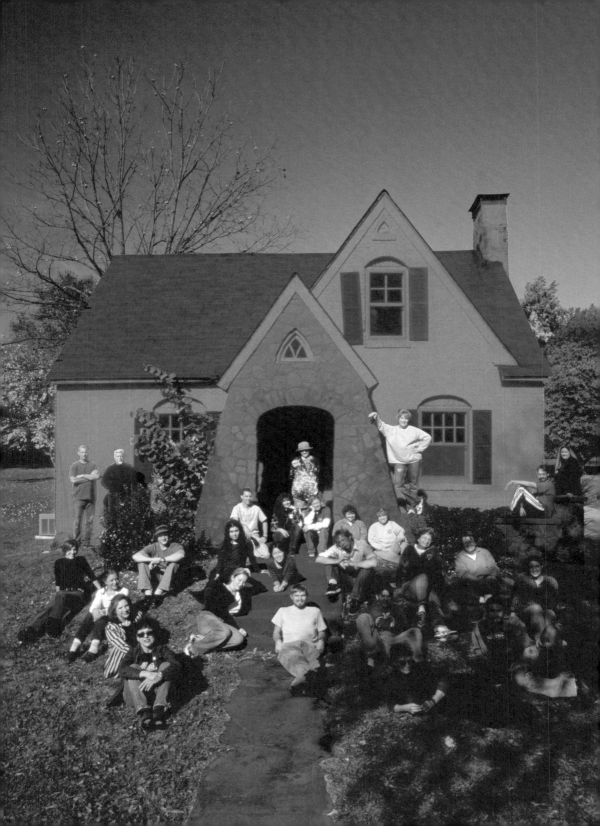

SIX:
SURPRISES

The first two years of my return to teaching had gone amazingly well. The exhibitions at IU–Bloomington and Duke had been enthusiastically received and I had learned that my pedagogical methods were effective with at least some men. Unfortunately, the next two stints—at Western Kentucky University and California State Polytechnic University–Pomona (Cal Poly)—were going to bring some less-gratifying surprises. In 1997, even before I had decided to start teaching again, I had been invited to WKU to present a lecture and conduct two seminars, one with art students and another with a group of young women in the women's studies department.

Given that Bowling Green, Kentucky, is such an out-of-the-way place, I was interested to find that women's studies had an independent endowment that secured its position at the institution and provided the department with its own quarters in a rambling old house. But my visit highlighted a striking lack of development among some of the female students, including those enrolled in women's studies, a fact that I discussed with some of the administration. At one point, a dean asked if I would consider doing a residency there.

Almost two years later, I was contacted by Jane Olmsted, an English professor I'd met during my initial trip to Bowling Green who had subsequently assumed the directorship of the women's studies program. In response to her inquiry, I told her I'd be interested in teaching at the university. She suggested doing a project based on *Womanhouse,* an intriguing proposition because my residency would take place in 2001, the thirtieth anniversary of that installation.

However, *Womanhouse* had grown out of a particular climate in California and I didn't want to impose 1970s attitudes (as liberating as they might have been) on a different time and place. During my previous visit to Bowling Green, I had discovered that people there

At Home participants, *At Home: A Kentucky Project,* 2001

seemed very tied to their roots in Kentucky. The idea of revisiting the subject of "home" seemed both appropriate and appealing, particularly because this time there would be both male and female participants. To top it off, impressed with the photo documentation that Donald had done on my earlier teaching projects, Jane invited him to team-teach with me. She thought he could work with students to document the project for an exhibition and a catalog, both of which would be titled *At Home, A Kentucky Project.*

In an odd coincidence, a few years later British art historian Frances Borzello would publish *At Home: The Domestic Interior in Art,* in which she noted, "Until the 1890s, art history is silent on the subject of the domestic interior. Domestic scenes were relegated to genre painting which was considered to be a second category in terms of the important subjects of history and allegory. By the second half of the 19th century, the home became an important subject for art which allowed women artists like Berthe Morisot and Mary Cassatt to feel 'at home' as it were as painters.... Still, for decades, images of domesticity were suffused with a romanticism that was brought into question by Feminist art, particularly *Womanhouse,* which challenged traditional views of the home as a place of comfort and pleasure . . . presenting the home as the site of oppression rather than a place of nurture."[57]

In mid-August 2001, our entire household relocated to Kentucky for four months. The university had offered us a house to live in and Jane Olmsted had sent photographs of what appeared to be a charming, historic log cabin structure on a grassy knoll. Imagine our chagrin when we drove up to the busy street corner in Bowling Green on which the log cabin was perched, adjacent to several high-rise dormitories. Students were walking across the lawn with impunity—not a good sign for two individuals who prize privacy and quiet.

The interior of the house was dark and the only air conditioner, which was in the cramped bedroom, was on the fritz at a time when it was hot (in the 90s) and humid. An even smaller room had supposedly been outfitted as an office, but given the stifling heat it seemed more like an oven than a comfortable work environment. There was one tiny bathroom—it had a leaky toilet. The thought of us trying to share that little cave-like room was enough to give me a rash, particularly because we would also have to put the cats' litter box in there.

Jane and the students had tried their best, but they had no idea how horrified we were. Our original plan had been to live in the log house and

rent a studio space, but Donald suggested we use the cabin as our studio and live elsewhere. Given Donald's ingenuity, I could see that he might be able to be turn it into a passable work space. Intent on finding an apartment or a house—preferably one with lots of light and a working air conditioner—I began making phone calls.

Finally, a sympathetic woman referred us to someone she thought might have a place. Sure enough, Kandee had a two-bedroom apartment that she would consider renting to us and our bevy of cats, though we would have to pay a nonrefundable "pet fee," which we were glad to do. While we were on our way to check out the apartment, Jane called. She had contacted the provost to make sure we could use the log house as a studio, though I couldn't imagine why she would care.

Apparently she did, insisting that if we didn't want to live in the log cabin, we were on our own. I asked Jane for her number, thinking that I could call and change her mind. Boy, was I wrong. She subjected me to a screaming tirade about how accommodating the university had been to a succession of changes (we had not been informed about most of these) over the two years it had taken Jane to organize our residency. I tried to explain the situation but could barely get a word in edgewise. Finally, the provost said that she would let us know her decision after she had consulted the people "who might be impacted by [our] decision to use the log cabin as a studio." In what way, I had no clue.

This story only begins to suggest the often uneasy relationship between artists and academia. As Howard Singerman points out in *Art Subjects,* since art programs became part of university curricula, there has been an ongoing discussion about whether artists and art can fit into a university structure. As Singerman states, "in the debates over the place of art in college, artists, even if they can and must be liberally educated, cannot be taught, or as it is often less arguably put, they cannot be made."[58] He also quotes the painter Raymond Parker, a recognized painter who received his M.F.A. from the University of Iowa in 1948: "the . . . Master of Fine Arts degree reflects a dilemma . . . since art escapes the formulation of standards and methods"[59] In fact, that's what makes it art.

And it is not only the problem of art fitting into an academic structure, there is also the issue that—like many other artists—Donald and I bristle at the overly bureaucratic nature of universities, not to mention intractable administrators. No matter the historic challenges of integrating art (and artists) into academia, our immediate problem was that we had to find a

place to live and work. Although the provost had not yet provided us with the answer to her inquiry, we decided to move forward with a rental because we wanted to get settled. Kandee's place was in an apartment complex that was amazingly quiet. The compact, two-story townhouse was simple, clean, full of light, air conditioned, and had two bathrooms. We rented it on the spot and went back to the log cabin to get the cats and all our stuff. Jane loaned us a mattress, some bedding, and towels so we were set, at least for the night.

The next morning, Jane informed us that the provost had phoned her. She didn't bother apologizing for her rudeness but she had relented, saying that we could use the log house as a studio if we so desired. But we had already signed a lease. Once Donald got done working his magic on our apartment, it was manageable—though the provost's decision not to lend us any of the log cabin's furnishings that had been purchased for our use meant that we had to spend a considerable amount of money on renting furniture and buying household goods.

In the midst of getting situated, we met Jane at the university-owned house that would be the site for the *At Home* project. When Donald and I first walked in, we could see that she was nervous. Who could blame her after the recent debacle? Fortunately, even though

At Home house. In the exhibition *At Home: A Kentucky Project,* 2001

the house was small, it had considerable charm. And there was a basement, a garage, and spacious grounds so that the participants could spread out if they wanted to. Jane was relieved, especially when we told her what a good job she had done.

On Monday, August 20, classes officially began. Donald and I met with the group at the project house, and we all sat in a large circle on the wooden floor of the empty living room and introduced ourselves. There were twenty-four participants, but only three of them were photo students. We had hoped that Donald would get ten photographers, especially because the university was known for its photojournalism department.

As we soon discovered, though, that department had a rigid program with no room for the type of creative photography that Donald would promote. In fact, they had actively discouraged their students from enrolling. However, it was not only the photo faculty that was uncooperative. John Oakes, a member of the art department, informed us that few of his colleagues supported our residencies; the rest, he said, were "pretending" we weren't there. Jane had insisted that we accept several women's studies students with writing skills. We had agreed reluctantly, thinking that they could help with text for the photo-documentation project and provide some of the essays for the catalog.

Judy Chicago and participants, *At Home: A Kentucky Project*, 2001

Shortly after school began, we discovered that Jane had not been able to secure funding for that publication. Although we were sorry that there would be no permanent written record of the project, we were relieved not to have to produce a book in the four months we would be in Bowling Green, particularly given the limited number of students with photo skills.

The issue of inadequate funding would continue to plague the project. For example, Jane had organized a lecture series about domesticity and the history of the home that was intended to amplify the assigned readings. Unfortunately, because of the hostility of the art and photojournalism departments, few of their students attended. In fact, the turnout for most of the lectures was limited—it was not embarrassing, but it was smaller than one would have hoped given that the series brought some well-known speakers to the campus. Moreover, it was free and open to the public. We would soon realize that another reason for the low turnout was that Jane had overscheduled, underbudgeted, and spread what limited monies she had been able to raise over too wide a spectrum of activities, which meant that there was not much left for advertising.

Although we had been assured that there would be sufficient financing for the project itself (which involved two separate exhibitions, as the photo show was to be held at the university art museum), this turned out to be another area of disappointment. To establish some perspective, consider that in 1971 the budget provided by CalArts for *Womanhouse* was $5,000, which would be equivalent to at least $15,000 today. In contrast, WKU was providing only $3,000. With the lab and materials fees the students were required to pay, our total budget came to $4,500. It hardly seemed like enough to transform an extremely run-down building into a work of art.

For the first month, the participants met as a group four afternoons a week. It took several days to get through the nuts-and-bolts discussions, which included preparing the class for the fact that they would have to supplement the budget with their own funds, find sponsors, or scrounge. In addition to the three photo students and the four from women's studies, there were nine students from fine arts plus eight practicing artists—including John Oakes—most of whom came from the local community. By the end of the first week, we were ready to begin the self-presentations.

Karen, one of the local artists, went first. She had insisted upon doing a PowerPoint presentation and, predictably, the technology failed. This meant that everyone had to crowd around her laptop and squint at the screen—not the most desirable way to view art. Moreover, her work, some

of which resembled Georgia O'Keeffe's, was a smorgasbord of ideas. When I gently pointed the similarity out to her she replied, "Yes, but I'm better than she is." This type of response reveals a problem that sometimes afflicts regional artists—when an artist is connected to the larger world, s/he usually avoids making art that closely resembles the work of more famous artists because it instantly marks one's art as derivative. To claim that such work is superior to the well-known art is not only ludicrous, it is a telling mark of isolation, naïveté, or downright ignorance.

On the bright side, it was clear that many of the participants put a great deal of effort into their presentations. As they continued, they became more personal and more poignant. I cannot remember exactly when the "secrets" began to be told—maybe it was with Alice, an older, returning student. She showed slides of a substantial body of art while recounting a series of terrible personal experiences: incest perpetrated by her father, a brutal gang rape, years of an oppressive marriage marked by sexual service to her husband who repaid her with emotional and physical abuse. Finally, just as the class was getting under way, she divorced him.

The most unsettling aspect of her remarks was the sugarcoated nature of the delivery. The disconnection between the saccharine tone of her voice and her barely disguised anger seemed to parallel the disjuncture between form and content that existed in her art. For example in one piece, a large yellow panel filled with images of various foods, Alice had inscribed the phrase "Kissing won't last but cooking will." Its cheerful tone exuded a happiness that certainly did not exist in her life.

Alice's disclosures seemed to act as a springboard for the rest of the class to divulge ever-more-intimate information. I was surprised at how quickly painful truths were revealed. Perhaps it was the result of having an audience of attentive listeners. Or was it that these disclosures were so harrowing that at the first opportunity to share them, they came pouring out? (I would later joke that in the South, people had secrets whereas in the North, they went to therapy.)

Even though I had sat in many rooms over the years hearing about sexual abuse, I was still shocked by the large percentage of women here who had been violated by fathers, grandfathers, friends, or strangers. In addition, there were accounts of murderous sibling rivalries and marriages ruptured by adultery, along with stories about alcoholism, drugs, depression, and many kinds of dysfunctions. Kevin, an attractive, bisexual young man, told about having been a target for sexual predators of both genders from the time

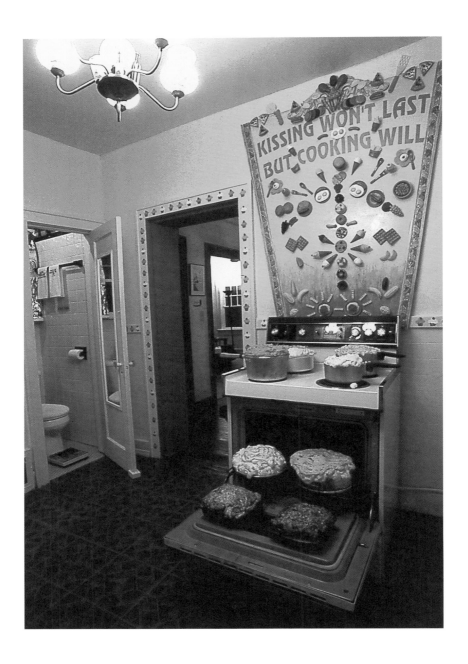

Alice Noel and Nancy Turner with
assistance of Stefanie Bruser and Clay
Smith, detail, *Heart of the Home Kitchen*,
2001. In *At Home: A Kentucky Project*

he was a child. His sexual orientation was unacceptable to his conservative, religious parents. This caused him great anguish, living as he did in a part of the country where home and family remained such a priority.

Holly, a women's studies major, discussed her inability to put into action the feminist theories that she had studied in her classes, which ended up making her feel guilty about her self-described weaknesses. This reminded me of the seeming contradiction between the strong women's studies department at Duke and the actual experiences of many female students there. I cannot imagine that any feminist worth her salt would be happy about feminist theory leading to guilt rather than liberation.

As Daphne Patai and Noretta Koertge noted in the introduction to their 1994 book, *Professing Feminism: Cautionary Tales from the Strange World of Women's Studies,* "As a brave new field that sprang up from grass roots efforts—first motivated by the student movement of the 1960s and later spurred by the example of Black Studies programs—Women's Studies faced many obstacles within the university. . . . This entailed a constant negotiation between feminist ideals (even assuming all feminist faculty agreed about what these were—which was hardly the case) and the pragmatism required to build a program in an academic setting."[60]

Perhaps women's studies, like art programs, were in an uncomfortable position vis-à-vis the university atmosphere in which a scientific-like objectivity is prized. As a result, maybe some women's studies professors overcompensated by distancing themselves from the emotion-driven activist roots of the women's movement. In so doing, they cut themselves off from the lived experiences of their students. Conversely, other women's studies programs seemed to promote an overly nurturing environment—a problem that would present itself later in the semester.

The most excruciating presentation was by a lovely young woman named Katie. She began by confiding that she had never told *anyone* what she was about to reveal. Poor Katie. Her mother was suicidal, her life marked by deep depression that was intensified by her husband's confession about an office affair. Additionally, Katie's sister was not only depressive and suicidal like her mother, but also subject to alcohol and drug abuse. She had always expressed a deep hatred towards Katie, constantly telling her that she wished her dead. Then, shortly after the girl had finally escaped her toxic family home for college, she had been raped by a friend when she visited him in his dorm room. She had never reported the crime because she blamed herself for having gone to his room in the first place.

Later, John Oakes mentioned that Katie had been in his class for two years. With some chagrin, he admitted that he had no idea what state she was really in, adding that "she looked like she really had it all together." And he was right. Her outward appearance gave absolutely no indication that her life was in such disarray. Nonetheless, one of her paintings contained a fairly trenchant (and obvious) visual metaphor—a knife brutally thrust into a voluptuously painted peach, which bore mute but tangible testimony to a deeply hurt girl.

A few weeks after classes had begun, the *At Home* project had to be put on hold because of the terrorist attacks in New York and Washington. We cancelled class on September 11 and 12, but decided to reassemble the next day in order to discuss what had happened. Although everyone was stunned, the group expressed gratitude that we had called them together. When Donald and I were working on the *Holocaust Project,* we had of course grappled with the issue of evil. But for most of our students, especially those who were young and innocent, the concept of organized evil was beyond their comprehension.

As usual we went around the circle, giving everyone a chance to speak. Gradually, the students began to get their bearings and, by the end of the session, everyone agreed that the best thing to do was to get back to work. We still needed to clarify what each person was going to do in terms of artmaking, but there were some tasks that could be done immediately, such as starting to renovate the house, which was in need of considerable repair. Everyone seemed relieved to have a tangible project and the class ended on an upbeat note.

The next day, Donald and I set off for Fort Wayne, Indiana, where *Resolutions: A Stitch in Time* (my last collaborative artmaking project) was scheduled to open at the museum there. Because the airports were shut down, we had to drive. While we were on the road, I called our project assistant to see how the class was doing. She informed me that Jane had paid a visit to the house, bringing cake and ice cream because she thought that the students "needed comforting." Of course, this had completely disrupted the group's focus and work virtually ended for the day. I was furious.

Over the years, there has been considerable criticism of the overly nurturing quality of some women's studies programs. Suddenly, I realized why. To again quote *Professing Feminism:* "In Women's Studies' extreme concern for providing students with a sustaining, nonjudgmental, reassuring atmosphere . . . there lurks a highly problematic view of young women.

Such educational tactics may seem appropriate for children. . . .But to treat university students in this way is to infantilize them . . ." This was precisely why I objected to Jane's actions. Earlier, the authors write, "the whole point of education is to introduce students to new ideas and methods, to expand their horizons, to move beyond what they already know and believe."[61]

I decided to contact Jane and ask why she had chosen to interrupt work in order to bring what I considered false comfort. Over the phone, she reiterated her concern for the students' well-being. Although I understood that she had been well intentioned, this did not mean that what she had done was appropriate. In fact, it had been counterproductive to the efforts we had made to get the students back on track. Moreover, as Patai and Koertge point out, the students were not in grade school, where such treats might have been appropriate. They were adults, and in our opinion, what she had done—to put it bluntly—sucked.

Until then, we had been on pretty good terms with Jane and we certainly appreciated all that she had done to get the project started. But this event signaled the beginning of a downhill slide in terms of our relationship, which I still feel bad about. Nevertheless, it was clear from that moment that we had vastly different ideas about education. She seemed to be from the touchy-feely school, while we were committed to rigorous work. Our aim was to help students understand what was involved in professional art practice.

We also had problems with the women's studies students who, for some unknown reason, announced that rather than doing research or writing (as we had anticipated), they wanted to create art too. Perhaps they saw this as a more glamorous activity. Unfortunately, besides having little talent and no training, these students had never experienced an art critique. As a result, they didn't understand that, as James Elkins puts it in *Art Critiques,* "the point of a critique is that it's an opportunity to put a little distance between yourself and what you have made."[62] Instead, they took personally the aesthetic criticism that was offered, complaining to Jane about how "mean" Donald and I were.

It took many weeks to get the project house in shape. Because it was in a rather sad state of disrepair, a great deal of time had to be spent scraping, rebuilding, and replastering walls, stairs, closets, and crannies—even before the painting could begin. And by this I mean painting walls, not images. While the students were preparing the house, I worked with them either individually or in teams on ideas for each of the rooms.

If several participants were interested in the same theme or area, they collaborated. Otherwise, they worked alone or participated in brainstorming sessions about a particular room or subject, then took the ideas back to their individual spaces. At regular intervals, we would meet to look at drawings, sketches, or models and discuss their progress. Many of the local artists preferred to work alone in their own studios, preparing pieces that would later be transported to the project house and hung. A few of them refused to consult with me along the way, which rendered their work less effective than it might have been.

Meanwhile, Donald worked with the photo students to develop the photo-documentation exhibition. They began to visit the project at odd hours, snapping pictures where and when they could. Not everyone worked at the house at the same times so, on occasion, it was difficult for the photographers to find enough activity to justify the use of much film and they often went away frustrated. But slowly, the house took shape.

On Thursdays, we had mandatory group meetings to discuss the progress of the project—or lack thereof—particularly in the area of research. Everyone had been encouraged to supplement the assigned readings with their own research, but this hadn't happened. When I asked why people seemed so reluctant to spend time at the library exploring, for instance, the history of the home or what previous art had been done on this subject, one student answered that they didn't want their ideas "tainted," that they wanted to be "original." I was dumbfounded, saying that one sure way to guarantee that their work would be either unoriginal or trite was to refuse to discover what aesthetic ground had already been covered or to examine their ideas in light of recent scholarship.

Actually, further discussion made it clear that many of them had very little experience doing research other than by surfing the Internet; some did not even know how to use the library. Our insistence that inquiry was an essential part of artmaking finally prompted some of them to overcome their initial resistance, often with exciting results. Apart from this point of contention, it was interesting to help the students negotiate the allocation of the spaces, which involved navigating between common issues and individual passions. There were certain subjects that everyone agreed had to be dealt with because they reflected the experiences reported by so many of the participants. These included child abuse, sibling rivalry, and rape—subjects that precipitated a number of collaborations. In other instances, participants wanted a specific room or space and would make their case for it.

While the students were at work on their projects, Donald and I began to plan the exhibition details such as signage, announcements, opening festivities, and a poster. Unfortunately, we had another run-in with Jane, this time about the poster, which, despite having no graphics background, she took it upon herself to design. Admittedly, Donald and I have very high professional standards. Jane's design did not meet our criteria, which meant that Donald had to spend almost two days redesigning it. Instead of being grateful, Jane became furious, saying in defense of her design abilities, "after all, we're not bozos." Henceforward, we began referring to Bowling Green as "Bozoville," which somehow made us feel better.

Even more exasperating was that, as the opening drew closer, the students seemed to be slowing down instead of working harder. By Thanksgiving, with only a few weeks left until the opening, the project was still a long way from done. I assumed that the Thanksgiving holiday would allow the students many uninterrupted hours of work, but I was wrong. On Sunday of that weekend, Donald and I stopped by to see how things were going and discovered that there was only one person there.

Panicked, I called John Oakes. He told me that WKU students customarily go into a post-Thanksgiving slump, something that had not happened at either IU or Duke. At both of those schools, teaching had become extremely enjoyable at that point in the semester because the participants had a good head of steam going. I could relax and guide them as they brought their work to a satisfying conclusion. Not so at Western Kentucky; Thanksgiving marked the moment when I had to become part cheerleader ("Go gang, go!"), part coach ("You can do it!"), and part Wicked Witch of the East ("I'll kill you if you don't finish!").

The week before the opening was a frantic time for the students (and for us). Many of them pulled successive all-nighters to make up for the fact that they had waited until the last possible minute to finish their work. Donald was extremely busy with his photo students, helping them put together a professional-looking show that documented each of the participants and the development of the various spaces. Fortunately, he was able to secure the cooperation and partial sponsorship of a local digital lab, resulting in a series of high-quality text and photo panels.

But we had considerable trouble getting assistance from the school's maintenance department for repairs that were too difficult for the students to do on their own (for example, the ceiling over the staircase, which was threatening to collapse). Also, the school put off installing a wheelchair

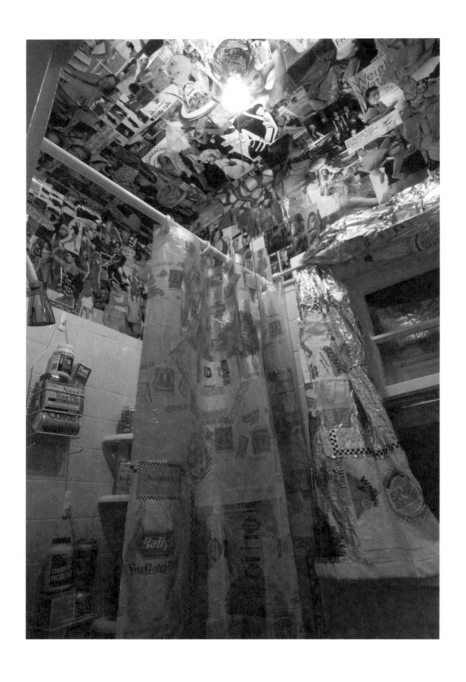

Katie Grone and Lindsey Lee, detail,
Eating Disorder Bathroom, 2001. In
At Home: A Kentucky Project

ramp even though it was federally mandated. And they never did provide an area for parking. As a result, visitors' cars were parked all over the grounds, which looked awful and guaranteed that dirt, mud, and snow would be tracked through the house during the three-month run of the exhibition.

At the beginning of our final week, Donald and I closed down our studios and began packing up our belongings in preparation for leaving on the day after the opening. We went to the project house every afternoon that week and quickly became enmeshed in solving the last-minute problems that inevitably develop. Many of our efforts were directed toward trying to pull together the disparate ideas, colors, textures, surfaces, and varying degrees of skills evident in the house into a coherent whole. Fortunately, the *At Home* project came together, but with barely a moment to lose before the grand opening.

Although I don't like to admit it, generally, the women's work did not add anything original to the body of art about female experiences that has evolved since the early 1970s. However, for many of the viewers, it *was* new. The one exception was the *Eating Disorder Bathroom,* which dealt with an affliction that either didn't exist or wasn't discussed at that time. Decoupaged onto the walls and ceilings were cut-out color advertisements of perfect bodies, both male and female. The shower and window curtains were fashioned out of fast-food wrappers and the bathroom was filled with over-the-counter medicines aimed at producing vomit, diarrhea, and fast weight loss. My favorite component was the *Self-Worth Scale,* an object to which every woman I know could relate (i.e. weigh yourself and feel bad).

As previously mentioned, the most startling work was done by the men, including *Rape Garage* and *Adolescent Bedroom* as well as the *Nightmare Nursery,* an intergenerational collabora-

Katie Grone and Lindsey Lee, *Self-Worth Scale* from *Eating Disorder Bathroom,* 2001. In *At Home: A Kentucky Project*

tion representing the abuse of children created by the aforementioned Kevin and Nancy, an older women who had come from Florida to participate in the project. One entered a small, gabled bedroom that was dark and ominous. Hovering over a child's bed was a huge, painted shadow figure that descended from the ceiling onto the wall. On a rack affixed to another wall hung a series of belts, along with other objects of punishment. Large painted footsteps on the floor moved from doorway to bed, threatening images of impending harm. Scrawled on the walls in a childish script were painful words revealing an abused child's sense of worthlessness. This room seemed to trigger memories and associations from a variety of viewers, including a man who entered the installation and began to sob.

In the basement of the house was the extremely powerful *Prejudice Basement.* Clay, a hardworking and able sculpture student, had disclosed his interest in the basement early on, insisting that he wanted to tackle it alone. The large, dismal space was dirty and unsafe. Clay cleaned it out and rebuilt it, including repairing the ceiling, which was covered with mold. Then he filled the entire space with hundreds of cardboard boxes. He painted the walls and ceiling the same brownish-yellow color to create a unified environment. He even painted the staircase leading into the basement with the same hue, a testament to his attention to detail.

The boxes were arranged so they established a pathway through the basement. They were labeled with their supposed contents, for instance, "Toys," "Christmas Ornaments," and other objects that would typically be stored in such a space. Gradually, these titles gave way to hateful words and phrases that related to four tableaus, each dealing with a different type of prejudice: religion, sexual

Kevin Baker and Nancy Turner, detail, *Nightmare Nursery,* 2001.

Opposite: Details, *Prejudice Basement,* 2001. In *At Home: A Kentucky Project*

orientation, gender, and race. Race occupied the coal cellar, in the farthest reaches of the basement. This was an apt symbol for the way in which racism and slavery were part of the very foundation of the South.

The last and most controversial installation was the *Rape Garage*. In the center of the room was a large wooden platform covered with brutal, sexually explicit materials. On the front of the platform, there were large wooden letters collaged with these same materials, spelling out the word "rape" and implying that pornography created a context in which rape became permissible. Emanating from within the platform and softly filling the room were the voices of rape victims recounting their stories, including Josh, whose personal trauma found a place in the larger framework of the rape of women—of course, the far more common type of crime. On top of the platform was a double mattress, its bedding clumsily pulled aside as if in haste or to hide the evidence of a violent act.

The wall to the left was covered with a pegboard full of tools and sporting goods, objects that one might find in any garage. These were mounted on the board against drawn silhouettes of phallic shapes both large and small, along with the maxim, printed on the pegboard, that "any tool can become a weapon if one knows how to use it," a painful reminder that a penis is not the only instrument that can be employed in the act of rape.

The twenty-foot-long back wall was covered with a myriad of pieces of broken mirror, the work of a painting student named Stefanie. Although she had not been raped, her sister had and Stefanie used her talents to create one of the most compelling pieces in the show. The shards of mirror combined to create a jumbled, shattered surface, an apt metaphor for the broken self-image described by many rape victims.

As the Vanderbilt art historian Vivien Green Fryd later wrote in an unpublished essay on *At Home,* "The *Rape Garage* created a powerful, oppressive space that affected all the senses—sight, hearing, and touch—through the visual images and recorded narratives of rape victims. . . . As one student (from the project) commented: 'These shocking images bring forth the shocking reality of how much of a problem rape is. I was amazed to find so many of the participants who were affected by rape. It had seemed nothing more than a statistic until these brave individuals shared their pain with us.'"

The exhibition openings were structured to begin at the university's museum, where the photo show was hung. Donald and I arrived to discover that the curator had placed white tape over parts of four small

Detail, *Prejudice Basement,* 2001. In *At Home: A Kentucky Project*

images in the *Rape Garage*. She had been after Donald for several days to replace those panels, but he and his students had refused. Instead, they hung them at the back of the show and posted signs warning about explicit sexual materials, which we had also done at the exhibition at the house. The funny part was that the curator had cut the bandages into the specific shapes of the "offending content," which made them all the more noticeable. As we walked through the show, she appeared and I said in a loud voice: "Ah, the art police."

We went upstairs, where the official speeches were to take place. I mentioned what had happened to the university president, whom we only met that day. I also told one of the friendlier deans, indicating that I would be forced to say something about this turn of events in my remarks. He asked me to hold off, scurried away, then returned in a few moments to say that the bandages had been removed. Later that afternoon, the director of the museum apologized, saying that the curator had acted on her own and that she planned to hold a staff meeting the next day to discuss what had happened, a meeting at which Donald and I wished we could have been flies on the wall.

The rest of the afternoon was pleasant enough. Hundreds of people made the shuttle bus trip from the museum to the proj-

Details, *Rape Garage*, 2001. In *At Home: A Kentucky Project*

ect house. Donald spent most of the time at the museum, while I went to the house and interacted with the many visitors, all of whom seemed impressed and moved by the work. After the opening, there was a gathering at a local Mexican restaurant where we and the students, along with their friends and families, ate, drank, celebrated, and unwound after some pretty demanding weeks.

By the time we left, we were more than through with Kentucky—though Kentucky was apparently not through with us. Before long, we received e-mails from four of the students complaining about having received Bs instead of As. Three of these were from the women's studies students and the last was from Galen, Jane Olmsted's son. Needless to say, we were extremely upset when she took it upon herself to overturn these grades. From our point of view, the work of these students was not of the same caliber as the rest of the class. But to Jane, the fact that they had worked hard was sufficient for them to deserve a higher grade, another example of our differing approaches to education.

Then we found out that the museum had dismantled the photo-documentation show early, presumably because of some needed renovations on the space. The exhibits had been widely advertised as being on display until May, so more than likely this was a pretext for getting rid of the "troublesome" images. At one point, we heard that the university had tried to close the house down before the advertised ending date. Apparently, they were only prevented from doing so by petitions and letters from viewers, many of whom asked that *At Home* become a permanent exhibition, something that was never in the realm of possibility. But the viewer response did force the college to let the show run until its scheduled termination, at which point the students took the art they wanted, then burned the rest in a celebratory bonfire around which they reputedly danced.

The university then razed the house. They were stopped from completely disowning the project, though, thanks to John Oakes. He helped it become the subject of a traveling show titled *At Home on Tour*. With the help of his assistant, Andee Rudloff, John created a 1:12 scale model of the house. He continued to work on it after the project was over until it became a complete record of all the installations. In addition to the model, the exhibit included photographs, a PowerPoint presentation, and a video interview with Donald and me.

At Home On Tour was exhibited at several venues, including at Vanderbilt University, which eventually led to our teaching there. John's model

was then included in the exhibition *The Family Experience* at the Florida State University Museum of Fine Arts (where it was used in a teacher training institute). Later, it was shown at Penn State University, where it is now part of my art education archive, which includes extensive files on *At Home*.

The project also lives on in some of the scholarship that it has engendered. Along with Vivien Fryd's writings (both published and unpublished), there have been other published analyses, including an essay by Viki Thompson Wylder (organizer of *The Family Experience* exhibition), in *The Journal of Gender Issues in Art and Education*. According to her: "Under

At Home participant John Oakes

Chicago's tutelage, the artworks produced by students sometimes have long-lasting historical effects. *Womanhouse,* Chicago's pedagogical project on which *At Home* was based, is still being written and talked about.... Just as *Womanhouse* reflected the feminist revolt against patriarchy, patriarchal formalism, and the patriarchal pedagogy of the 1970s, *At Home* reflects the spread of twenty-first century post-modernist feminism, feminist art, and feminist pedagogy, all of which *Womanhouse* helped to create. *At Home* evokes the wider scope of current feminist thinking in which diversity is actively embraced and gender is only one among a list of bases for issues and positions."[63]

Although the *At Home* project should probably be deemed a success in terms of the art that grew out of it, throughout the semester we were in Bowling Green, I kept thinking about something that Myles Brand had said to me before he hired me: that I should only teach at a certain level of institution. His advice was borne out by our experiences in Kentucky. No

matter how enticing a project might seem, if the sponsoring institution cannot provide appropriate administrative support, sufficient financing, and/or a welcoming intellectual and artistic climate, the price of such an undertaking is too high, at least for me. As for Donald, he still talks about having taken up drinking small-batch Kentucky bourbon while we were there because it was the only way to get through the experience.

Unfortunately, only in retrospect have I come to understand the wisdom of Myles's words. After we returned from Bowling Green, I became focused on finding other teaching opportunities, which is why Donald and I pursued another offer that didn't fit Myles's criteria, at least not in terms

Scale model of "At Home." In *At Home: A Kentucky Project,* 2001

of administrative support. This next project involved a public/private partnership that would be supported by Cal Poly and the Pomona Arts Colony, a collection of galleries, nonprofit arts organizations, artists, and institutions in and around downtown Pomona, which lies about forty miles east of Los Angeles in an area dubbed the "Inland Empire."

When we were first invited to visit in early 2002, it appeared to be a thriving arts and crafts scene, thanks to some enterprising business people, especially a charming fellow named Ed Tessier (whose family owned a lot of the downtown property). He had managed to change previously restrictive zoning laws so that once-derelict buildings could be used as studios, shops, and living quarters. As a result many practicing artists, craftspeople, and recent art graduates had settled there, the latter usually after emerging from one of the nearby schools (particularly the Claremont Graduate School). Space was cheap and plentiful, which is something that always attracts artists.

We met with Barbara Way, a dean at Cal Poly, which has a presence in the Pomona Art Colony through their Downtown Center, an arts and education hub. Barbara offered to provide administrative and financial support if we agreed to do a project there. After our experiences in Kentucky, we should probably have been more cautious, but we were seduced by the enthusiasm of the Tessiers, the artists, and especially, a woman named Cheryl Bookout, an artist who lived and worked in the Pomona Art Colony. Besides, we needed the salaries.

At a community meeting we had a stimulating discussion about what might be possible in Pomona given not only the Arts Colony but the many schools in the area. One issue that emerged from this conversation was the residents' concern about retaining the arts-oriented quality of the downtown while also encouraging growth. Because Pomona seemed to be flourishing, it was attracting attention, tourists, and developers. (Some time later, Starbucks opened there, a sure sign of coming gentrification.) By the end of the meeting, Donald and I agreed to spearhead a project, *Envisioning the Future,* which would enable the local participants to "envision" the future that they desired.

A few months after our trip, Cheryl and Barbara came to visit us in Belen. Our California visitors predicted that there would be many people who would want to become involved in the project, both students and local artists. At one point, Barbara suggested that instead of working directly with participants, Donald and I train a team of local artists as facilitators, then supervise them as they worked with the group members. Her goal was to introduce people to my pedagogy with the hope that this would produce a long-term impact on art education in the area. Although we were anxious about how many people we could handle, Barbara promised that Cal Poly would provide the necessary administrative support, assuring us about the efficiency of her staff.

I now realize that we probably should have spent more time thinking about what we were getting ourselves into. Even though I had never worked with more than twenty-five or thirty people at a time in a teaching situation, we agreed to eight groups, each of which would be composed of eight to ten people and have its own facilitator. In addition, there would be an ancillary performance group that would operate independently; we would occasionally visit to see what they were doing and offer input. Even with some attrition there would be more than eighty participants, which meant that during the months of the project we'd have our hands full.

I would handle the painting, sculpture, installation, and mural-making groups while Donald would deal with the artists involved with digital media, video, photography, and photo-documentation. Together, we devised a plan for an intensive week of facilitator training. We made the assumption that providing training for the preparatory stage of the project (introductions, self-presentations, reading discussions, and content search) was all that was necessary. Because the facilitators would be artists, we believed that they would be qualified to provide guidance during the process of making art. This presumption turned out not to be true, and a week of training proved to be woefully inadequate.

Even before any official announcements were posted, news about *Envisioning the Future* seemed to spread like wildfire. We began to refer to it as a snowball, as it just kept getting bigger. Applications came from all over California; there were almost three hundred candidates for the eighty participant slots and nearly thirty requests for the eight facilitator positions (the performance group handled applications on their own).

In selecting facilitators, we tried to choose the best people and to match their skills with the designated groups. In one instance, we had to reject a talented, experienced individual because we couldn't figure out how to incorporate her particular technical expertise. As for the participants, we tried to assemble like-minded people, taking into account each person's talents, abilities, and experience while balancing the number of students with practicing artists.

Among the facilitator applications was that of a woman named Dextra Frankel, an experienced exhibition designer and educator as well as an old friend of mine. As soon as I saw her name, I called her. I was surprised that she had applied; in fact, I was astounded. She had recently retired after many years as the director of the gallery at California State University at Fullerton, where she had put on an amazing array of exhibitions. Although her talents were not a good fit for any of the facilitator roles, we thought it would be an asset to have someone who could organize and oversee the project exhibitions.

Dextra proved invaluable; in fact, I would sometimes refer to her as "our secret weapon" because without her help the exhibits would never have turned out as well as they did. Originally, all the shows were to be in the Pomona Arts Colony, but this changed as additional institutions became involved and the project expanded in scale. As *Envisioning the Future* grew, it became obvious that we needed a coordinator to

handle the logistics, which were becoming more complex as the months went by.

Cheryl immediately volunteered, saying that she was thrilled that the project had taken off the way it had. Barbara offered to have the university pay her salary. Little did we know that she had an ulterior motive. For some reason, she believed that Cheryl could become the director of Cal Poly's Downtown Center while simultaneously acting as project coordinator, promising that even though Cheryl's salary would come from the Center, she could focus most of her energies on *Envisioning the Future* (which proved to be false). Initially, we had planned that Cal Poly's Downtown Center would be the hub of the project, where Cheryl would work, and where the facilitator training would take place. The area outside her office was supposed to be set up as a central clearinghouse for updates about the project for participants and the interested public.

In the fall of 2003, the project officially began with the week of facilitator training, which generally went quite well. One of the male facilitators did not like my circle-based methodology, perhaps because it required a level of intimacy that made him uncomfortable. However, Donald and I insisted that it was an important component of the process. I'm not sure if the fellow actually implemented it in his group. Like earlier teaching projects, there was a structured course of related readings, which the facilitators would oversee, beginning with two weekends of panels and lectures with invited speakers from around the world who were to discuss issues related to the future, including globalization and its potential impact on the arts.

We had planned that Cheryl would sit in on the training sessions to answer questions and become familiar with the group leaders and the process. However, throughout the week, she had to keep excusing herself because of the demands of the Downtown Center. In addition, a great deal of the essential organizational work remained undone. It soon became obvious that because Cheryl was trying to do two jobs; it was impossible for her to keep up with everything. To make a bad situation even worse, Ed Tessier had established a charter school, which began at the same time as the facilitator training. The space for the school wasn't finished, so nearly one hundred students and faculty moved into the Downtown Center. The result was a raucous environment.

At the end of the week, I walked into Cheryl's office, closed the door, and sat down. I basically said our initial plan was unworkable; the Downtown Center was too noisy to be the center of the project. Moreover, unless we

had her full attention as the coordinator, there was no way that *Envisioning the Future* could be accomplished. If this didn't happen, I added, we were going home.

That night Cheryl and her husband, Bob, came over to our place. If Cheryl resigned from the Center, she would have no income, which would of course impact her husband too—that's why we felt obliged to involve him in the discussion. After a long conversation we all agreed that, no matter how difficult the choice, Cheryl had to decide about her priorities. Bob was wonderfully supportive, insisting that his salary would be sufficient for them if Cheryl wanted to devote herself to the project without monetary compensation, which is what she decided to do.

The next hurdle would be telling Barbara. Contrary to my public image, I dislike confrontation; in fact, it terrifies me. Cheryl suffers from the same fear. We knew that, in all likelihood, Barbara would not be pleased by this turn of events. A few days later, Donald, Cheryl, and I met her for lunch at a nearby restaurant. Both Cheryl and I were nervous, Donald less so (guy that he is). Cheryl was determined to tell Barbara that she had decided to resign from the Downtown Center and why. To her credit, she did so. None of us had any idea how Barbara would react. The dean, who was normally an extremely collected person, burst out crying, leaving us stunned. To this day, we don't know what caused this response—she refused to tell us. Instead, she retired to the bathroom until she regained her composure.

When she returned, we tried to explain the many challenges of such a large-scale project. She took our comments as criticism of her staff (who had consistently underperformed). Even if they had been as efficient as promised, given how *Envisioning the Future* had grown (largely due to her insistence), we still needed a full-time coordinator. But she kept insisting that the job could be done in quarter-time, which demonstrated a lack of comprehension about the magnitude of the task. We all left that lunch disquieted, but there was not much to do but move on. Unfortunately, Barbara's resistance would continue throughout the semester, making her almost impossible to work with and difficult to be around.

I wish that I could say that this unfortunate encounter with a university administrator was an anomaly, but it was not. We have faced many times similar challenges that illustrated the uneasy relationship between art and academia. At the beginning of this chapter, I mentioned the ongoing debate about whether studio art belongs on a university campus. In 2009, Stanford University convened a discussion about this very subject. In the subsequent

report that was issued, several comments amplify the sentiment of the quote by Raymond Parker that I cited earlier.

One panelist said that the artistic process involves "getting lost, making mistakes, being out of control" and working at "the edge of risk and danger and error that isn't normally part of the agenda" of a university. Another panelist claimed that academia was "a cancer for creative work." I might add that academia can be a cancer for creative people as well, if our disagreeable interactions at a number of institutions are any indication. Perhaps the entrepreneurial students who leave college to start their own companies have a lot in common with artists like Donald and me, who are accustomed to steering our own ships as it were, beholden only to our creative drives.

By the time of our conflict with Barbara, the first week of school had begun and the project was under way. With Cheryl acting as the full-time coordinator, everything went more smoothly. The facilitators started meeting with their groups and everyone seemed in high spirits. Donald and I had decided to wait a week before starting our regular visits as we wanted to give the teams a chance to bond. Also, we didn't want to undercut the facilitators' authority or make it seem as if we were checking up on them. However, by the second week, we faced a real dilemma.

The installation group wasn't going well. The facilitator was a lovely person but had a limited art background, which had not been apparent from her application. Also, she was foreign-born and had difficulty with English. She tried her best, but she was no match for what turned out to be an extremely unruly group. Before long she left, driven out either by the group's continual arguing or by the needs of a sick mother in Poland; I was never sure which.

Cheryl and I started taking turns meeting with the group, but they resisted all our

Judy Chicago working with painting group. *Envisioning the Future,* Pomona, California, 2003

attempts to move them along. After a few weeks, in a fit of frustration, I told them they were the worst group of the lot and they were driving us crazy. They immediately tried to defend themselves by denying what was obvious— instead of cooperating, they were struggling with one another.

Finally, in an extremely memorable moment, Anna, one of the participants, stood up and screamed (the only way one could be heard above the din): "At what moment of what hour of what day in this project have we not fought?" The question seemed to finally interrupt the bickering long

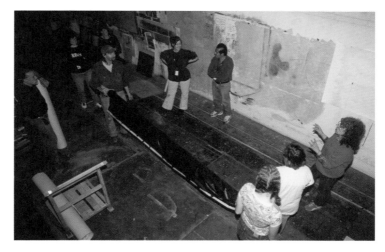

Mural group meeting.
Envisioning the Future,
Pomona, 2003

enough for them to agree that they were getting nowhere fast. Eventually, she offered to take over as facilitator.

Fortunately, Anna was able to establish some measure of control but it took several months. I cannot account for this group's problem; it was like nothing I had ever experienced. Maybe because the original facilitator was not strong enough to establish firm guidelines some strange, negative process took over. Whatever the explanation, to their credit the participants managed to complete the project with a sense of satisfaction that, for quite a while, had seemed entirely out of reach.

Other than the difficulties with the installation team, everything went well for the first month. The facilitators were able to handle the self-presentations, group discussions, and content search. The groups were bonding and everyone seemed engaged. For some reason, the painting and sculpture groups were outstanding, perhaps because both were led by seasoned artists. Due to attrition, the painting group became all women, which seemed to energize its members to produce work that was singularly female

in its subject matter. The sculpture group was a hoot—energetic and eager. Sometimes, though, they got carried away with ideas that they had neither the time nor the resources to realize.

During the facilitator training, there had been many questions about how to do content-based critiques, which I would demonstrate whenever I met with the various teams. However, I didn't realize how difficult these would be for some of the facilitators, perhaps because they are so unlike what usually goes on in studio art programs. Moreover, such critiques do not follow a set process. They require facilitators to recognize or elicit the particular content in which participants are interested, then help them to express it in the most appropriate form. Content-based critiques also demand sensitivity, acuity, and personal engagement. The fact that different facilitators were at varying stages of their own development greatly affected their abilities to move through this next phase.

It was precisely at this point that the mural group derailed. The Tessier family had provided a huge wall on the side of one of their buildings that abutted a public square. Although everyone in the mural group had extensive painting experience, few of them had ever worked on a mural project—certainly not one of this size. But their facilitator was supposedly a pro; Kevin even had a special studio in the Pomona Arts Colony with an immense wall specifically for mural work, which he made available to his group.

For the first month, he did a fabulous job. Whenever I met with the group, it was evident that they were brimming with ideas. So I paid no attention when Kevin asked me not to visit for a few weeks. I accepted his explanation that they were not done with the colored rendering that would guide them when they began painting what was an extremely daunting wall. By the time I did see them again, the group was a mess.

Admittedly, they faced a problem that no other team encountered. The choice of working individually or collaboratively had been up to each group. Though we had hoped that there would be a few more attempts at collaboration, most of the participants had decided to pursue a singular vision. Not so the mural team. They were the only ones to attempt a major collaborative project. Everything was fine as long as everyone was working on their own ideas. It was when they tried to bring their disparate concepts together that Kevin went into some sort of meltdown.

The group's intention was to represent the history of the area. So far so good. Everyone did research and came up with a multiplicity of sketches.

At this point, Kevin needed to use the critique process to help them create a unified image. Despite his years of mural experience, he just couldn't accomplish this. Nor could he bring himself to ask for help, which I certainly would have tried to provide. When I realized what was happening, I advised them to divide up the wall into multiple panels and do individual paintings, a suggestion they rejected, as they were determined to collaborate.

I then offered an alternative, one that drew upon Kevin's extensive mural experience. What if he took all their ideas and sketches and combined them, creating a composite drawing that represented all their views? He could then bring it back to the group for input, making changes until everyone felt satisfied with the design.

I am not going to try and explain why he couldn't do that either; he just couldn't. By the time I met with them again, Kevin had descended into a spiral of self-pity and rage. Prior to this meeting, I had called several of the participants, all of whom expressed frustration. One team member was ready to drop out because she felt that all their efforts (and mine) had come to naught. A common theme in their comments was, "Poor guy." Instead of being inspired by Kevin, they were feeling sorry for him, which was not a good sign.

By this time, we were halfway through the project and Donald and I were feeling as if we'd gotten *way* more than we'd bargained for when we agreed to such a complicated project. Moreover, I am not a muralist and found it hard to provide advice about how to resolve some of the design problems, not to mention the interpersonal dynamics. I decided to call my old friend and well-known muralist Judy Baca for help. Pal that she is, Judy agreed to meet with the group and guide them to a design consensus. Thanks to her, the mural was eventually finished—but at the January opening of the project, it was still far from complete.

As to the four groups under Donald's supervision, the two photography teams did not do well. We had originally planned that one of these teams would chronicle both the development of the project and the finished work. The other team would undertake more creative photography. Both of the facilitators had a range of skills that would have qualified them to lead either group. We decided to let them sort this out themselves, which was a mistake because neither of them wanted to take on the documentation task. We finally combined all the photographers into one group since everyone was doing the same type of work anyway. Then participants started dropping out, though we were not sure why. Obviously, something was wrong but Donald wasn't able to focus on that. Because no one was documenting the

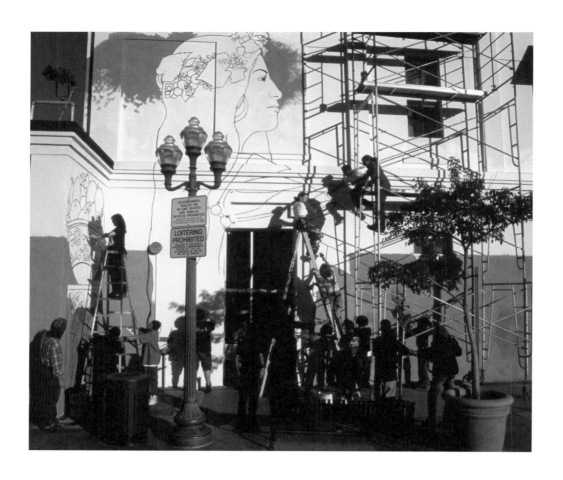

Above: Mural group at work and, opposite above, finished mural, and below, participants. *Envisioning the Future*, Pomona, 2003

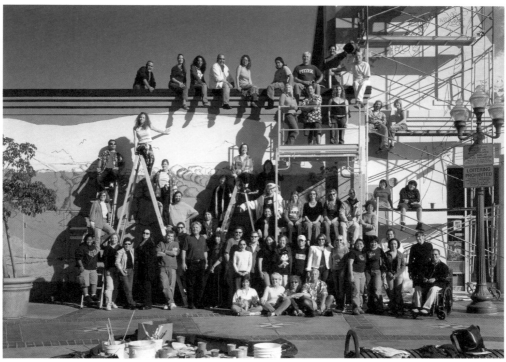

project, he had to take on that responsibility, which added greatly to his workload. Perhaps that distracted him.

At one point the two facilitators sort of teamed up to rebel against Donald's authority. I could not help but wonder if—because of my fame—people more readily deferred to me than to him. Whatever the explanation, the photo groups were the least successful in terms of both process and production. We also made another error, which was allowing the facilitators to choose which pieces from their groups would be exhibited. This wasn't an issue with most of the teams, but the two photo people made some poor selections and as a result their show was one of the weakest.

The other two groups that Donald supervised did much better. The digital media class had far more undergraduate students than the other teams, which included more graduate students and practicing artists. It would have been reasonable to expect the younger people's work to be less sophisticated. But they did very well, probably because they had a really good facilitator who—in contrast to the photographers—accepted Donald's input. The video group's exhibition was outstanding and extremely varied. One of its members, Shirley Harlan, created an ambitious series of individual videos chronicling the processes of each team, which were shown in their respective exhibits. Moreover, even though Shirley was older than most of the participants, her work pace put most of them to shame.

As I mentioned, we had originally planned for all the shows to be held in and around the Pomona Arts Colony. But this changed as the project expanded and ancillary exhibits were initiated. In addition to the multiple exhibitions, there were performances throughout the Inland Valley. It was a good thing that Dextra had taken on the task of coordinating everything because creating a coherent installation plan for so many venues was no small task. Fortunately, she was up to the challenge.

Early in the project, she had begun working with the members of the various groups to help them format their work in relation to the exhibition space where it would be displayed. Few of the students had ever been in a show, so this was an important learning experience for them. And for the practicing artists, working with Dextra exposed them to a higher level of exhibition design than they had ever encountered.

The shows opened in early January 2004. One of our goals had been to facilitate a diverse array of art—a goal that I believe we surpassed. There were a multitude of perspectives, materials, and media along with a wide range of attitudes about the future. They ranged from the humorous to the

apocryphal. Still, we had no idea what type of reactions the work would engender. The private preview was scheduled for a Friday evening. Even before the official opening time, there were visitors waiting outside the doors. At the end of the evening, there had probably been five or six hundred people in the gallery where the preview took place, with buses shuttling people to the other venues. The response was overwhelmingly positive—far more so than any of us would have dreamed.

The next night, I presented a lecture about the project prior to the public opening. Afterward, Donald and I walked around the Pomona Art Colony, which housed a preponderance of the exhibits. We could hardly believe our eyes. There were thousands of people thronging the galleries. It was exceedingly gratifying, especially for Cheryl, Dextra, Donald, and me. As for most of the participants, they were beside themselves with joy.

From what we've heard since then, many lives were changed. Certainly, some really interesting art was made that wouldn't have happened without us. And perhaps some of the facilitators have implemented aspects of our pedagogy, though it's hard to be sure. One nice note is that Wikipedia features an entry about the mural, which now stands as a lasting legacy to an ambitious though somewhat flawed project.

Installation view, painting exhibition. *Envisioning the Future,* Pitzer College, Claremont, California, 2003

Before ending the saga of *Envisioning the Future,* I'd like to discuss our efforts to train facilitators, which required the first effort to codify my teaching methods. This involved having to elucidate processes that I, and then Donald and I, employed rather intuitively. Because I have spent most of my career in my studio and away from academia, I had little occasion to formulate or articulate my theories about teaching. Instead, I developed and modified my approach as I went along.

I also didn't know if other teachers were introducing feminist ideas into the classroom and I was not familiar with the literature on the subject. Given the emphasis that I've always placed on research, this might seem strange. Even now, I am not sure why I never investigated the topic, except that for most of my career, university life seemed very far away. When I returned to teaching I was allowed great freedom. Basically I taught, worked in my studio, and kept myself apart from campus life. As a result, I had neither the motivation nor the intellectual tools with which to explain my pedagogical methods.

Installation view, sculpture exhibition.
Envisioning the Future, Pomona, 2003

Quite coincidentally, in the fall of 2002, when plans for *Envisioning the Future* were well under way, I was visited by Karen Keifer-Boyd, a scholar, art educator, and expert in web-based learning. Karen teaches at Penn State, which is one of the the most advanced institutions in the country in regard to art education (something that I didn't know at the time). She wanted to interview me about my content-based approach and whether I thought my methodology could be replicated in a web-based learning environment. At the time, I authoritatively said no, arguing that my method of teaching necessitated face-to-face contact, a presumption that I later reevaluated.

Karen also wanted to better understand my pedagogy (she was familiar with some of my early teaching projects). When I told her about *Envisioning the Future,* she was intrigued. She had only studied my projects *after* they were done and thought that being involved from the beginning could be useful to her research into feminist art education and my approach in particular. I mentioned Karen's interest to Barbara (when we were still on good terms), who became quite enthusiastic about having her involved. With the support of both Penn State and Cal Poly, Karen was able to make several trips to Pomona, starting with an extended stay in the fall of 2003, when the project began.

Over the course of the semester, Karen gathered a range of research materials through questionnaires, video and audio tapes, and observation (something she is trained to do). She started by making a video record of the facilitators' training sessions and also interviewed some of the participants, whose progress she then followed. Successive visits amplified her research until the end of the project, at which point she did final, follow-up interviews.

All of this information provided sufficient data for her to create the first formal analysis of my pedagogy. Sometime after *Envisioning the Future* was over, she produced a DVD that has been made available through a variety of outlets. Then, in 2007, she published an article about my teaching methods in *Studies in Art Education.*[64] In both the DVD and the essay, she outlined my pedagogical approach, describing its emphasis on facilitating the creation of high-quality, content-based art.

After describing the three stages in my classes—preparation (self-presentations, preliminary readings, and research), process (site preparation if necessary and content search), and artmaking—Karen stated, "Chicago's approach involves guiding participants to identify their concerns and then to deeply research theoretical, empirical, and aesthetic work

related to those issues. This inquiry leads to the content of the artwork in a way that captures and sustains attention (and) is accessible to the public for contemplation . . . the facilitator and participants discuss individual choices of work mode, media, and format; and how to navigate the constraints of time, space, and resources."

In her essay, Karen also emphasized how different my pedagogy was from the ways in which studio art courses are generally taught. As she described it, most art classes involve teacher demonstrations of techniques, faculty critiques about the visual form of each student's work, and an emphasis on color theory and composition with little or no discussion about subject matter. As one of the *Envisioning the Future* participants (who had recently graduated from art school) stated in a personal communication to Karen, "This (project) was very different than anything I've ever experienced before."

Karen also pointed out an important distinction between my classes and those of other feminist educators. Whereas most of them value and draw out personal experience for *personal growth,* I see my role as a teacher in a very different way. As I've tried to make clear, my focus is to help participants transform personal experience into content-based expression in the tangible form of visual art. Thus, the quality of the art is what provides the basis for the evaluation of each individual's performance.

This difference in approach probably helps to explain the collision between Jane Olmsted, Donald, and me in Bowling Green, something that I didn't understand at the time. Perhaps, from Jane's point of view, all of the participants deserved an A because they had undergone significant personal growth, which was true. But we were using a different form of measurement, that is, the quality of their work. And in terms of the art, not all of the students' achievements were equal. Therefore, from our perspective, not everyone was entitled to the same grade.

It would probably have been helpful to have had Karen's analysis *before* we started to train facilitators, as we could have shared her insights with them. As it was, there were many missteps and difficulties in that training process, some of which might have been avoided. All I can say is that we did the best we could.

I wish to end this chapter on a positive note. In 2011, thanks to Karen, my art education archive was deposited at Penn State, where it has become a "living archive," housed in the Special Collections Library, where students

and scholars can study The Judy Chicago Art Education Collection in perpetuity, an unexpected turn of events.

Because Karen specializes in K–12 art education, perhaps those scholars who focus on university-level education will do what Karen did in terms of K–12, that is, analyze my pedagogical methods so that they will be useful to artists teaching studio art, particularly those who want to inform their classrooms with the values that I have attempted to uphold, notably, that all voices are important, and all human experiences can be worthwhile subject matter for art.

SEVEN:
BEYOND THE DIPLOMA

In February 2004, we made a trip to Vanderbilt University in Nashville, Tennessee, which is about an hour from Bowling Green, Kentucky. As previously mentioned, Vanderbilt was hosting the *At Home on Tour* exhibition. I was to present a lecture after the opening. We had been invited to stay at Braeburn, the home of the chancellor, Gordon Gee, and his (now ex) wife, Constance, who holds a doctorate in art education with a specialty in art and public policy.

After the opening and my talk, we went back to Braeburn, where the Gees hosted a dinner for a lively group of guests. Constance, like Peg Brand, had started out studying to be an artist. She confided that my talk made her realize that her university studio art education caused her to lose her own voice. Although she knew *how* to make art, she ended up feeling like she had nothing to say. After ten years of studio practice, she went into art education. But she was frustrated that there was no art education program at Vanderbilt, though she taught a few classes in art and public policy.

The next morning I went to the Braeburn exercise room to work out, where I was joined by Constance. I have no idea what had transpired between Gordon and Constance during the night—perhaps some "pillow talk." But she soon said: "You and Donald should do a project at Vanderbilt." I tell this story because Donald and I are frequently asked how we have managed to be invited to campuses around the country. I'm sure that most people never imagine that such offers sometimes stem from the most mundane situations, like working out next to the chancellor's wife. Without her support, the Vanderbilt project would never have happened.

At Home participants, *At Home: A Kentucky Project,* 2001

In August of 2005 Constance and Vivien Fryd, the art historian, made a trip to Belen. In the intervening months, via phone and e-mail, Constance and I had formulated a plan for Donald and me to do a class like the one I'd done at IU, along with an exhibition. Gordon had asked Vivien to act as liaison between us and the art department which, at that time, included both studio art and art history. With Gordon's endorsement and some university funding, Vivien was already lecturing about *At Home* and was planning to include a chapter about the *Rape Garage* in her as-yet-unpublished book on sexual violence in contemporary art, *Against Our Will: Representations of Sexual Trauma in American Feminist Art 1970–2004.* It made sense for her to become part of the project, offering weekly art history seminars and helping the participants with research.

Constance and I were particularly interested in trying to integrate studio art, art history, and art education more closely. In most university art departments, these are compartmentalized—with art education almost always a dubious third. Our hope was that Vivien would provide the students with a grounding in contemporary art and theory while Constance's expertise as an art educator would benefit the class discussions and critiques. Ironically, our plans were being formulated at a time when the art and art history divisions had been warring in a way that had prompted the university to contemplate putting them into receivership,

Cohen Building. Peabody Campus, Vanderbilt University, Nashville, Tennessee, 2006.

a radical procedure in which the administration takes over a department and reorganizes it. Instead, it had been decided the two departments should be physically separated.

One fortuitous aspect of this situation was that the studio art department was moving into a brand-new building, leaving vacant a wonderful neoclassical structure on the Peabody Campus (originally the site of a women's school that had been absorbed into the university). The somewhat dilapidated Cohen Building was built by McKim, Mead & White, a prominent architectural firm at the turn of the twentieth century. The structure, slated to be empty by the end of 2005, would provide 13,000 square feet of space—enough for large studios and ample exhibition room.

As in previous projects, we wanted to involve practicing artists from outside the university community. Fortuitously, one of Gordon's desires was to build better relations between Vanderbilt and the town, something that many institutions fail to do (hence the perennial "town and gown" problem). The school has an immense presence in Nashville, but at the same time remains somewhat separate from it. Also, the music industry so dominates the airwaves (so to speak) that visual art is often drowned out. When we told Gordon that we wanted to open the project to local artists, he was supportive but wanted there to be an equal number of students, which was fine with us.

In the fall of 2005, a few months after the discussions with Constance and Vivien, Donald and I made another trip to Nashville for a series of meetings as well as a public presentation on the project, which was scheduled to begin in January 2006. By then, Constance had been diagnosed with Ménière's disease, a debilitating condition of the inner ear that would plague her for months. Nevertheless, she mustered enough strength to participate in some of the planning sessions and also to spend some pleasurable time with us. Moreover, she was thinking about becoming a participant in the project as well, though she didn't know if she would have the time given her position as "first lady" of Vanderbilt. I assured her that Peg had been in the same situation and it had worked out fine.

During that trip, we met some of the members of the art department. Vivien had repeatedly told us that the studio art faculty was hostile to our residency, so it was a big surprise when we were effusively greeted by Marilyn Murphy, the acting chair of the department, who presented us with a bag of Southern goodies as a welcome gift. It was only later that we discovered that the antipathy Vivien had described had more to do with the rift between the studio art and art history departments than with us and our project.

In fact, with a few exceptions, the art faculty was extremely helpful, even offering to screen prospective students—a great boon because they knew them. As a result, we got the best group possible, considering that an undergraduate art major had only recently been established. (Like Duke, they didn't have a graduate art program).

To help us find qualified local artists, we turned to a former student of mine who taught at the nearby Watkins College of Art, Design & Film. I had first met Lesley Patterson when she was in my graduate seminar at UNC, after which she relocated to Bowling Green in order to be part of the *At Home* project. Then she moved to Nashville. The artists she recommended were smart, energetic, and savvy about recent art and theory. We ended up with twenty-five participants, half students/half local artists, who were selected from an applicant pool twice that size, plus Constance and Vivien.

Initially, Gordon had suggested that the logistics of the project be handled by his office, but it soon became apparent that this was a bigger job than he'd anticipated. Moreover, Vanderbilt is a large university with a complex administration and we knew almost nothing about its systems. Consequently, we all agreed that we needed a coordinator, preferably someone who knew their way around campus. Like other administrators before him, at first the chancellor did not entirely grasp how complex and challenging our projects can be. He had proposed a half-time position, but Constance managed to convince him that this would not do.

Having heard our complaints about previous institutions, Gordon promised that the university would make our relocation to Nashville as easy as possible. The school rented and furnished a three-bedroom house for us. One bedroom would be used for sleeping and the other two for studio/offices. On the day after Christmas, we set off in our Saab station wagon, which was again packed with six slightly sedated cats in their respective cages. Because we were hauling a large trailer full of work-related materials and equipment, plus enough clothes for four months of winter weather, our progress across the country was rather slow.

By the time we pulled into the driveway on the afternoon of December 28th, we were pretty frazzled. Our spirits rose when we saw the house, a pretty brick structure set on a spacious lot. Jack, a Vanderbilt graduate and the newly hired project coordinator, was waiting for us, along with a woman who worked in the public affairs office. She had been charged with getting everything ready for us but, unfortunately, she had dropped the ball.

There was no furniture in the living room; the lock on the front door was broken, which posed a security issue, particularly given Donald's expensive photo and digital equipment; all the lightbulbs were burned out and there were no spares; the bathrooms lacked shower rods or towel racks; the dishwasher was broken; and there were ants everywhere. Over the next few days, Donald did his best to fix what was broken and to build whatever was necessary so that we could have some degree of comfort.

Although the litany of difficulties we have had with institutions might be irritating to the reader, to omit this information would result in an overly rosy picture of my years in academia. Even teaching at Vanderbilt—

Judy Chicago with participants. *Evoke/Invoke/Provoke,* 2006

as fine an institution as it is—didn't mean that we were insulated from lackluster staff. The challenge has always been to prevent these recurring problems from interfering with the success of the projects, which we've managed to do, though not without considerable stress. Also, we soon discovered that Constance and Gordon were having marital difficulties. As we would spend a good deal of time with them, this made for a somewhat delicate situation.

The project officially began on January 11, 2006, when we all met in the empty Cohen Building. We focused on introductions the first day; the rest of the week was occupied with conversations about project logistics, grading criteria, meeting times, budget restrictions, space preferences, and answering the participants' myriad of questions. The university was providing a modest budget that allowed everyone to have a small amount of money. But we would still have to help the students navigate aesthetic, financial, and time constraints.

On Monday, the self-presentations began; each was supposed to last twenty minutes, but they often went over. Everyone was so eager to share information about themselves and their work that Donald had to continually remind them about their time allotment.

Strangely, many of the participants showed work that was quite different from what they had submitted in their applications. Perhaps, after being accepted, they felt freer to disclose their true interests. There were the usual revelations about sexual abuse, family dysfunction, problems with drugs and/or alcohol, and other personal issues. I hate to sound blasé, but after having facilitated so many self-presentations, these confessions sounded all too familiar. Of course, for the participants, they were shocking.

Both Constance and Vivien sat in on the preliminary group sessions. Vivien expressed amazement at the secrets that came pouring out, which now seems odd given that a few weeks before class began, she had revealed her own private struggle After twenty-five years of marriage, she was getting divorced because—she admitted—she had been unhappy for years. Why she chose the moment the project was starting to finally make her move was a mystery, but the upheaval in her personal life definitely affected her state of mind. Also, she had health problems that were aggravated by the stress of the break-up of her marriage.

Because the self-presentations took longer than we'd anticipated, it was not until the third week that the reading discussions and Vivien's art history seminar began. Her initial lecture was on self-representation, which dovetailed perfectly with the self-presentations and was a great example of the way in which art history could support the artmaking process. But then, gradually, seminar attendance began to taper off. When I asked the students why, they said they were frustrated with the lack of inclusion of women and artists of color and that Vivien didn't allow any class discussion. The students eventually confronted her, after which the situation changed to everyone's benefit. In fact, at the end of the project, she stated that she was going to alter aspects of her approach to teaching based on what she had learned in the seminar.

For some reason, Vivien attended few of the critiques (we never really knew why), which was disappointing. But she did help the students with research, which was beneficial. At the same time, she was disquieted by hearing the participants' descriptions of their technical processes, saying that it was like listening to a foreign language. Vivien's statement would have astounded me had I not recently learned that, these days, many art

historians know little about studio practice. That was one reason Constance and I wanted to integrate studio art and art history. It would seem that knowing something about the practice of making art would greatly enhance an art historian's understanding of the work.

In contrast, Constance seemed comfortable with these conversations, probably because she had started out as an artist. As an educator, she placed the same emphasis that I did on the importance of making art that was accessible to the audience. As Carol Becker, the current dean of Columbia University's School of the Arts, was quoted as saying, "The issue of audience is not raised enough while looking at student work in art school. . . . Educators should guide artists to help viewers through their work's complexity. This is what art students find most difficult to actualize,"[65] which was another reason we had thought Constance's input would be valuable.

As usual, one tedious but essential task involved making our space functional for the group's needs. This required a mass effort to set up the common areas, which included a workshop, communal darkroom, and kitchen. Everyone was generous with their equipment—especially the local artists, many of whom brought tools to share. The need for a darkroom was obvious as a number of the participants were interested in photo-based work. As for the kitchen, since everyone anticipated many late-nighters, there had to be a refrigerator and a place to store and eat the food that would fuel long hours of work.

For a little while, work seemed to stall. Everyone appeared to be avoiding what were admittedly unpleasant tasks: clearing out the remaining debris left by the art department, cleaning the various spaces, and setting up the work areas. Finally, it was done and we moved on to content search. This phase didn't take long because at this point, the participants were eager to start making art.

What went more slowly were the discussions about each person's project because, after the self-presentations, everyone wanted to remain together. We had originally planned to divide the participants into two teams since dealing with so many people at once can be cumbersome, if only because it takes so long to go around the circle. Still, there was definitely a coherence among the group so we decided not to separate them. Studio space selections were negotiated based upon individual aesthetic needs. Although these transactions were sometimes fierce when several participants vied for the same room, eventually all the group members were satisfied. This same intense process also produced the exhibition title, *EVOKE/INVOKE/*

EVOKE
INVOKE
PROVOKE

A
Multi-Media
Project
of
Discovery

Facilitated by
Judy Chicago
&
Donald Woodman

April 21 - May 11
2006

PROVOKE, which seemed to summarize everyone's goals for the show.

Once this stage of the project was over, most of the participants jumped right in while others were somewhat slow to start. Spring break seemed to interrupt some of the momentum, particularly for the students. Before long, though, people were working in the Cohen Building at all hours of the day and night. While Donald and I interacted with participants about their respective installations, Jack helped with the logistics of purchasing supplies, monitoring the budget, and providing support as needed, especially to the younger students. Behind the scenes, Donald and I interacted with various members of the administration to develop signage, press materials, and to plan the opening festivities.

A few weeks prior to the opening, I was working out at Braeburn before a dinner date with Constance. I had always been proud of the fact that, in over thirty-five years of exercising, I had never injured myself in any significant way. This all changed in the course of a few moments. I tripped on the treadmill, heard a loud crack in the back of my knee, and felt an awful pain. I asked Constance to get some ice and to take me to the emergency room. I soon learned that I had torn my hamstring muscle. I ended up with a knee brace and a cane, which definitely slowed me down. The only thing I can say is that if you have to have an accident while exercising, it is a great advantage to do so in the chancellor's private gym; Gordon expedited my trip to the hospital.

Slowly, my leg started healing but it did incapacitate me, which meant that most of the installation coordination fell on Donald and Jack. Fortunately, a number of the participants' spouses, partners, relatives, and friends pitched in to help. During the last few days, the atmo-

Exhibition banner for *Evoke/Invoke/ Provoke,* Vanderbilt University, 2006*t*

sphere at the building was frenetic as everyone tried desperately to make up for lost time. Despite being somewhat handicapped, I went in every afternoon, limping around the building and trying to help solve the inevitable last-minute challenges.

For instance, Michelle, a painter, had worked hard to produce five large images on the subject of toxic female friendships. She varnished them with a product she had never used before and hadn't bothered to test. It was only after she applied the varnish to all the pictures that she realized it was producing a cloudy surface, one that threatened to destroy months of effort. Fortunately, I was able to resolve this problem, as well as most of the other issues that arose.

There was one crisis that was completely beyond my capacities to remedy: Jo Ann, a Korean first-year student, was desperately trying to complete an ambitious series of paintings about interracial relationships that evidenced considerable skill, particularly for an eighteen-year-old girl. She was dating an African-American boy, which posed a problem for her because such relationships are unacceptable in Korean society, or at least in her family. Consequently, she had kept the truth from her parents. A few days before the opening, Jo Ann's mother walked unannounced into her daughter's dorm room and found her daughter with her boyfriend. The mother became irate. A tearful Jo Ann tried to reason with

Jo Ann Lee and friend with the installation of her *Romeo and Juliet Revisited,* 2006. In *Evoke/Invoke/Provoke*

her, admitting that she had not been honest because she was so frightened of her parents' response.

Nothing she said could allay her mother's fury. The woman began to beat her daughter and her boyfriend, who restrained himself from retaliating. The ensuing struggle became so loud that someone in the dorm called the police, who arrested the mother for domestic abuse. The next day, Jo Ann arrived at the Cohen Building completely distraught. Thanks to her boyfriend and supportive project members, she was able to muster enough strength to not only stand up to her parents, but to finish her paintings as well. Sadly, her mother never saw her daughter's work because the judge issued a restraining order that prevented her from visiting the campus. The outcome of this terrible altercation was still unclear when the project ended. Hopefully, the girl was able to continue with her schooling (her mother had threatened to take her out of college), her art, and her relationship as she seemed to genuinely love the boy.

While this example may be extreme, it does show that it's always difficult to anticipate the outcome of such big projects, which have so many variables, including personal problems. Also, some of the people who start out with what appear to be the best ideas don't realize their potential, while others do far better than would have been predicted based upon their portfolios or self-presentations. For example, one student who had initially seemed unimaginative built a wonderful piece in the middle of the workshop. Amid the mess of project leftovers, his clean, white space sparkled with a series of constructions representing the members of his family, all of whom apparently had an overwhelming need to control every facet of their lives—a fact he had divulged during the self-presentations.

One of the most startling installations in the show was by JoEl, a local artist who worked at Vanderbilt in administration. A modest and unassuming woman, she turned out to be remarkable—generous, open, and truly responsive to input. Perhaps because of her receptive attitude, she seemed to truly benefit from the project, and created a work that was far better than anything she had done before. Her piece was a searing exploration of her experience as the victim of a serial rapist that demonstrated how personal anguish can be transformed into a work of art that is painful, powerful, and exquisite. She painted a small room in stark colors—black, red, and white. On the far side was a cross filled with text describing her ordeal. The side walls were covered with panels containing photos and spikes that expressed extreme pain and suffering.

Another series of paintings about sexual abuse was created by a young woman named Kate, who had received a postgraduate scholarship from Vanderbilt that allowed her to spend several months in New York. There, she continued painting the semiabstract landscapes she had begun while still in school. During the self-presentations, Kate confessed to having been raped several times. Although she insisted that therapy had allowed her to move on, her preoccupation with those events was obvious, so I encouraged her to deal with them in her art.

At several points during the semester, I felt unsure that she would make it through what proved to be an exceedingly difficult process. She tended to work late at night, and I would often come into the Cohen Building in the mornings to discover an astonishing (if tortured) new image, such as an isolated female figure in a desolate space. However, by the subsequent afternoon, Kate would have either covered it up or abstracted it. Although this disappointed me, I recognized that—like the woman at IU—Kate had to be the one to decide how much of herself she was ready to expose.

By the end of the semester, she had managed to create an impressive series of paintings. To my mind, though, they would have been much stronger had she followed her original impulses and not obscured the images with abstract forms, as her undergraduate painting teacher—with whom she had continued to consult upon her return from New York—

JoEL Levy Logiudice, installation view, *Releasing the Rage,* 2006. In *Evoke/Invoke/Provoke*

had advised. She had even invited him to the Cohen Building to critique her work. Who knows? Perhaps his advice ran counter to my own, thereby contributing to her decision to conceal her imagery.

There were some terrific videos in the show, including a powerful installation in a downstairs closet by Constance Gee. In the piece, she verbalized her radical political views while wearing a mask as a metaphor for having to conceal her true feelings because of her position as "first lady" at the university.

Upstairs, there was a series of three videos in adjoining spaces. One room was painted gold, to evoke a religious environment. It was devoted to an odd juxtaposition of eating disorders and the Catholic Church, perhaps as a way of suggesting that people were being force-fed Christian dogma. In an adjacent white vestibule, the walls were inscribed with the names of one hundred women who had influenced the male artist.

Kate McSpadden, *Physical Education*, 2006. In *Evoke/Invoke/Provoke*

Inside the tiny room, there were three video monitors showing him performing a series of actions traditionally enacted by women, like cleaning up baby vomit and feces. In order to watch the films, viewers had to kneel at a railing, as if in homage to women's traditional roles. The third installation caused somewhat of a sensation because it dealt with homosexual desire and featured long, loving pans of the artist's body. Unfortunately, the university forced us to put up a warning sign about nudity next to it.

Eric, a talented gay student who had come from the Blair School of Music, filled a large red room with an ambitious sound-and-text installation about AIDS. Photo panels on the wall revealed people's attitudes toward the disease while sound speakers transmitted their personal stories. Although he was demonstrably gifted, he insisted that he had no intention of pursuing either music or art, and preferred to concentrate on making money by going into investment banking.

Clay Carroll, installation view, *[White Space] in Shop,* 2006. In *Evoke/Invoke/Provoke*

A young Indian spoken-word artist did a phenomenal installation in a specially constructed, curtained space. He transformed himself into the Hindu goddess Maa Durga. Using text, movement, and language, he conveyed this goddess's power—she is worshiped as the divine feminine. His gender-bending work, along with that of the other artists of color, demonstrated that my pedagogy could be as effective with them as it had proven to be with Caucasians. Gordon Gee had previously introduced a program to build greater heterogeneity on campus, and this was reflected in the racial diversity of our students; their integration into the group was virtually seamless.

The night before the opening, we held a celebration dinner at a nearby restaurant. It was a wonderful evening full of tears, laughter, and participants' testimonies about the positive impact of the project. The opening itself was spectacular and proved Myles Brand's point about what happens when a sponsoring institution has enough resources to support a project such as ours. The chancellor's office handled the logistics and they did a splendid job, erecting a huge tent outside the Cohen Building for the opening that was replete with abundant food and drink. They also booked a great band. We painted the entry walls of the exhibition with bright colors and the administration filled the space with flowers, which created a festive atmosphere.

The evening began with a private preview during which Gordon, Constance, Vivien, Donald, and I spoke. After that ended, the public opening began. Suddenly, streams of people began to appear and an excited babble filled the previously empty galleries. As the viewers moved around the building, they kept saying that they were "blown away." Even the head of public affairs—with whom we had butted heads during the semester—repeated the word "fabulous" at least ten times.

Gordon seemed overwhelmed by the hundreds of people in attendance and pleased by their positive responses. Later, we shared with him the student's evaluations, which repeatedly stated that they had learned more in the four months with us than they had during the rest of their college life (admittedly, some of the students had rather limited experience). The fact that the exhibition was such a triumph was especially nice for us because the Vanderbilt project marked the termination of our forays into academia.

It might have been the end for me, but for some of the participants it was another step toward life beyond the diploma, a subject I now wish to address. During the opening Fumiko Futamura, a young Japanese

Debangshu Roychoudhury, *Durga Temple: Reclaiming the Legendary Goddess,* 2006. In *Evoke/Invoke/Provoke*

American graduate student in mathematics who had gone to great lengths to get into the class, came up to me asking for advice. Earlier in the semester, Fumiko revealed that her therapist had suggested that she apply to the project because she was very conflicted. She had a strong drive to be an artist, but her parents were concerned that she be able to make a living. They therefore pressured her to pursue mathematics—for which she had an affinity. Her therapist thought that the project might offer her the chance to figure out if she wanted to be a professional artist or if she could be content as a mathematician who did art on the side.

Fumiko had created a series of images that dealt with stereotypes about Asian women. Because she had little or no formal art training, she developed her paintings backward. Normally, one lays in the background first, then large areas of paint, and finally gets to the smaller sections. Instead, she began with meticulous self-portrait heads that seemed to float in the middle of the empty canvases. She then painted in the details, and waited until they were complete to lay in the background color, which was the same hue in each image. In some cases, the ground and the clothing were so close in value that the figures disappeared.

At several points during the semester, I tried to provide some insights about how to improve the drawing of the figures and the color relationships. But Fumiko was not receptive to my input. Because she had constructed the images in reverse order, she had to work almost until

Judy Chicago with participant Fumiko Futamara. *Evoke/Invoke/Provoke,* 2006

Fumiko Futamara, *Self-Portraits as Other People's Preconceptions,* 2006. In *Evoke/ Invoke/Provoke*

the last moment to pull them together. To her credit, they looked great; so great that during the opening she received many positive comments, especially from Asian viewers. There were also several people who offered to purchase her work. Suddenly, her earlier resolve to consign art to the sideline evaporated, because she realized that something she had created could be meaningful to other people.

Flustered by this turn of events, Fumiko asked me whether she should sell her work and, if so, for how much? I tried to help her decide on an appropriate figure, though she wasn't sure she wanted to part with any of the paintings. More important, she wanted to know if she should abandon mathematics. I counseled her to wait to make her decision until the momentary flush of success had passed.

I was never told whether she decided to sell her paintings. Nor am I aware of the outcome of her dilemma, though I do know that she became a mathematics professor. The main point, however, is that, for most of my life, I would have urged Fumiko to pursue her desire to be an artist without heeding the financial consequences, which is what I myself have done. But times have changed considerably since I was a young artist. Tuition was cheap then and when I graduated from art school, I was able to get by on minimal resources and to work long hours in my studio.

That is no longer the case. High tuition fees often make art school a place of privilege. As Steven Henry Madoff noted in the introduction to *Art Schools,* "current and new students . . . are paying fortunes for . . . inadequate art educations and getting into bank-loan debt, which is a huge disservice to them."[66] In addition, the sheer number of graduate students is formidable. According to one source (GradSchools.com), there are 918 graduate programs in art and fine arts in the United States alone. Between 1990 and 1995, there were over 10,000 M.F.A. degrees awarded—a number that is in no danger of diminishing.

Most graduates emerge into an art world that provides very few ways for them to earn a living. This forces many to work at full-time jobs, which leaves little time (or energy) for making art. As the Raqs Media Collective state in *Art School,* "It is not a matter of dispute that a large number of people who train in art academies finally end up as wage workers (with regular or precarious employment) within the continually burgeoning culture industry. When art students graduate from their academies, they usually end up as 'no-collar' workers in the industry by day and as artists by night in their dreams."[67]

Malu Byrne (daughter of musician David Byrne) described the life of her young artist friends in New York in the same vein: "Many of my friends . . . find menial freelance jobs during the year so that they can afford to escape in the summertime to recharge their creativity. They'll use the off time to create artwork they hope to get into galleries, which will sustain them through another winter of menial freelance work."[68] In her article, she also cites Francesca Capone, a writer and textile designer who says that she'll "probably get more done during her two-week term as an artist-in-residence in Haystack Mountain School" (a crafts school in Maine) "than she has accomplished in two years in her Manhattan studio."

In general, unless an artist comes from a wealthy family, there are only two sources of funding other than holding a full-time job. One is the gallery system, which supports but a fraction of the many artists working (or wanting to work) in their profession. As Don Thompson points out in *The $12 Million Stuffed Shark,* at any given time there are thought to be forty thousand artists walking the streets of New York looking for gallery representation (and a comparable number in London).[69] Moreover, he states that "This number actually increases each year as publicity given to the high prices paid for contemporary art attracts more young artists to the profession . . . a gallery may see slides or completed work from a dozen new artists a week, but take on only one or two a year."[70]

Despite the limited gallery opportunities, many university art programs hold out the possibility of art stardom to their students, most of whom have little or no chance of ever attaining such stature—not necessarily through a lack of talent or dedication, just through the law of averages. Nevertheless, like the thousands of young men and women who stream toward Hollywood praying to be discovered at a drugstore counter, many young artists head for New York, Los Angeles, or other international art markets, hoping against hope that they will become rich and famous, presumably within a very short time.

The only other wellspring of support is academia, where the competition is fierce because the quantity of candidates greatly exceeds the limited number of jobs. In a world of shrinking dollars for education, the number of M.F.A. graduates competing for the few university teaching jobs is staggering—as anyone who has attended a College Art Association hiring session can attest. This situation is made even worse by tenure, which ties up positions for decades even when the professors have ceased creating or exhibiting, which is not uncommon.

One unfortunate outcome is that the primary source of personal satisfaction for entrenched faculty becomes not their studios, but teaching. In some instances, the professors fulfill their obligations with grace and generosity. But too often, tenured teaching positions become a vehicle for unbridled egotism, particularly for male professors in undergraduate programs where most of the students are female. Although the situation has definitely improved since the seventies—when professors openly preyed upon their female students—women are still disadvantaged.

As Ann Douglas indicates in "Crashing the Top," "on several significant fronts women are losing ground in the academy, and the more prestigious the institution the greater the discrimination. . . . While more women are qualified for [tenure-track] jobs, a smaller percentage are getting them. . . . More full-time male faculty (72 percent) have tenured jobs now than did in 1975 (64 percent), but the number of tenured full-time women remains the same (46 percent)."[71] This situation is mirrored in the art world. It's lonely at the top—at least for women. In *The $12 Million Stuffed Shark,* Don Thompson discusses a poll he took of art dealers, auction specialists, and other art world experts about the top twenty-five contemporary artists. No women made the list.[72]

The absence of women in the top tier of the art world sends a strong, disempowering message to young women artists. And the small number of tenured female art faculty has significant implications for their education. As I learned at IU, tenured, full professors enjoy an incredible amount of control and can prevent applicants with more enlightened (and less sexist) attitudes from obtaining the few jobs that open up. Even well-intentioned and responsible faculty (both male and female) end up in the classroom when they'd rather be in their studios. But it's hard to reject what the universities provide. In addition to a salary, health care benefits, and a retirement program, there are benefits like studio space and grants—except for adjuncts, which more and more faculty are, especially women. If faculty members really long to be in their studios, it's easy to see how—as Gordon Gee remarked at our first dinner together—they can become bad citizens on their campuses.

At the same time, a university teaching job can be deleterious to one's credibility as an artist. According to the editors of the widely praised book *Draw It with Your Eyes Closed: The Art of the Art Assignment,* "some artists who teach would rather not be publicly identified as such . . . the implication that one isn't selling enough work . . . the diminished cred that comes

with shouldering an academic title, the psychic strain of associating your-self with any institution—all of these would be reason enough to take a paycheck (and maybe health insurance) and keep quiet about your day job. At the same time, while the artist-teacher who excels in the classroom is often stigmatized . . . the figure of the star artist who acquiesces to teach is in some ways respected, or even mythologized, for not doing a very good job."[73] (Think Chris Burden and his visit to Ohio State.) The only other teaching option would be K–12 art classes, which do nothing to fur-ther one's art career and, in fact, contribute to the idea that one is not a serious artist.

Steven Henry Madoff—editor of *Art School* and quoted earlier in refer-ence to the inadequacy of art school education—is an award-winning writer, editor, and poet. Since 2003, he has worked with the Anaphiel Founda-tion in Miami to define the future of art education. As mentioned, when I returned to teaching in 1999, one of my goals was to discover the current state of university studio art education. After crisscrossing the country and visiting numerous universities—both distinguished and mediocre—I have concluded that Madoff is right in his previously quoted evaluation. Most students are not receiving anything close to a sufficient education in studio art.

In Chapter One, I described the transformation wrought at CalArts by Paul Brach, which, as Howard Singerman noted, shifted the emphasis of studio art education from *how* to make art to *what it means to be an art-ist*. Ironically, this was happening—unbeknownst to me—at the same time that Paul's wife, Mimi, and I were pioneering a content-based pedagogy that emphasized skill development in order to express personal subject matter. It is only through writing this book that I have come to understand how diametrically opposed these two approaches are; no wonder I felt so uncomfortable at CalArts.

As one of the premier art institutions in the country, CalArts' influ-ence slowly spread. At the same time, new forms like performance, video, installation, and digital media began to alter the landscape of contempo-rary art. By the late 1990s, art schools had begun to move away from the traditional foundation courses that had dominated studio art education for decades. (Such courses introduced students to the basics of drawing, color, light, and design in two and three dimensions.) Some programs still offer foundation courses in the first two years of undergraduate school. Others provide almost no foundation courses, a tendency that has led students at

some institutions to establish their own drawing classes (leading one to justifiably ask why they are paying tuition).

In most art programs today, as Singerman points out, "manual competence no longer plays a central role in judging works or makers . . . the artist need not demonstrate the traditional manual skills and techniques of representation."[74] If students are no longer learning the fundamental tools of the trade, as it were, what is being emphasized? Currently, studio art curriculum is in great flux, with no agreed-upon approach and little training for teachers. Remarkably, colleges and universities are the only places where art teachers need no background in education (although a few schools have established programs to better prepare graduate students). Often, artists are hired based upon their professional credentials—such as having been in a Whitney biennial—without regard to whether they can teach. No wonder there is a hodgepodge of approaches in studio art classes, including a lot of winging it.

Here are a few examples. The first are excerpts from John Baldessari's list of 109 assignments he gave at CalArts, also quoted in *Draw It with Your Eyes Closed*:

1. Imitate Baldessari in actions and speech.
2. Make up an art game. Structure a set of rules with which to play. A physical game is not necessary; more important are the rules and their structure. Do we in life operate by rules? Does all art?
3. How can we prevent art boredom?
16. Given: $1. What art can you do for that amount?
30. Design and have printed your calling card.
94. Verbally describe a landscape instead of painting one.

John is a gifted teacher who has produced a good number of successful artists, probably because his rather informal curriculum is just a means to an end—in his case, to get students to approach art with a questioning attitude and to understand that any idea can be a pathway to art. But in the hands of a less-talented educator, it is easy to imagine how such an approach might confuse students rather than help them to think outside the box, which is probably John's intent.

At the same time, it seems important to ask whether studio art assignments should be left to individual teachers or if there should be some set of basic guidelines. The absence of these allows for a wide latitude of

approaches, some of which seem altogether lacking in value. There are dozens of examples in the same book, which, as I said, has been widely praised though I have no idea why. For instance, this assignment from Yale, one of the most prestigious graduate art programs in America, strikes me as nonsensical. At each session of a four-week drawing course, there was a setup to work with. The presumed intention of the class was the examination of "subject and meaning" (whatever that means). This is the statement given out by the teacher:

> How does subject differ from content?
> Is subject something that we are responsible for?
> If so, can we be responsible for what time does to subject?
> Is subject what the viewer perceives or what we intend? (This is the only question that seems remotely lucid.)
> Can formal concerns become a subject or is that a conceit?
> Does abstraction have a subject or is it the realist's burden?
> Is it a burden or a gift?

Or consider this drawing assignment from an unnamed school:

> You will need a big piece of paper. Big.
> Make a drawing with
> - no lines
> - no value
> - no shapes
> - no "subject"
> - no narrative
> - no pictorial content whatsoever
> - no symbols
> - no color
> - no collage
> - no spills, drips, etc.
> - no Xerox transfers
> - no design software
> - no street art (no using your paper on pedestrians)
> - no spray paint
> - no a/v equipment
> And especially:

- no use of a stylus (pencil, pen, marker, crayon, basically any kind of drawing tool that comes in stick form)
- no direct hand contact with the drawing

I have been drawing all my life and if I were given such an assignment, my response would be: "You've got to be kidding." As the writer Andrew Bernardini comments in this book about his graduate school experience at CalArts, "The best I could figure out what art school and its assignments teach (and with great success) is not how to be an artist, but how to act like one." If these assignments represent the type of art education (or lack thereof) students are receiving, no wonder so many of them emerge from school stranded and unprepared for a meaningful professional life.

As both Bernardini and Singerman imply, graduates may know how to talk about being an artist, but they are unable to make art; they may have a slick résumé (one type of skill training many students have received) but a mountain of debt; and they might possess a good line of patter but have no way to earn a living, at least not in art.

In the aforementioned publication *Art School,* there is considerable emphasis placed upon the increasing impact of digital media on art school education. Ernesto Pujol writes: "At the dawn of the twenty-first century, American middle-class students now enter art school with . . . tools . . . [that] generate instant information [and] communication . . . and several include image capture . . . the future of art education will be based on the notion of universal immediate access."[75]

In this same book, the prominent architect Charles Renfro contends that "The art school for the twenty-first century will operate on an entirely different playing field from previous generations of art academies. . . . How will the school address issues of technological innovation that will inevitably shift artistic practice even more?" Renfro also argues that "Art practices of the late twentieth and early twenty-first centuries have challenged the very notion of the studio. While the artist working solitarily within a single discipline persists, it is becoming just as common for artists to use an array of traditional media . . . [in fact] many artists outsource their production."[76] Although I find any artmaking means to be valid, outsourcing has allowed some artists to avoid altogether the slow and sometimes tedious process of acquiring technical skills.

For instance, a recent article about a young artist quotes him as rejecting the importance of having any visual skills "so as not to be bothered."

Instead, he "outsources" his paintings to India, where they are executed for him. He did not mention whether he sent drawings or studies—probably not since he admitted to having no skills—or simply described what he wanted. I suppose that in the short run, this could be an efficient strategy if one views art as simple production.

But for me, art is about discovery. In my opinion, there is no substitute for the long, silent hours spent in the studio, struggling to give form to your ideas with whatever technique is best suited for the job. However, if you can't use a pencil to draw, a tool to sculpt, a chisel to carve, or a video camera to film because you don't have the ability, there is no way that you can even start down the joyful path of discovery that art can be.

Certainly, the significance of new media has to be recognized and integrated into studio art education. Moreover, the advent of online education requires rethinking the delivery of information, as well as the space and form of education. But does the importance of new technology really justify throwing out traditional skill training? As an artist who has worked in a variety of media—including video, installation, and photography (all popular modes)—the fact that I had a traditional art training has served me well in whatever method I chose. Conceiving and realizing an image is the same process no matter what media you select; you start with an idea, decide how best to communicate it, then struggle to translate your intentions into visual form, often making changes as you go along. As a result, the finished work may be far different and (perhaps) better than the original concept.

Additionally, as the architect Michael Graves pointed out in a *New York Times* op-ed piece, there is no substitute for drawing by hand: "Drawings are not just end products; they are part of the thought process. . . . Drawings express the interaction of our minds, eyes and hands . . . there is a certain joy in their creation, which comes from the interaction between the mind and the hand . . . drawing by hand stimulates the imagination and allows us to speculate about ideas, a good sign we're truly alive."[77]

I have referenced both CalArts and Yale, which are considered among the top art schools in America. Students there do have some definite advantages because their reputations can provide an entrée into the gallery scene. Also, they attract collectors who visit student shows in an effort to pick a potentially successful artist, sort of like betting on a winning horse. Often, the glamour that surrounds the art world masks the realities of how it operates. To many people, the art community is exceedingly opaque—and even

to many of those involved in it and certainly to most art school graduates and young artists trying to make their way professionally.

To again quote Don Thompson, "The art trade is the least transparent and least regulated major commercial activity in the world."[78] His book marks one of the first efforts to penetrate the labyrinthian ways of this world, a world in which appearances are paramount. As a result, there is a great deal of dishonesty; for instance, artists can claim to have sold out their shows even while their apparent financial ease is actually the result of a generous trust fund, and dealers can insist that they've just enjoyed their greatest year ever despite a severe economic downturn.

This lack of transparency often results in unrealistic expectations, especially for young artists. Over the years, Donald and I have had many youthful visitors, most of whom express shock upon entering our art storage facility. I cannot count the number of times these young people have said confidently, "Oh, I'm going to sell *all* my work, so I won't need art storage." I then point out that the incredibly successful Andy Warhol left 100,000 unsold pieces when he died. If he had so much work remaining, what chance do most other artists have of selling even a portion of their production?

This story is just one example of the gulf between appearances and reality in the art world, an abyss that is often difficult for outsiders to comprehend because it does not operate according to any known business model. Even though only a tiny percentage of young artists will succeed, the art community promises untold riches, in part because it has become increasingly market-driven, as is evidenced by the dizzying prices on the auction block.

However, these high prices often mask quite a different reality for some of the artists upon whom the market depends. According to Thompson, the renowned twentieth-century British painter Francis Bacon was paid roughly $10,000 a year by his gallery (one of the most prestigious in the world) during the last decade of his life, even while his auction prices were escalating into the multimillions. (Apparently, Bacon didn't care much about money, but that is beside the point.)

Most people do not appreciate the crucial importance of art in defining who we are as a culture. When a society succumbs to the collapse that all known civilizations have eventually experienced, it is the art objects that remain to convey the nature of that culture. As the *New York Times* art critic Holland Cotter observed, "Art is about power. . . . The power to say 'mine'; the power to control and manipulate images and ideas . . . the power to

claim the touchstone authority of the past. . . . All museums are purveyors of ideology."[79] Although Cotter was writing about Chinese art, his statements are equally true for most of the art in our museums.

In 2009, Cotter discussed the state of the art market in the face of the recession, saying, "Every year art schools across the country spit out thousands of groomed-for success graduates, whose job is to supply galleries and auction houses with desirable retail. They are backed up by cadres of public relations specialists—otherwise known as critics, curators, editors, publishers and career theorists—who provide timely updates on what desirable means. . . . The present goal of studio programs (and of ever more specialized art history programs) seems to be to narrow talent to a sharp point that it can push its way aggressively into the competitive arena. . . . Will contemporary art continue to be, as it is now, a fancyish Fortunoff's, a party supply shop for the Love Boat crew? Or will artists—and teachers and critics—jump ship . . . carving out a place . . . where imagining the unknown and the unknowable—impossible to buy or sell—is the primary enterprise[?]"[80]

But this is easier said than done. Increasingly, art schools act as a feeding system for the international art market. As artist, curator, and educator Ute Meta Bauer stated in *Art School*, "The pressure is on the art schools and programs to connect early with the art market and generate a smooth entry into the system while young artists are still under the school's umbrella. That is a major shift from even a decade ago. . . . With the globalization of the market, the boom in biennials and art fairs around the world, and the rapid expansion of a new generation of collectors, the chance to catch a ride on the art carousel has increased enormously."[81]

When I was a young artist in Los Angeles, there was almost no market for contemporary art, at least not in Southern California. Therefore, it was easy to "imagine the unknown and the unknowable," as Cotter put it. But this has changed dramatically with the advent of the international art market and its insatiable appetite for the next hot thing. The art world picks up, extols, rewards, and then discards young artists like so many used clothes, an unfortunate tendency because careers disintegrate before the artists have the opportunity to mature.

As fast as the ride can be, tumbling off the carousel can be equally swift. Bauer notes: "Today it feels as if the art market has replaced the music industry, with its annual top-of-the-pops and one-hit wonders . . . the market embraces each new spot that pops up on the global market. . . . Yesterday it

was China, today it is India, and tomorrow Dubai and the Gulf. Who knows what it will be a year of two from now? . . . art has . . . become a huge operating machine in need of skilled and 'educated' labor" (i.e. young artists) . . . who are . . . increasingly shaped, if not dictated, by the allure of success in the market."[82]

Of course, this state of affairs is not limited to the West. An article published in the *New York Times* by David Barboza (who is based in Shanghai) described Chinese art schools, like Beijing's state-run Central Academy of Fine Arts, as having "been transformed into a breeding ground for hot young artists and designers who are quickly snapped up by dealers in Beijing and Shanghai. . . . And with the booming market for contemporary Chinese art . . . students are suddenly so popular that collectors frequently show up on campus in search of the next art superstar."[83]

Surprisingly, one person lamenting this state of affairs was a Chinese art dealer who could be expected to benefit from this situation. Instead, he complained: "This can be a dangerous thing . . . young artists need time to develop."[84] Even some successful artists like Chi Peng expressed concern about his meteoric rise to stardom: "It's fast, really fast. I never could have imagined this, and I'm not sure it's a good thing for me."[85] Far be it from me to begrudge artists whatever success they can find. At the same time, Chi Peng has cause to worry.

Over the years, there have been countless young artists who've been picked up by a savvy curator or critic and made to shine in one of the (too many) biennials and art fairs only to disappear into the ether, never to be heard from again. As Steven Henry Madoff observes, "the dominance of the marketplace holds the power to determine the course of artistic production—and does so with impunity to the judgments of the critical press and with curators often walking in lockstep with the most powerful collectors and art dealers."[86]

If someone does become an overnight sensation, standing in the spotlight can be difficult. I had my own experience with *The Dinner Party,* which opened at the San Francisco Museum of Modern Art when I was not yet forty. The ensuing attention and controversy caused Henry Hopkins, the museum's director, to state that I had attained the "culmination of my career." "What are you talking about?" I naively asked, "I'm only getting started." Even though I went on to create three other major projects and countless singular works of art, for a long time *The Dinner Party* blocked all these from view. Finally, now that I am in my seventies, some of this other

work is being recognized. But my popular success was not accompanied by financial reward, so I was never tempted to keep churning out work because it would sell.

This is not the case for many artists. Too often, creating art that becomes instantly successful and remunerative makes it difficult to take the risks that are essential to grow as an artist, especially if it means not being financially rewarded for that next body of work. As I've said before, when I was young money was not my focus; it was making and showing art that was paramount. Sales were secondary. What was important was to keep creating art in the hope that—like Matisse and his paper cutouts—I would be producing the best work at the end of my life.

I often receive requests for advice from young artists. The best response I can imagine is Fred Wilson's eloquent answer in *Art School:* "I think M.F.A. programs should resist the art world. Already legions of young artists come to New York to 'make it.' . . . Fresh from graduate school, they come armed with a rap about their art. Their art is finite. It is ready to be consumed. The idea that this is the beginning of a life-long journey into the mysteries of making things seems to be a back-burner thought, if it is thought at all. They view getting into a gallery as the moment when they can truly be creative because 'they will be taken care of.' How unfortunate. How wrong. Why would graduate schools want to encourage this line of thinking? Many young artists seem to want 'success' so much that they confuse financial success with artistic success. . . . They yearn to be somebody, and somebody important. Maybe 'somebody important' means 'famous,' maybe it means 'powerful,' or maybe it just means 'rich.' But being a nobody has its benefits. You can decide what you think about things, realize what is important to you, develop your own way of seeing things and then your own way of creating things. And with that, you are truly in control of your destiny."[87] My sentiments exactly.

Regarding the role of art galleries: at one time, they did feel a responsibility to the artists they represented and usually made a long-term commitment to them. This is no longer the case. More and more, if one has a show and there are few sales, the gallery loses interest. Moreover, some galleries now expect artists to bring clients to them and even ask young artists to foot a lot of the bills for their exhibitions. From personal experience, I can say that almost all galleries are disappointments.

Nonetheless, even mature artists often have unrealistic expectations. For example, Donald and I knew one guy in Santa Fe who had his eyes set

on a particular gallery, which he finally managed to get into. He worked really hard on his show, in the process spending more money than he could afford. When he sold next to nothing, he was shocked and in debt because he had convinced himself that getting into that gallery meant that success was assured.

So what is an artist to do? First and foremost, you must be entrepreneurial and take charge of your own career. Also, instead of competing for the small number of rewards available in the current art system, artists might consider joining forces to combat an art system that is bad for art and toxic for artists. In my own case, I had no choice; the hostile reception of *The Dinner Party* forced me to make my own opportunities and find my own sources of support, largely outside the art world. This was well before Kickstarter, so I often raised money in small donations from people who believed in my work and didn't pay attention to the opinions of art critics. And as I often say when asked how I have funded my projects: if you can't raise money, you can't make art.

I might be accused of being old-fashioned in agreeing with Ernesto Pujol when he says: "Artistic success should be about continuing to grow and produce, constructively critiquing and regenerating, because no one should be blindly tied to tools that become obsolete, to mediums that cease to be relevant to people's lives, to theories that no longer explain who we have become as a people, both mirroring the culture and providing alternatives for the culture."[88]

But in order to attain this type of artistic success, you must believe in yourself no matter the obstacles. I recently had an experience that demonstrated this. In 2011, the Getty-funded initiative *Pacific Standard Time* brought together almost every institution in Southern California to document and celebrate art in the region from 1945–1960. I have already described the difficult times I had during the twenty years I was living in Los Angeles—so difficult that my early work was in storage for over four decades.

In preparation for the many shows I was in, I looked through that collection—including some unfinished car hoods with images that my male professors at UCLA had hated—which I decided to finally complete. When these were exhibited, people were astounded. Clearly, there had never been anything wrong with that work in the first place; I should have believed in myself instead of obscuring my imagery, hiding it away, or destroying the art.

I recognize that it can be extremely difficult to stand up to hostility, rejection, and misunderstanding, all of which I have experienced. Being an artist is a difficult life path but if that is what you want to be, it is best to be armed with the truth about the art world, which is what I have attempted to convey in these pages and in my teaching. And if you hang in there, you never know what might happen. For the *Pacific Standard Time* "Performance Festival," I re-created (with Donald) several early performance/installation pieces involving fireworks and dry ice. For the *Sublime Environment,* which involved over twenty-five tons of dry ice, we worked with an organization called Materials & Applications, which assembled a large group of volunteers.

At one of my subsequent L.A. gallery openings, I ran into some of the young women artists from that project. They asked me to 'adopt them,' which I thought charming. Because I was so prominent in *Pacific Standard Time,* they saw me as a successful female role model, one who had forged her own path and survived in the face of innumerable obstacles. By the way, one of them—referring to her graduate experience at a Los Angeles university—said that it was a "joke." All the more reason for me to publish this book in the hopes that my story and insights can help open new avenues for young artists. And to provide what I would consider the most important advice: *believe in yourself and don't give up.*

"The classroom, with all its limitations remains a location of possibility. In that field of possibility, we have the opportunity to labor for freedom, to demand of ourselves and our comrades an openness of mind and heart that allows us to face reality even as we collectively imagine ways to move beyond boundaries, to transgress. This is education as the practice of freedom."

EIGHT:
SO WHAT'S THE ANSWER?

Earlier, I mentioned that throughout my career, I have raised money for my work primarily through private donations. In order to complete *The Dinner Party,* I created Through the Flower, a small, nonprofit arts organization whose mission is to ensure that women's achievements become a permanent part of our cultural history. The organization provided a fiscal structure for contributions and administrative support for my collaborative projects; it also handled the exhibition tours of the *Birth Project* and the *Holocaust Project* as well as *The Dinner Party.*

During the years *The Dinner Party* was traveling, the organization received many testaments from teachers who had based classroom activities on the piece. Most of these were mini "dinner parties" in which students created place settings for women of their choice. In 1996, I visited one such enterprise in an inner-city school that coincided with the exhibition *Sexual Politics: Judy Chicago's* Dinner Party *in Feminist Art History* at the UCLA Armand Hammer Museum. The only reason I went was that one of the teachers was a cousin of Henry Hopkins, the museum's director.

The boys and girls in the grade school class selected women to research and then made plates and runners for each one. At the end of the year, their creations were exhibited on open, triangular tables. During the opening of the show, the children read reports on their chosen woman and then discussed the ways in which they had represented them. I still remember one proud Hispanic boy explaining his tribute to Frida Kahlo. It was touching, especially hearing the teacher talk about how engaged the children had become and how much they had learned. But even though this undertaking was better than most, I really hadn't paid much heed to such activities for reasons that will become clear.

While we were still at Vanderbilt, I received a copy of an upcoming article in a K–12 art education journal that was presumably a tribute to me and

The Dinner Party. Although I understood that the teacher had good intentions, her project unnerved me. She had encouraged her students to create autobiographical plates, which was a fine assignment, but had nothing to do with *The Dinner Party*. Actually, such a project could be considered antithetical to my goals in that *The Dinner Party* is meant to teach women's history through art and to build awareness of the many significant women who are worthy of study and honor. Equally important is the installation's aim at helping girls—who are sometimes prone to being overly self-preoccupied—move *beyond* the personal in order to see themselves within the context of women's rich heritage.

By that time, plans were well under way for *The Dinner Party's* permanent housing at the Brooklyn Museum. Reading the article convinced me that there should be some guidelines for teachers who wished to incorporate the piece into their art classes. Like many university-trained artists, I had always looked down on art education departments, which helps to explain my previous lack of interest in the many school "dinner parties." During our Vanderbilt tenure, Donald and I were privy to several intense dinner conversations at Braeburn during which Constance Gee held forth about her educational theories, the most unexpected of which had to do with her conviction that K–12 art programs should not focus exclusively on making art. This was news to me; like many people, I had assumed that art in the schools should be hands-on, perhaps because I'd never been exposed to any other approach.

Thinking back on my own education, I realized that my public school art classes had provided a place for me to ply the skills that I was developing at the Art Institute Junior School. However, as Constance pointed out, most children are not going to become professional artists. She believed that K–12 art programs should therefore introduce students to a broad range of ways to relate to art, which struck a chord with me. In this book, I have discussed the importance of building a larger constituency for art, but it had never occurred to me that art education might help to achieve this goal.

I began to think about ways that K–12 art programs could expand support for visual art as well as how to provide teachers with materials about *Dinner Party* school activities beyond mimicking the place settings. What I am describing is the process by which I came to a new perspective on art education along with the idea of establishing a *Dinner Party* curriculum. Although Through the Flower had offered a variety of public programs over

the years, these were always secondary to the exhibitions that had been supported and toured by the organization. But this phase was over and the board was increasingly focused on educational programming, which is why I asked Constance to become a member. She took the lead in creating a K–12 curriculum that is introducing generations of young people to *The Dinner Party* and the largely unknown heritage that it represents.

Some readers might wonder why I was willing to spend even more time on a piece that I had created so long ago. Like most artists, I prefer to put finished work behind me and move on to new challenges. But *The Dinner Party* has always been distinct. My initial aim involved permanent housing, which took far longer to achieve than I had ever anticipated and tied me to the work for a protracted period of time. But more important is the historic information that the piece embodies—information that empowered me, those who worked on it, and the tens of thousands of viewers who saw it. Even today, people from all over the world visit *The Dinner Party* and I was recently told that the Queen of Norway considers it her favorite work of art.

I have always felt an obligation to the largely unknown information that I pieced together, which is one reason that I spent so much time re-researching the 1,038 women on *The Dinner Party* table and the *Heritage Floor* for the 2007 book, published in conjunction with *The Dinner Party*'s permanent housing. My initial research had been done before the advent of computers and the Internet, and I wanted the data to be as accurate as possible. Plus, when I finally understood the implications of so many teachers using the concept of *The Dinner Party* in their classrooms—sometimes well and sometimes egregiously—I took it upon myself to provide them with appropriate materials. With Constance as my guide, I ventured into the unknown territory (to me) of K–12 art education and curriculum development.

In the summer of 2006, she organized an initial meeting with a small team of people including two curriculum writers, a high school art teacher, and a district supervisor from Virginia Beach (which Constance referred to as "Vagina Beach," which is pretty funny considering what subsequently happened). The initial idea was that they would pilot the curriculum they developed in their district. Though they made a good start, some issues arose rather quickly, in particular, concerns about the supposed sexual content of *The Dinner Party*. One of the curriculum writers became so agitated about the imagery of the plates that she quit (which was what I meant about the irony of "Vagina Beach").

I wasn't happy that my complex visual forms were interpreted in such a simplistic manner and wrote a stern e-mail explaining that it was essential to place the (sometimes) vaginal imagery of the plates into the context of the overall installation. Given some of the sexual content of our mass media, not to mention the ubiquity of computer porn, it seemed ridiculous to get so riled up about a work of art, especially one created in the 1970s.

Another issue that came up was whether it was possible to teach *The Dinner Party* to students below the high school level. Some members of the group didn't think so while others argued that there were already teachers in elementary and middle schools who were incorporating it into their classrooms; it would be foolish if the curriculum didn't provide for them as well.

And then there was money. Several participants in that first group had unrealistic ideas about what they should be paid. It was not a matter of what they were worth but, rather, what Through the Flower could afford. As Through the Flower has a minimal budget, whatever funds were needed for this project would have to be raised by the organization. While we were still trying to resolve these issues, Marilyn Stewart, a renowned curriculum writer and a pivotal member of the team, announced that she would have to withdraw from the project because of a conflicting publishing contract. In one of those strange (and wonderful) twists that sometimes happen in life, Constance convinced her to stay involved and in fact to spearhead the development of a curriculum that was even more ambitious than we had originally imagined.

As it turned out, a number of Marilyn's colleagues in the Kutztown University art education department were already using *The Dinner Party* in both their classes and their published works. In fact, Peg Speirs, one of the professors, had written her dissertation on *The Dinner Party*. Fortunately, this team was willing to volunteer—in part because they believed that the enterprise would benefit their own research. Be that as it may, it is such generosity of spirit that has fueled many of my projects and *The Dinner Party* Curriculum Project turned out to be no exception.

In October 2006, I was to attend a meeting at Marilyn's house near Kutztown University, in eastern Pennsylvania. In preparation for the gathering, Marilyn (whom I had not yet met) sent me two books, *Rethinking Curriculum in Art,* written by her (with Sydney Walker)[89] and *Gender Matters in Art Education*[90] by Martin Rosenberg and Frances Thurber. To say that I was blown away by these publications would be greatly underestimating my reaction.

While studio art programs were continuing to stress an outdated modernist agenda, K–12 art education seemed to have undergone a revolution.

In contrast to the paltry amount of discourse on university studio art education, K–12 educators have long been involved in a comprehensive rethinking of art curriculum. Marilyn's book is an outstanding example of this effort, and her content-based approach to art mirrors my own. This is reflected in the worksheets in the back of her book, intended for teachers in planning their units of study, which are structured around a number of key principles. Early on, I filled out one of the worksheets and quickly discovered that my goals with *The Dinner Party* could be easily transposed into this intellectual framework. I have listed the different principles along with my responses (in italics) below in order to demonstrate the near-perfect fit between my work and Marilyn's approach. My answers are intended to promote deep study (one of the tenets of Marilyn's book) of *The Dinner Party*:

1. Enduring Idea:
 The importance of women's history
2. Rationale:
 To counter the idea (both explicit and implicit in education) that only men have a history worthy of study
3. Key Concepts:
 a. Women have a significant history
 b. Women have made unique contributions that need to be integrated into mainstream culture
4. Key Concepts about Art that will be addressed:
 Contrast images of women in The Dinner Party *with male representations in order to introduce students to the concept of the male gaze*
5. Essential Questions:
 a. Why did I create The Dinner Party?
 b. How did I do it?
 c. How do the images translate historic information about each of the women represented?
6. Unit objectives:
 a. Learn about women's history
 b. Develop an appreciation of all that is involved in the process of making art

7. Evidence:

After studying The Dinner Party, *students will create their own projects which will involve:*

a. research

b. written texts or art about the women researched

c. developing skills to accomplish either written or visual projects

The notion of "Enduring Ideas" spoke to me because I have always focused on subjects that have global significance, from women's history to the Holocaust in a contemporary context. In Marilyn's view, "such ideas have educational import because they link academic subject matter with life-focused issues,"[91] which is exactly what I have promoted through my pedagogy. Additionally, her book addresses the role of the teacher, which the authors insist: "must shift from that of one who dictates information to one who is a fellow inquirer . . . this shift has been characterized . . . as a shift from the teacher as 'sage on the stage' to 'guide on the side.'"[92] In other words, a facilitator, which is precisely what I've practiced in the classroom and been advocating in this manuscript.

In *Gender Matters in Art Education,* Rosenberg and Thurber stress the importance of gender in the classroom, asking: "What does gender have to do with education or art in general and art education in particular? Reflect on your own school experiences. . . . Did you learn as much about women's contributions to history and society as men's? . . . Did you learn about women artists? . . . Were images of their . . . work displayed on your classroom walls? . . . For most of us, the answer to all of these questions would be a resounding no. . . . Since the art classroom places a special emphasis on individual expression . . . it can either contribute to inequality or provide a potent site for promoting gender equity."[93]

Reading these two books, it became obvious that many of the changes I have been recommending *were already happening,* at least among a number of K–12 art education curriculum writers. They were advocating a more content-based, inclusive curriculum, one that made room for women, artists of color, gays and lesbians, and other marginalized groups. There was also an emphasis on "discipline-based art education" (DBAE), which is a comprehensive approach to learning in the arts, developed primarily for K–12 but also for adult education, lifelong learning, and cultural institutions.

DBAE was developed and formalized in the early 1980s by the Getty Center for Arts Education (later known as the Getty Education Institute).

Its intention was to broaden the content and strengthen the requirements of arts education within the school system and was a reaction to the fact that art in the schools was traditionally taught exclusively through studio activities. Instead, DBAE promoted a more expansive curriculum that consisted of four parts: art history and culture, criticism, aesthetics, and art production. Unfortunately, in the late 1990s, the Getty Trust closed its center for art education and shifted its priorities.

I learned about the Getty initiative only while researching this chapter. Even though I never discussed that endeavor with either Marilyn or Constance, in retrospect, I can see that their respective positions reflected many of the Getty-supported ideas. And my insistence that there are a variety of ways to be involved in art (which would be reflected in *The Dinner Party* Curriculum) was also consistent with the Getty thesis.

The meeting at Marilyn's house was lively and enlightening. The group had assembled a variety of curriculum materials for me to review. Many of them had been put out by museums and were slickly packaged. In contrast, one of the attending high school teachers had brought her own curriculum packet—a three-ring binder that was bursting at the seams. Apparently, many teachers prefer to assemble their own materials with selections from various publications and bits and pieces from other sources. This led me to the notion that our curriculum should not be prescriptive, but rather a flexible framework on which teachers could build. After all, perceptions of *The Dinner Party* have changed dramatically over the course of thirty years. Because I imagine that this will continue to happen, I wanted the curriculum to be able to evolve accordingly.

In the summer of 2007, the Kutztown team organized the first of what became an annual *Dinner Party* Institute. Fifty teachers from around the country, working at all levels of education, attended (thereby demonstrating the importance of creating a curriculum that could be used by different grade levels). The curriculum team felt strongly that our materials should be developed in the same collaborative spirit that had produced the piece (a view that I strongly supported) so teachers would be involved from the start.

I am not going to discuss the development of the curriculum in any detail. For those who are interested, it is available online at: http://judy-chicago.arted.psu.edu and http://www.thedinnerpartyinstitute.com/. The point is that I learned a lot about the rigorous discourse on curriculum development that has occurred among K–12 art educators for many years. It was thrilling to benefit from their extensive experience.

In the spring of 2009, Through the Flower held an official launch of *The Dinner Party* Curriculum at the New Mexico state capitol building in Santa Fe. Our original thought had been to produce a printed edition but for several reasons we changed course. In order to create a nonprescriptive curriculum, it would be better to have a more flexible format. Also, teachers tend to be environmentally sensitive and many of them don't want to use printed books because of the number of trees that are destroyed in the process. And printed copies are expensive to produce. Given Through the Flower's limited resources, it made more sense to produce downloadable materials that would allow teachers to pick and choose from what became a complex curriculum. Needless to say, I had to revise my original opinion about online education and whether my pedagogy could be translated into this new mode, which meant eating a lot of crow with the Penn State art educator Karen Keifer-Boyd. Live and learn. Some months after the launch, the curriculum team and I did a session at the annual conference of the National Art Education Association (NAEA), which now cosponsors *The Dinner Party* Institute. One of the teachers came up to me afterward to express her appreciation, especially for the fact that I had worked with art educators to create the curriculum, saying plaintively, "I wish that more artists would do this."

I found her comment extremely intriguing. I've already discussed the importance of making art more accessible; working with art educators showed me that another way to broaden the audience for art (and with that, the potential support base for artists) might be for more artists to engage with them. I'm not talking about artists-in-the-schools programs, which are ubiquitous and perpetuate the idea that art education consists only of studio-based activities.

I'm suggesting a more comprehensive approach, wherein artists work with art educators to develop curricula that can teach children how important art can be. Although *The Dinner Party* Curriculum grew out of a single work of art, it exemplifies how art can educate, inspire, and empower students in all areas of their lives. And it can be used by teachers in subjects besides art. In fact, most of the school groups that visit *The Dinner Party* are not art classes (funding cuts for the arts means they cannot afford the transportation).

In 2009 I did another presentation, this time for the New Mexico branch of the NAEA. After my talk, a member of the audience stood up and addressed the group, saying: "Look at us; most of us are women. In

fact, most art teachers are women. But most of us don't teach about women. Why is that?" This question should be raised more frequently in order to recognize women's complicity in perpetuating the lack of recognition of female achievement. As bell hooks has pointed out many times, all of us are raised in a male-centered society. It is easy to absorb its values and conclude that what women do is not significant. This is precisely the bias that *The Dinner Party* challenges. Our curriculum provides the materials with which teachers can become empowered to change this attitude in themselves and their students.

Before long, teachers from all over the world were downloading the curriculum. Through the Flower then began to receive requests for training sessions from teachers who wanted instruction on how to implement the curriculum in their classrooms. Because our small nonprofit organization was unequipped to handle these requests, we decided to partner with two institutions, Kutztown University and Penn State. As part of my Art Education Archive, Penn State established permanent online access to *The Dinner Party* Curriculum. And each summer, Kutztown now hosts an annual summer *Dinner Party* Institute, which provides teacher education based on the curriculum—a job they are far more qualified for than Through the Flower could ever be.

From the beginning, I participated in *The Dinner Party* Institute by meeting the attendees for one day at the Brooklyn Museum so we could explore the piece together and discuss its implications for K–12 education. Although these sessions are enjoyable, my one frustration is with the difficulty of weaning teachers from their insistence that art education should only involve hands-on artmaking activities. As I discovered, there is a distinction between curriculum writers (who often teach art education in universities) and the art teachers themselves.

Like university studio art professors, many art teachers start out as artists but soon realize that they cannot support themselves through their studio practice. Perhaps the classroom studio activities provide the teachers with some connection to art production; this could explain why so many of them are resistant to the broader approach to teaching art advocated by the Getty, curriculum writers like Marilyn Stewart, and *The Dinner Party* Curriculum.

In our curriculum, I had hoped to inspire K–12 teachers to think about teaching art in a new way, one that acknowledges that even though most students won't become artists, there are other modes of involvement. For

instance, I sometimes speak about an imaginary student in a high school art history class who learns that even though Elisabeth Vigée-LeBrun created a larger body of art than any woman artist who preceded her, her work had never been catalogued. At that moment, the student has an epiphany, realizing that s/he can have a career in the arts by becoming an art historian specializing in Vigée-LeBrun, thereby protecting the artist's legacy and making a contribution to art while carving out a paying career. Unfortunately, not enough teachers have paid attention to this idea. (Equally frustrating are the teachers who insist on inventing their own *Dinner Party* curriculum without reference to ours, which took over two years and many minds to create.)

In 2012, at *The Dinner Party* Institute's annual trip to the Brooklyn Museum, I recounted the story about the New Mexico teacher who had confronted her colleagues about why they didn't teach their students about women artists. In response, one fellow said that he worked with two women whose curriculum included even fewer women than his (the workshop also stimulated him to include even more), adding that he was going to confront them when he returned home. Of course, there are many factors that prevent educators from devoting time to teaching about women.

Habit is a powerful motivator; imagine if a law were passed mandating that equal time be devoted in all classes (not just women's studies) to women's activities. As the authors of *Still Failing at Fairness* suggest, "Few things stir up more controversy than the content of school curriculum"[94] because it strikes at the core of what is considered significant. Additionally, this would require educators to overhaul their lectures and lesson plans; it is far easier to stick with the status quo even if it means perpetuating one-sided information.

And then there is social resistance. In the inner-city school that I mentioned at the beginning of this chapter, several of the students reported that their parents had asked why they were only focusing on women that year. One of the children replied, "Usually we study men so it's only right," which seemed like a perfect answer. I wish it were that easy to convince mainstream culture of this.

One cannot discount downright ignorance as another factor, which is disappointing because there is so much information now available. I recently read *How to Be a Woman* by Caitlin Moran, a lively young British feminist. In one chapter, she writes: "Even the most ardent feminist historian, male *or* female . . . can't conceal that women have basically done

fuck-all for the last 100,000 years. . . . We have no Mozart; no Einstein; no Galileo; no Gandhi. No Beatles, no Churchill. . . . It just didn't happen."[95] Upon encountering this quote, I thought back to my UCLA history professor who so confidently pronounced that women had made no contributions to European intellectual thought. How could it be that after forty-plus years of feminist scholarship, history, and art history, a young feminist is still convinced of such a preposterous (and sexist) idea?

Clearly, change is difficult, but why do such ideas continue to hold sway? In addition to habit, social resistance, and ignorance, I would like to suggest another reason, one that also helps to explain why little or no attention has been paid to the changes in K–12 curriculum by the university studio art community.

Previously, I mentioned that teaching K–12 art classes is not a good career choice if you want to be taken seriously as an artist. I also referenced the low esteem in which art education is held in many art departments. For example, the Vanderbilt faculty was not interested in establishing an art education department even though Constance Gee had found donors to create two endowed chairs. Then there is the abyss between the College Art Association (CAA) and Foundations in Art: Theory and Education (FATE), a national organization that is trying to improve undergraduate foundational art courses in studio art and art history. Even though FATE has existed for thirty years, in my research for this book I never found any references to it in the (sparse) literature on studio art education. And while some art educators attend CAA conferences, no studio people ever go to the NAEA conferences.

I hate to state the obvious, but most art educators are women and, as bell hooks suggested, what women do is not only considered unimportant, it is often disregarded. I believe that this helps to explain the fact that the radical changes in art education might have happened on another planet as far as university studio art is concerned. One of the hallmarks of my work is that I have been able to see the value in marginalized activities like china-painting and needlework. The aesthetic potential of these techniques had not been appreciated because perceptions had been filtered through the lens of gender, which elevated what men did and ignored women's work, especially when it was produced with "women's" techniques.

In The Dinner Party, the Birth Project, and Resolutions: A Stitch in Time, I demonstrated that china-painting can transform subject matter just as well as oil paint and that thread can be like a brushstroke. Although there was

considerable opposition initially, my work helped to create a new climate in contemporary art; it is now commonplace to see all sorts of previously taboo techniques being employed by both male and female artists. Just as I was able to help pave the way to greater freedom in terms of media, I hope that I will be able to clarify what K–12 art educators have to offer to university studio art programs.

I've learned over the course of my recent teaching projects that there's a deep hunger among students to learn how to find and express personal content. They also need to be able to transform content into visual form, which means skill training, regardless of the chosen medium. Lastly, I have learned from the response to both my work and my teaching projects that there is a large audience for art that deals with real issues in an accessible way.

As I have tried to clarify, my approach is markedly different from most present-day studio art programs, which have almost no agreed-upon curriculum. In contrast, K–12 art educators have been grappling with curriculum issues for years, writing curriculum for others to use, integrating a sensitivity to gender and diversity, and promoting a content-based and broad approach to the arts. Even if there is some degree of resistance, still, the efforts they are making have a lot to offer.

Of course, it is important to acknowledge that teaching art to children is different from training artists or providing a substantive art education to undergraduates. The one commonality is that most students will not become practicing artists, a fact that needs to be addressed in formulating a more sensible form of art education at all levels. At the same time, I cannot help but wonder why so few qualified curriculum writers have turned their attention to the problems in university studio art programs. Perhaps they are deterred by the inhospitable climate—as exemplified by the situation at Vanderbilt—or by the scorn toward art education generally. All the more reason for me to try and provide a bridge between these two worlds.

Let's begin with some of the peculiar contradictions in studio art programs. Dating back to Walter Gropius and the Bauhaus, there has been a recurring argument that art cannot be taught. All the while, studio art programs have been proliferating. If art cannot be taught, why are so many people trying to teach it? Perhaps it would make more sense to start with the premise that art *is* being taught in many forms all over the world. The question would then be: what should be taught in the twenty-first century? This is precisely the issue that the book *Art School,* which I have been citing, presumably addressed.

In an essay, Robert Storr—influential artist, critic, curator, and now dean of the Yale School of Art—took up the state of studio art education, writing that, "the problems...in the United States, as well as in many other countries, issue directly from a long-standing tendency to reassert obsolete philosophical dichotomies (mind-body/intellect-intuition/creation-interpretation/aesthetics-criticality) and impose them on institutions offering differing types in order to pit those institutions against one another or against non-institutional or quasi-institutional forms of teaching and learning."

Well, at least we agree that art education is suffering from a number of problems, even if I consider his assessment far off the mark and needlessly obtuse. He then puts forth a series of axioms, a selection of which I present here, assuming they constitute his idea of a solution:

> Students who go to art schools lack something.
> Students go to art schools to get what they lack.
> Students don't always know what they lack.
> The purpose of art schools is to provide students with the things they know they lack and ways of finding the things they don't know they lack.
> Schools that do not recognize what students lack should rethink what they are doing.
> Schools that do not rethink what they are doing are the enemies of art and the enemies of anti-art. They should close.
> All schools are academies.
> Any student who goes to art school is an academic artist. [. . .]
> Bliss is bliss, just as presentness is grace when grace is present. [. . .]
> It is not right to critique popular culture but never go bowling.
> It is not right to go bowling and think that you are in touch with America.[96]

As the head of one of the most important art schools in America, one might assume that Storr would have provided a path toward a relevant, comprehensive, contemporary curriculum for university studio art programs, something that K–12 art educators have been attempting to do in their field for years. Perhaps he felt he was being informative or maybe he was being playfully provocative. Whatever the explanation, he avoided the task of articulating a coherent educational philosophy. In contrast, consider this passage from Stewart and Walker's introduction to *Rethinking Curriculum*

in Art: "The ideas put forward are in response to more than a decade of school reform efforts in education regarding teaching for understanding, accountability, student relevance, and the information and visual explosion stemming from the continued growth of media and technology."[97]

At least their book provides some philosophical framework upon which curriculum development can take place, a framework that is sorely lacking at the university level. What I am suggesting is that significant discourse of the subject of studio art education is long overdue. Because curriculum development is common among K–12 art educators, their methods might provide a model even if their focus is different.

Any restructuring of curriculum needs to build upon their work in terms of gender and diversity, which means fully integrating the artistic achievements of women along with others who have been marginalized by the modernist agenda that emphasizes a linear art history of predominately white men. This integration would affect the composition of studio art faculty as well as what is studied and promoted as important in art history classes. And it would necessarily include women's history, women's art, and the history of the feminist art movement because this movement marked the moment when women artists were first able to claim the right to express their own experiences clearly.

There is an urgent need for a radical restructuring of the programs that are now offered, which, frankly, are deficient, dishonest, and lacking in standards. In addition, we need to recognize that being an artist—even a successful one—does not automatically make you a qualified teacher. Of course, there can be significant value in bringing working artists to art schools as there is no substitute for exposure to such role models, something I learned as a student at UCLA when Billy Al Bengston taught there for a year.

However, allowing visiting artists to act like prima donnas (Chris Burden's 1976 "performance" at Ohio State University comes to mind) instead of people with valuable experiences to share with students is scandalous. Is the purpose of such visits to provide revenue to artists who need money, or is it for educational value? If it is the latter, then schools should put guidelines into place outlining what is expected from a visiting artist.

Moreover, full-time studio art professors should have some grounding in education in order to have the tools to be effective teachers. Here again, art educators could be helpful as part of their job involves training teachers. Along with a wider array of both art and artists, students need to be exposed to a variety of techniques across gender lines so that needlework,

for example, takes its place alongside welding and, of course, an expanding number of new media options.

Perhaps the first two years of art school could offer a broad-based arts program until students decide if they want to become artists or prefer to be involved in art in other ways. For them, there might be options including apprenticeships with conservators, framers, art installers, or other professions (or they could just be encouraged to include art as an important aspect of their lives by becoming collectors or regular museum visitors). Upper-division courses could lay the foundation for those art students destined for graduate school, including helping them to find their personal voices.

As for graduate students, they must be better prepared for the realities of the art world. Instead of promoting the false idea that the goal of graduate school is to become an art star (as too many programs do), perhaps it would be more productive to expose students to a greater variety of art practitioners, by studying and meeting a range of artists, including muralists, community-based artists, street and activist artists, as well as other types. Most of these are rarely invited to art schools.

In the same way that Constance and I tried to reintegrate studio art, art history, and art education in the Vanderbilt program in order to provide a more comprehensive approach to art, a reconstructed art program could unite these disciplines so that art history students would learn how art is made, art students would have the opportunity to learn from art educators in terms of broadening their approach to art, and education students would be encouraged to bring the insights of their profession to bear on the other fields, especially how to teach. As I mentioned, instruction for teachers is almost wholly absent in graduate schools, even though many of these students will find employment in university studio art programs.

I've already argued that there needs to be a greater focus on content across the arts. As demonstrated, there is a serious disconnect between form and content, not only in studio art programs but also in art history classes. I will never forget a story I heard about a graduate art history class in the 1970s whose students (mostly female, of course) were being exposed to the burgeoning women's movement at the same time as they were sitting in classes where professors customarily discussed paintings like *The Rape of the Sabine Women* by Peter Paul Rubens exclusively in terms of brushstrokes. "But isn't that a rape?" one student whispered to another. The question swirled around the classroom, building in volume until one woman yelled: "That's a rape; why on earth are you talking about the application of the paint?"

In addition to helping students find their own subject matter, critiques should include discussions about content as part of a more holistic approach to art. The overly harsh and unsupportive critiques that are prevalent today need to be acknowledged for what they are: a misguided attempt to separate out serious students from the rest (if, in fact, that is their intent; I'm still trying to understand the purpose of the brutality that often prevails). Of course, if comprehensive undergraduate art education produces a wider audience for art, there will be room for more artists and no need to drum out those students who aren't tough enough to withstand the critique system.

Given the evolving nature of contemporary art, any curriculum has to be flexible and adaptable. Certainly, it cannot be the product of one person's thinking, which is why I offer my suggestions as just that. Rather, there needs to be a wide-ranging collaboration between studio art and art history professors, art educators, and art professionals of all kinds. What I am calling for is the beginning of a serious national—or international—dialogue to radically restructure studio art and art history education. If such a goal seems overly ambitious, I would like to remind the reader that, long ago, I set out all alone to teach women's history through art. Even though the transformation that I envisioned is not yet complete, still, my work demonstrated that change is possible, especially if people work together for a common purpose.

I have written this book in the hopes that there are many members of the art community who are dissatisfied with the state of university studio art education and who will come together to achieve what bell hooks outlined in *Teaching to Transgress:* "The classroom, with all its limitations remains a location of possibility. In that field of possibility, we have the opportunity to labor for freedom, to demand of ourselves and our comrades, an openness of mind and heart that allows us to face reality even as we collectively imagine ways to move beyond boundaries, to transgress. This is education as the practice of freedom."[98]

If art is to once again become "the practice of freedom" instead of a steady reiteration of old or inconsequential ideas—as too many art schools seem to promote—we have to work together to retrieve art from the twisted paths into which it has gone. It has become mired in marketplace values and trivial pursuits instead of being "the practice of freedom," which is the highest form of human endeavor. To me, that is what art is all about and, in my opinion, it is worth fighting for.

NOTES

1. Linda Nochlin, "Why Have There Been No Great Women Artists?" *ARTnews* 69, January 1971, 22–39.
2. Robert Bersson, "Building the Literature of Art Pedagogy," *College Art Association News* 30, no. 5 (September 2005): 1, 3, 39–40.
3. Howard Singerman, *Art Subjects: Making Artists in the American University* (Berkeley and Los Angeles: University of California Press, 1999).
4. Hannah Wilke, "Stand Up," a song on the album *Revolutions per Minute (The Art Record),* recorded in New York by Ronald Feldman Fine Art, and the Charing Hill Company, 1982.
5. Griselda Pollock, "What's Wrong with Images of Women?" in *The Sexual Subject: A* Screen *Reader in Sexuality* (London: Routledge, 1992), 140.
6. Lucy Lippard, "Going Around in Circles," in *From Site to Vision: The Woman's Building in Contemporary Culture,* ed. Sondra Hale and Terry Wolverton (Los Angeles: Otis College of Art and Design, 2011), 12.
7. *From Site to Vision.*
8. Jane F. Gerhard (Atlanta: University of Georgia Press, 2013).
9. Norma Broude and Mary D. Garrard, eds. *Reclaiming Female Agency: Feminist Art History after Postmodernism* (Berkeley and Los Angeles: University of California Press, 2005), 5.
10. Steven Henry Madoff, ed., *Art School (Propositions for the 21st Century),* (Cambridge, MA: MIT Press, 2009), 39.
11. Frances Borzello, *Seeing Ourselves: Women's Self-Portraits* (New York: Harry N. Abrams, 1998), 112.
12. Octave Uzanne, *The Modern Parisienne.* Transl. William Heineman (London: William Heineman, 1912) 129. Originally published as *Parisiennes de ce temps en leurs divers milieux, états et conditions* (Paris: Mercure de France, 1910).
13. Howard Singerman, *Art Subjects,* 89.
14. Gyorgy Kepes, *Language of Vision* (Chicago: Paul Theobold, 1944), 201.
15. Vincent Katz and Martin Brody, *Black Mountain College: Experiment in Art* (Cambridge, MA: MIT Press, 2003), 188.
16. Mary D. Garrard, "Of Men, Women and Art: Some Historical Reflections," *Art Journal* 34, no. 4 (January, 1976), 324.
17. Susan S. Klein et al., eds. *Handbook for Achieving Gender Equity Through Education,* (Mahwah, NJ: Lawrence Erlbaum, 2007).
18. David and Myra Sadker and Karen R. Zittelman, *Still Failing at Fairness: How Gender Bias Cheats Girls and Boys in School and What We Can Do About It* (New York: 2009), 87.
19. Robert Maynard Hutchins, *Great Books: The Foundation of a Liberal Education* (New York: Simon & Schuster, 1954), 3.
20. Amelia Jones, *Sexual Politics: Judy Chicago's* Dinner Party *in Feminist Art History* (Los Angeles: University of California Press, 1996), quoted in Jane F. Gerhard, *The Dinner Party: Judy Chicago and the Power of Popular Feminism, 1970–2007* (University of Georgia Press, 2013), 268.
21. Madoff, *Art School,* 7.
22. *Art Journal* 58, no. 1 (Spring 1999).
23. Susan Sontag, "Against Interpretation," in *Against Interpretation and Other Essays* (New York: Picador, 1966), 15.
24. Madoff, *Art School,* 4.
25. David and Myra Sadker and Karen R. Zittelman, *Still Failing at Fairness: How Gender Bias Cheats Girls and Boys in School and What We Can Do About It* (New York: Scribner, 2009), 8–9.
26. Ibid., 20–21.
27. Anthologized in Joanna Frueh, Cassandra L. Langer, and Arlene Raven, eds., *New Feminist Criticism: Art, Identity, Action* (New York: HarperCollins, 1994), 42.
28. When I use first names only, it is either that I am protecting the privacy of people who do not have public visibility in the art world or, occasionally, because I have no access to the class lists to be able to identify them more fully.
29. Lisa Jervis and Andi Zeisler, eds., *Bitchfest: Ten Years of Cultural Criticism from the Pages of* Bitch *Magazine* (New York: Farrar, Straus and Giroux, 2006), xx.
30. Anna Quindlen, "The Leadership Lid," *Newsweek,* Oct. 3, 2008.
31. Anne-Marie Slaughter, "Why Women Still Can't Have It All," *The Atlantic,* July/August 2012.
32. James Elkins, *Artists with PhDs: On the New Doctoral Degree in Studio Art* (Washington, DC: New Academia Publishing, 2009), iv.
33. Judy Chicago and Edward Lucie-Smith, *Women and Art: Contested Territory* (New York: Crown, 1999).
34. Martin Rosenberg and Frances Thurber, *Gender Matters in Art Education* (Worcester, MA: Davis Publications, 2007), 48.
35. bell hooks, *Teaching to Transgress: Education as the Practice of Freedom* (New York: Routledge, 1994), 39.
36. bell hooks, *Feminism is for Everybody: Passionate Politics* (Cambridge, MA: South End Press, 2000), 1, x.
37. Ariel Levy, *Female Chauvinist Pigs: Women and the Rise of Raunch Culture* (New York: Free Press, 2005).
38. Deborah Siegel, *Sisterhood, Interrupted: From Radical Women to Grrls Gone Wild* (New York: Palgrave Macmillan, 2007), 155.
39. Ariel Levy, "This bawdy world of boobs and gams shows how far we've left to go," *The Guardian,* February 16, 2006.
40. Mary Ann Gawelek, Maggie Mulqueen, and Jill Mattuck Tarule, "Woman to Woman: Understanding the Needs of Our Female Students," in *Gender and Academe: Feminist Pedagogy and Politics,* ed. Sara Munson Deats and Lagretta Talent Lenker (Lanham, MD: Rowman & Littlefield, 1994).
41. Gawelek et al, "Woman to Woman," 186.

42. Gerda Lerner, *The Creation of Patriarchy* (New York: Oxford University Press, 1986), 214, 226.
43. Charlotte Templin, "The Male-Dominated Curriculum in English: How Did We Get Here and Where Are We Going?" in *Gender and Academe,* 51–52.
44. Eleanor Flexner, *Century of Struggle: The Woman's Rights Movement in the United States* (Cambridge, MA: Belknap Press of Harvard University Press, 1975).
45. Catherine G. Krupnick, "Women and Men in the Classroom: Inequality and its Remedies," *On Teaching and Learning: The Journal of the Harvard-Danforth Center,* vol. 1 (1985): 18–25.
46. Ibid.
47. bell hooks, *Feminism Is for Everybody,* 116.
48. Michael Kimmel and Thomas Mosmiller, eds. *Against the Tide: Pro-Feminist Men in the United States, 1776–1990: A Documentary History* (Boston: Beacon Press, 1992), xix.
49. Ibid., 209.
50. James Elkins, *Art Critiques: A Guide* (Washington, DC: New Academia Publishing, 2011), viii–ix.
51. Howard Singerman, *Art Subjects,* 211.
52. Ibid., 161.
53. Sheila Tarrant, ed. *Men Speak Out: Views on Gender, Sex, and Power* (New York: Routledge, 2008).
54. bell hooks, *All About Love: New Visions* (New York: HarperCollins, 2001), 36.
55. bell hooks, *Feminism Is for Everybody,* 70.
56. Kyle Brilliante, "Engendering the Classroom: Experiences of a Man in Women's and Gender Studies" in Sheila Tarrant, ed., *Men Speak Out,* 224, 226.
57. Frances Borzello, *At Home: The Domestic Interior in Art* (London: Thames & Hudson, 2006), 16.
58. Howard Singerman, *Art Subjects,* 20.
59. Ibid.
60. Daphne Patai and Noretta Koertge, *Professing Feminism: Cautionary Tales from the Strange World of Women's Studies* (New York: Basic Books, 1994), 4–5.
61. Ibid., 113, 107.
62. James Elkins, *Art Critiques: A Guide* (Washington DC: New Academia Publishing, 2011).
63. Viki Thompson Wylder, *The Journal of Gender Issues in Art and Education,* vol. 3, 2002–3.
64. Karen Keifer-Boyd, "From Content to Form: Judy Chicago's Pedagogy with Reflections by Judy Chicago," *Studies in Art Education,* 2007.
65. Madoff, *Art School,* 10.
66. Ibid., 3.
67. Ibid., 72–73.
68. Malu Byrne, "Running from the City," *New York Times,* May 27, 2012.
69. Don Thompson, *The $12 Million Stuffed Shark: The Curious Economics of Contemporary Art* (New York: Palgrave Macmillan, 2008), 59.
70. Ibid., 60.
71. Ann Douglas, "Crashing the Top," *Salon* (October 11, 1999): at http://www.salon.com/1999/10/11/douglas/; accessed September 11, 2013.
72. Thompson, *The $12 Million Stuffed Shark,* 55.
73. Dushko Petrovich and Roger White, eds., *Draw It with Your Eyes Closed: The Art of the Art Assignment* (Brooklyn: Paper Monument, 2012).
74. Howard Singerman, *Art Subjects,* 173.
75. Ernesto Pujol, "On the Ground: Practical Observations for Regenerating Art Education," in Madoff, *Art School,* 3.
76. Charles Renfro, "Undesigning the New Art School," in Madoff, *Art School,* 162, 164.
77. Michael Graves, "Drawing with a Purpose," *New York Times,* September 2, 2012.
78. Thompson, *The $12 Million Stuffed Shark,* 29.
79. Holland Cotter, "China's Legacy: Let a Million Museums Bloom," *New York Times,* July 4, 2008.
80. Holland Cotter, "The Boom Is Over. Long Live the Art!" *New York Times,* February 12, 2009.
81. Ute Meta Bauer, "Under Pressure," in Madoff, *Art School,* 221.
82. Ibid.
83. David Barboza, "Schooling the Artists' Republic of China," *New York Times,* March 30, 2008.
84. Ibid.
85. Ibid.
86. Steven Henry Madoff, "States of Exception," in Madoff, *Art School,* 275.
87. Fred Wilson, "Questionnaires," in Madoff, *Art School,* 300.
88. Ernesto Pujol, "On the Ground: Practical Observations for Regenerating Art Education," 13.
89. Marilyn G. Stewart and Sydney R. Walker, *Rethinking Curriculum in Art* (Worcester, MA: Davis Publications, 2005).
90. Rosenberg and Thurber, *Gender Matters.*
91. Stewart and Walker, *Rethinking Curriculum in Art.*
92. Ibid.
93. Rosenberg and Thurber, *Gender Matters in Art Education,* xvi.
94. David and Myra Sadker and Karen R. Zittelman, *Still Failing at Fairness: How Gender Bias Cheats Girls and Boys in School and What We Can Do About It* (New York: Scribner, 2009), 87.
95. Caitlin Moran, *How to Be a Woman* (New York: Harper Collins, 2011).
96. Robert Storr, "Dear Colleague," in Madoff, *Art School,* 65.
97. Stewart and Walker, *Rethinking Curriculum in Art.*
98. bell hooks, *Teaching to Transgress,* 207.

APPENDIX A:
"COCK AND CUNT" AS A PEDAGOGICAL TOOL
JUDY CHICAGO, 1970

The *Cock and Cunt* play is to be performed in a highly stylized manner. Words are to be spoken haltingly and in stilted form. Poses and movements should be awkward, slow, and jerky, resembling the motion of puppets. Arms and legs are held akimbo, palms upright, and feet pointing out. Voices are highly exaggerated and in singsong rhythm with the body movements. Male voice is low and authoritarian. Female voice is high and obsequious. This piece can be very effective as a way of raising consciousness about gender roles and attitudes. In order to employ it as such, the facilitator can use a number of methods including the following:

(1) Separate the class into two groups: "male" and "female." If there are men in the class, ask them to play the female role and ask the women to take the male part. Give everyone a copy of the play. After they have read it, ask each group to read their parts together. Do this several times until everyone becomes familiar with the words. Then begin clapping hands in a brisk one-two, one-two rhythm. Everyone then reads the words along with that rhythm until the play goes very smoothly, with everyone reciting their lines.

(2) Ask the class to form a single line. Pass out the script. Then tell everyone to begin walking around the room in a circle, lifting their legs in the one-two, one-two rhythm. Perform the entire play this way until everyone feels comfortable. Then ask people to split up into teams of two in which each person takes a turn in the male and then the female role. After about thirty minutes of practice, ask the teams to perform the play twice; one team at a time so that everyone gets a chance to play both roles.

(3) Pass out the script to everyone assembled. Tell them to divide into teams of two and, if men are present, ask each person to take the role of the opposite gender. Show them how to perform the piece in puppet-like

fashion. Then let each team practice in a separate part of the space. After a while, request that the group reassemble and ask for volunteer teams to perform the piece.

After the performances, it is very important to have a discussion using the circle-based method so that everyone has a chance to speak. The questions to solicit responses could include: Which part did you like better? Why? How did you feel about playing a "man"/"woman"? Usually, the problems that developed in the process of performing the piece indicate the difficulties women have in being assertive, expressing their own sexuality, or in sharing housework. For men, the issues might involve fear or hatred of the feminine, distaste for violence, discomfort with the male role, or a resistance to doing housework. Whatever concerns participants raise after they have performed the play should be discussed, either at that session or a later time.

ACT I

Two women, dressed identically in black leotards, enter stage left. On stage right is a large sink full of dirty dishes. Stage center, an oversized bed. Regular lighting. Or the performance can take place in a large room with audience seated on floor facing performers. First woman (SHE) has a plastic vagina strapped to her crotch. SHE crosses stage to sink, turns and faces audience, head turned toward second woman (HE), who has followed SHE across stage and stopped beside her, also facing audience. HE has a plastic phallus strapped to his crotch.

Lights darken. Single spot on performers and sink.
SHE: "Will you help me do the dishes?"
HE: (Shocked) "Help you do the dishes?"
SHE: "Well, they're your dishes as much as mine!"
HE: "But you don't have a cock!" (grasps cock and begins stroking it proudly)
SHE: "What's that got to do with it?"
HE: "A cock means you don't wash dishes. You have a cunt. A cunt means you wash dishes."
SHE: (looking at cunt) "I don't see where it says that on my cunt."
HE: (pointing at her cunt) "Stu-upid, your cunt/pussy/gash/hole or whatever it is, is round like a dish. Therefore it's only right for you to wash dishes. My cock is long and hard and straight and meant to shoot like

guns or missiles. Anyone can see that." (*emphasis on cock, long, hard, straight shoot; strokes cock on each emphasis*)

HE turns toward SHE, begins to move in erotic manner, as if having sexual relations. SHE follows his motion, still in one-two rhythm. "Speaking of shooting, I need to shoot—off, that is, you know—drop my load, shoot my wad, get my rocks off—you know—I *have* to; I *have* to; you know; *come*, that is. I *have* to, no matter what—*I have to come!*" (voice becomes progressively louder—last phrase said facing audience) HE and SHE walk in jerky manner in line to bed. HE mounts SHE (spotlight on bed).

ACT II
SHE lying spread-eagled on bed with head hung over end of bed toward audience, smiling deliriously. HE is on top of her with his plastic phallus in her plastic vagina, humping her mechanically, eyes glazed but looking into audience.
HE: (voice building to crescendo) "*I-I-I—me-me-me—I have to—I need to—I must—I-I-I-I—I!*" (falls on her gasping, as if after climax)
Silence. Couple get up mechanically and walk as before to stand in front of bed.

ACT III
Single spot. Couple standing center stage in front of bed.
SHE: "Was it all right? Did I do it right?"
HE: "Yes, yes, it was fine. Now let's go to sleep."
SHE: (almost wistfully) "You know, sometimes I wish I could come too."
HE: (reprimandingly) "Now, you know you don't need to come like I do. Your cunt is made to receive."
SHE: (slowly, in sing-song voice) "I know. My cunt is made to receive. My cunt has an opening in the middle. Therefore, I must receive. My cunt is shaped like a dish. Therefore I must wash dishes." (beginning to sing)
　"My cunt is shaped like a dish.
　　Therefore I must wash dishes."
(next verse sung five times, singing becoming louder and shriller, like a cantata)
　"I have a cunt.
　　I must receive.

I have a cunt.

I must wash dishes."

HE begins to speak simultaneously with first verse of cantata (in sing-song voice, low tones).

"I have a cock.

It is long and hard and straight.

It is shaped like a gun or missile.

Therefore I must shoot.

I must shoot, I must shoot.

I have a cock."

Next verse is sung three or four times. HE stops. SHE continues singing, HE glares at her for several bars. SHE, embarrassed, stops.

"I have a cock.

I must shoot.

I must shoot.

I have a cock."

HE: "You know, if you keep all this up, making all these demands on me, like asking me to help with the dishes, and wanting to come and everything—you're going to castrate me."

SHE: (timidly) "Castrate you?"

HE: "*Yes*, castrate me!"

SHE: (scared) "Castrate you?"

HE: "*Yes, castrate, castrate . . . castration!*"

As he says this last phrase, screaming, he rips off his plastic phallus and begins chasing after her, hitting her with his cock. Lights are all on. As they run, he keeps yelling "castrate," "castration," "castrate me." As they run they knock dishes off sink, pull bedding off bed until SHE sinks to her knees in a pile of bedding. HE keeps beating her fiercely until SHE slumps and dies, lying straight out with the bedding twisted around her. HE glares at her body self-righteously with pursed lips, and in an imperious stance, puts one foot on her body and triumphantly puts his arm in a salute, flexing his whole torso in victory.

HE and SHE rise and walk off stage right, in puppet fashion.

End

APPENDIX B:
SMITH COLLEGE COMMENCEMENT SPEECH BY JUDY CHICAGO
MAY 14, 2000

Although I have given several commencement speeches, I became quite nervous at the prospect of composing remarks to present here at Smith, the reason being—and my apologies to the male students who are here today—I care passionately about female education and I wanted to say something meaningful to you. In my previous talks at various coed commencements, I had to be careful about what I said because I didn't wish to exclude the male graduates, something that would have been easy for me to do given my overwhelming desire to address the young women.

In preparation for composing my remarks, I spoke to your president, Ruth Simmons, who urged me to share with you some of what I have learned during the nearly four decades of my career. Let me begin my saying that I have lived the life I wanted to live and, even though it has often been difficult, I have no regrets about the path I chose. However, I do not quite know how much of what I have learned should be shared with you, in part because I am still not sure whether my parents' failure to warn me about what the world was like helped or harmed me in the end.

From the time I was a young child, I wanted to be an artist and to be a part of art history, a history that I saw represented at the Art Institute of Chicago, which I visited every Saturday from the time I was five years old in order to take art lessons and wander through the galleries. From childhood, I was encouraged in this goal. I was raised in a family that believed in equal rights for women, which was quite unusual at the time, though I did not know this as my parents never told me that their beliefs were not shared by most other people of their generation.

So it should come as no surprise that no one ever pointed out to me the lack of women artists in the Art Institute's collection—even less than the 5 percent that comprises our nation's art collections today. At any rate, in addition to being raised to believe that I could be and do what I wanted, I was also taught to believe that the purpose of life was to make a contribution to a better world, an attitude that today, in what is sometimes described as

a "post-feminist" world, is often seen as quaint, particularly if one's idea of making a difference concerns the status of women.

Many of my friends bemoan the fact that too many young women seem unwilling to call themselves feminists, all the while benefitting from the hard work of our generation. I, however, have a different view; one based upon my own experience. When I was in school at UCLA, there were two tenured female faculty members (two more than there were for a good many years thereafter). In fact, one of them had a collection of women's art.

I would imagine that those people here who are familiar with my career are thinking that I must have really been inspired by these women and by this art collection. On the contrary, I wanted absolutely nothing to do with either of them, nor was I interested in the collection, as I could not imagine why anyone would exclusively collect "women's art."

Like many women of my generation, once I began attending school, I learned that it was what men did that was important, a perspective that was not conveyed overtly, but rather through the fact that almost everything we studied was by men. That this was a contradiction to my own desire to do important work did not deter me from pursuing my goals with determination and incredibly hard work.

However—and despite the fact that in my youth I had what might be described as a proto-feminist consciousness—I absolutely did not want to be called a "suffragette," which is the term that was thrown at me whenever I tried to challenge the overt sexism of my male teachers and, later, that of the L.A. art scene of the sixties, which, if described as "macho," would be considered an understatement. It took me ten years to realize that, even if I didn't wish to identify with other women, in the eyes of the art world my gender figured prominently—and negatively.

My singular goal was to be taken seriously by my "fellow" artists (there were few women artists who were visible then). In order to achieve this, I felt compelled to move away from my natural impulses as an artist, impulses that revealed my gender. For even if art has no gender, artists do, and it is often the case that one unconsciously reveals aspects of oneself when one creates art. In my case, my forms tended to be biomorphic and feminine, which was definitely a no-no at that time—the end of the heyday of abstract expressionism and the beginning of minimal art.

It took me a decade of denying my natural impulses to decide that it wasn't worth it, that I had best be who I was. Would it have helped me if my parents had told me that even though they believed in equal rights for women, not everyone shared their beliefs? Would I have been spared the years of moving away

from myself? Or would it have only made me give up before I had even tried? There is no answer to such a question, for who can predict what "might have happened," but it did trouble me when I was working on these remarks, as I didn't want to be discouraging in any way.

In my conversation with President Simmons, she told me something that surprised me, that today, many students work for a few years before entering graduate or professional school. This is quite different than my own experience, which involved going directly to graduate school and then into the rough-and-tumble Los Angeles art scene of the sixties.

I must say that almost nothing I learned in school prepared me for the reality of professional life—with one exception. During my first year in graduate school at UCLA, one of the local art stars came for a year's residency. He was quite different from the rest of the faculty, who tended to be more teachers than artists. Moreover, he was handsome, dashing, and tough.

He allowed me to visit his studio and to see, for the first time, what a "real" artist's life was like, thereby exposing me to not just the glamour of the art world, but to the many challenges involved in an artmaking life—for example, the need to support a studio and a lifestyle that seemed both frightening and exciting in its level of risk. It was he who first introduced me to the "something's going to happen" way of living, which involved never getting a full-time job because one's studio work was full time enough.

This meant living from month to month on meager earnings and hoping that "something would happen" so that the next month's rent could be paid. I have lived this way for most of my life, only recently moving into a home of my own and, with it, having to deal with the responsibility of a mortgage (something which has definitely curtailed my freedom).

Of course, things were quite different when I graduated; the international art market was just developing and had certainly not yet extended its reach to the West Coast. There was no notion of reaping any real financial success from art, which was good for art but bad for artists.

Last fall, I taught for a semester at Indiana University in Bloomington, my first formal teaching job in more than twenty-five years. Although my studio class was open to both men and women, only women enrolled. They were from twenty-six to sixty in age and all of them had experienced leaving school and facing the void of having no studio, no equipment, limited money, and a lack of context and stimulation in terms of being around other people who were vitally interested in art. Before very long, they all stopped making art. Their solution to this problem was to reenroll in school, sometimes repeatedly, which only served to put off the moment of truth, as it were.

My class was a project class aimed at addressing this very problem, that is, the gap between art school and art professional practice. My students were provided with a group studio and my course was structured to help them move from concept to artmaking to exhibition in the I. M. Pei–designed university art museum, an intense process that involved long hours of work on their part.

Along the way, I learned something very important. Without meaning to, most of our educational institutions infantalize women. Although it is difficult for *all* students to make the transition from school to life, it is harder for women because, no matter how excellent their education, few of them are schooled in how to become independent in the sense that I am describing, i.e., feeling able to generate what they need for themselves rather than being dependent upon others, be it family, husbands, significant others, or friends.

Once I recognized this, I encouraged my students to find a way to create art without depending upon the facilities of the university so that they would have some experience of what it would be like after they left school. I spent a considerable amount of time during class discussing what was involved in professional art practice, something I had only learned by accident, thanks to the happy coincidence of the residency of the aforementioned art star. Unfortunately, my education came at the price of having to endure many comments like "you cannot be a woman and an artist too."

When I met this fellow, I—like any of my students at IU—had no idea that becoming a professional artist involved establishing and supporting a studio, generating money for supplies, sustaining myself in the face of the world's general indifference to art, and most of all, being able to stand up to criticism, which is particularly difficult for women as most of us are raised to want to be loved—I know that I was.

Regarding criticism, another thing I learned from my mentor was the following: "Never read reviews," he told me. "Just count the column inches of the article and note how many reproductions of your work are included. Then go back to work. That's what counts—to keep on working, no matter what." Had I not been given this advice, given the piles of bad reviews I've received, there is no way I would be standing here before you, presumably because of my "success."

But how was I able to achieve such self-confidence that I could overcome my need to be loved, learn to generate the money I needed to make art and run a studio, and most important, disregard what others thought and continue with my own vision, even when it was publicly ridiculed as it has often been? My explanation rests in my childhood and the love and support I received

from my parents and also, the lessons I learned from my father about the crucial importance of history, although I cannot recall his ever including women's history in his lessons.

Nevertheless, I was fortunate in having received such an upbringing. However, it would have not been sufficient had I not applied my father's lessons about the importance of history by investigating my own heritage as a woman. A few years back, I was at the Schlesinger Library on the History of Women in America, where I was engaged in discussions about their becoming the repository of my papers, which, happily, has occurred.

Mary Maples Dunn, then the director (and a former president of Smith) asked me whether my archives should not be in an art institution. My answer was that indeed, my art belonged in such an institution, but that I would not have survived as an artist had I not known about my female predecessors and that consequently, my papers belonged with theirs. For it was only through my discoveries of the stories of such women as Elizabeth Blackwell, Susan B. Anthony, and Sojourner Truth that I was able to overcome the many obstacles I encountered.

When I experienced rejections or disappointments, I thought about Elizabeth Blackwell's experience in medical school in Rochester. For the two years she was there, no one ever invited her to dinner and she was sometimes spit upon by women in the street. And I thought: "If she could do it, I can do it." When I became discouraged, I thought about Susan B. Anthony and how she had stood firm for fifty years, helping to change many of the discriminatory laws against women that allow us to stand together in this place today. And I thought: "If she could do it, I can do it." When I felt hurt by the attitudes of my colleagues, I thought about Sojourner Truth and how she had stood up to ridicule, humiliation, and prejudice in order to bring her message to the world. And I thought: "If she could do it, I can do it."

Earlier, I mentioned young women's discomfort with the word "feminist"—I hope that many of you will come to see that in disowning that word, you disown the history that will allow you to do what you want to do. For only by standing upon the shoulders of your foremothers will it be possible to achieve all that you are capable of doing, a lesson I learned painfully and which I would like to pass on to you.

In terms of learning, I should like to again talk about something that I learned—also at IU—in order to share another lesson with you. A male graduate theater student enrolled in a seminar class I team-taught entitled "Feminist Art: History, Philosophy, and Context," and asked if he could add a performance section to the exhibition of my project class. He wanted to

re-create some of the performances I had done with my students during the seventies at *Womanhouse*, one of the first openly female-centered art installations. Also, he wished to employ my pedagogical methods to create new, more up-to-date performances with a group of female theater students.

I was quite enthusiastic about this idea and looked forward to seeing what they might come up with. As it turned out, a number of the original performances involved the theme of conflicting desires. The most effective of these pieces focused on one young woman and a clown, who kept bringing her balloons which she first blew up, then attempted to juggle. These balloons were labeled: parents, education, friends, career, relationship and baby. All important parts of life but too much for anyone to juggle, no matter how able they might be. Sure enough, one or more of the balloons kept getting away from her.

The reason I am describing this performance to you is that I believe that one of the pernicious lies that has been told to your generation is that one can "have it all." Although I can't explain how I knew it, I always knew was that this was not possible. Again, I looked to history and discovered that those women who had achieved at the level at which I had set my sights had been childless and those that were not had suffered constant guilt at not being able to meet the demands of both their work and their child.

Although I would be the first to say that this situation is not a fair one, I must also state that I would hate for you to discover that choices must be made *after* you had already made those whose consequences will shape your life for years to come. I believe that it is exceedingly important to be clear about your goals and to be willing to construct your life in a way that makes them possible to achieve. For it is not a lack of talent, intelligence, or ability that has prevented from women from fully realizing their potential, it is a life structure that makes too many demands.

I realize that I have said some things that are not popular and that, if you follow my advice, your choices will not always be popular either. But if I am truly to pass on lessons about what I have learned and also what I have done to achieve my own successes, I would be less than honest if I did not include some uncomfortable facts.

In closing, let me congratulate you on your graduation, wish you success in your chosen career, and wish for you the sense that you have made a difference in whatever sphere becomes your own. Last but not least, I feel obliged to tell you that feeling that my life has had a purpose has brought me the most intense satisfaction, a satisfaction I hope that you will all experience in the years to come.

ACKNOWLEDGMENTS

I have been exceedingly fortunate to have worked with my editor, Mindy Werner, on numerous publications over the years of our literary relationship, which dates back to the early 1990s. But this book presented both of us with a formidable challenge because my writing style tends towards narration. This time, I was asked to balance a narrative approach with a series of themes, which was very difficult for me. Without Mindy as my guide, there was no way that I could have accomplished it so I owe her a huge debt of gratitude. And of course, as always, I am indebted to my husband, Donald Woodman, who is both a wonderful photographer and a great life partner. We were aided in the many tasks that an illustrated publication requires by our assistant, Chris Hensley, and I want to thank him for his help. On the publishing side, this is the second book I've done with Christopher Lyon, the creative Executive Editor of The Monacelli Press. I would like to express my appreciation for his input, his help, and most of all, his faith in me. Thanks are also due to Stacee Gravelle Lawrence, the copy editor, the designer, Gina Rossi, who worked hard to make this book visually lively, and the resourceful Michael Vagnetti, production manager at Monacelli.

SELECTED BIBLIOGRAPHY

Ashton-Warner, Sylvia. *Teacher.* New York: Touchstone, 1963.

Darder, Antonia, Marta Baltodano, and Rodolfo D. Torres, eds. *The Critical Pedagogy Reader.* New York: Routledge-Falmer, 2003.

Deats, Sara Munson, and Lagretta Tallent Lenker, eds. *Gender and Academe: Feminist Pedagogy and Politics.* Lanham, MD: Rowman & Littlefield Publishers, Inc., 1994.

Elkins, James. *Artists with PhDs: On the New Doctoral Degree in Studio Art.* Washington, DC.: New Academia Publishing, 2009.

Elkins, James. *Why Art Cannot Be Taught: A Handbook for Art Students.* Urbana, IL: University of Illinois Press, 2001.

Fehr, Dennis E., Kris Fehr, and Karen Keifer-Boyd. *Real-World Readings in Art Education: Things Your Professors Never Told You.* New York: Routledge, 2000.

Freire, Paulo. *Pedagogy of the Oppressed.* New York: Herder and Herder, 1970.

Gubar, Susan, ed. *True Confessions: Feminist Professors Tell Stories Out of School.* New York: W. W. Norton, 2011.

Hale, Sondra, and Terry Wolverton, eds. *From Site to Vision: The Woman's Building in Contemporary Culture.* Los Angeles: Otis College of Art and Design, 2011.

hooks, bell. *Feminism Is for Everybody: Passionate Politics.* Cambridge, MA: South End Press, 2000.

hooks, bell. *Teaching to Transgress: Education as the Practice of Freedom.* New York: Routledge, 1994.

Irwin, Rita L., and Alex de Cosson, eds. *A/r/tography: Rendering Self Through Arts-Based Living Inquiry.* Vancouver, BC: Pacific Educational Press, 2004.

Kaplan, Janet A., ed. *Art Journal* 58, no. 4 (Winter 1999).

Keifer-Boyd, Karen T., and Jane Maitland-Gholson. *Engaging Visual Culture.* Worcester, MA: Davis Publications, Inc., 2007.

Kimmel, Michael S., and Thomas E. Mosmiller, eds. *Against the Tide: Pro-Feminist Men in the United States, 1776–1990: A Documentary History.* Boston: Beacon Press, 1992.

Klein, Susan S. *Handbook for Achieving Gender Equity through Education.* Mahwah, NJ: Lawrence Erlbaum Associates, Inc., 2007.

Macdonald, Stuart. *The History and Philosophy of Art Education.* Cambridge, England: The Lutterworth Press, 2004.

Madoff, Steven Henry, ed. *Art School (Propositions for the 21st Century).* Cambridge, MA: MIT Press, 2009.

Maher, Frances A., and Mary Kay Thompson Tetreault. *The Feminist Classroom.* New York: Basic Books, 1994.

Patai, Daphne, and Noretta Koertge. *Professing Feminism: Cautionary Tales from the Strange World of Women's Studies.* New York: Basic Books, 1994.

Petrovich, Dushko, and Roger White, eds. *Draw It With Your Eyes Closed: The Art of the Art Assignment.* Brooklyn: Paper Monument, 2012.

Rosenberg, Martin, and Frances Thurber. *Gender Matters in Art Education.* Worcester, MA: Davis, 2007.

Sadker, David, Myra Sadker, and Karen R. Zittleman. *Still Failing at Fairness: How Gender Bias Cheats Girls and Boys in School and What We Can Do About It.* New York: Scribner, 2009.

Schweickart, Patrocinio P., ed. *NWSA Journal* (Indiana University Bloomington) *7, no. 2* (1995).

Scott, Joan Wallach, ed. *Women's Studies On the Edge.* Durham: Duke University Press, 2008.

Shor, Ira. *Empowering Education: Critical Teaching for Social Change.* Chicago: University of Chicago Press, 1992.

Singerman, Howard. *Art Subjects: Making Artists in the American University.* Berkeley and Los Angeles: University of California Press, 1999.

Spiers, Peg. "Collapsing Distinctions: Feminist Art Educations as Research, Art and Pedagogy." PhD diss., Pennsylvania State University, 1998.

Stewart, Marilyn G., and Sydney R. Walker. *Rethinking Curriculum in Art.* Worcester, MA: Davis Publications, Inc., 2005.

Sullivan, Graeme. *Art Practice as Research: Inquiry in Visual Arts.* Thousand Oaks, CA: SAGE Publications, Inc., 2010.

Thompson, Don. *The $12 Million Stuffed Shark: The Curious Economics of Contemporary Art.* New York: Palgrave Macmillan, 2008.

Wye, Pamela, ed. *Art Journal* 58, no. 1 (Spring 1999).

INDEX